Complete Anatomy and Figure Drawing

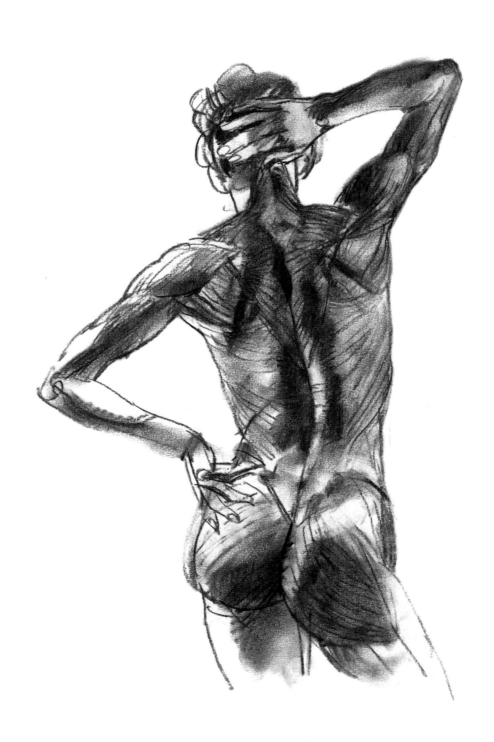

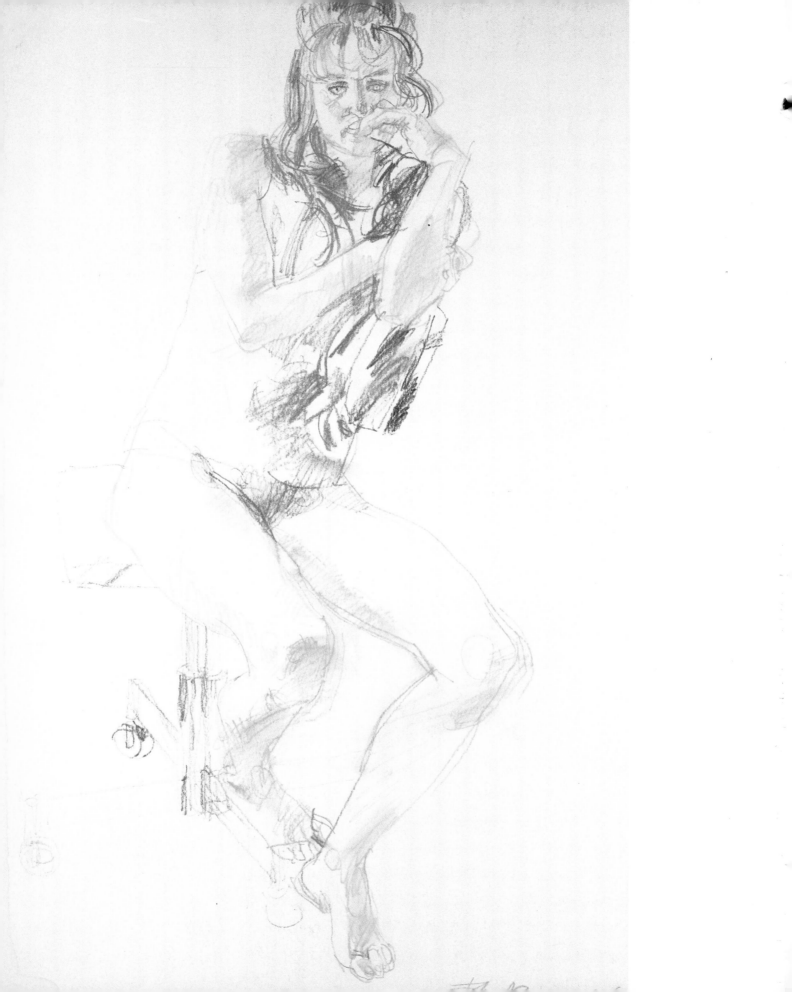

Complete Anatomy and Figure Drawing

John Raynes

BATSFORD

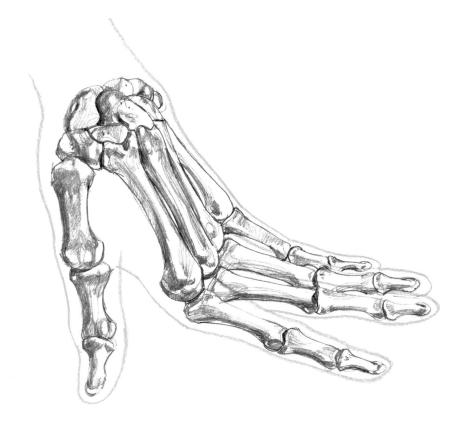

First published in the United Kingdom in 2007 by
Batsford
10 Southcombe Street
London W14 0RA

An imprint of Anova Books Company Ltd

ISBN-13: 9780713490367

A CIP catalogue record for this book is available from the British Library.

15 14 13 12 11 10 09 08 07
10 9 8 7 6 5 4 3 2 1

Reproduction by Classicscan Pte Ltd, Singapore
Printed by Times Offset, Malaysia

This book can be ordered direct from the publisher at the website:
www.anovabooks.com, or try your local bookshop

Distributed in the United States and Canada by Sterling Publishing Co.,
387 Park Avenue South, New York, NY 10016, USA

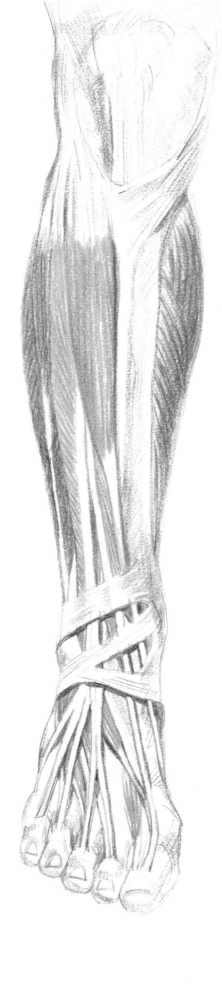

Contents

Introduction

Many would-be artists find that the most demanding problem they encounter is that of drawing other people.

Many would-be artists find that the most demanding problem they encounter is that of drawing other people. Much of the problem resides in the acuteness of human recognition: everybody can see instantly if a drawing of a person is wrong. They may not be able to say exactly what makes it wrong and are even less likely to know how to put it right, but especially in the area of personal likeness, they will know if it is right or not.

Sorting out the subtle and infinitely varied forms of the human face and figure is not easy; it would be unfair and dishonest to pretend that it is. Just as with drawing any other objects, analytical observation, perhaps accompanied by careful measurements, will enable you better to see the familiar shapes with a more dispassionate, objective vision.

But how do you decide which of the myriad bumps and hollows, smooth curves and sharp angles are significant enough to be measured? It is easy to see that the shapes of features, such as eyes, nose, mouth and ears, are important but as well as seeing their shapes it is essential to place them accurately.

To do this you need to look at the spaces between the features, the forehead, cheekbones, temple and chin – all forms made of bone thinly covered by tissue, all therefore fixed by the shape of the skull and lower jaw. Elsewhere on the human figure the bones tend generally to be deeper beneath the surface; but there are a number of places where parts of the bones can be seen just below the skin. They may appear as ridges or nodules, dimples or grooves and these more or less constant salient points can be immensely helpful in identifying the positions of the main skeletal elements. As such, they are the first clues for which you need to search.

Luckily, most or all of these important points are identifiable, even in well-covered individuals. Whereas with very light musculature and little fat they may appear at the surface as projections, they are never covered by heavier muscles but instead can be recognized at the skin surface as depressions between the main muscle masses. Even in massively overweight individuals the signs remain, albeit a little more difficult to pinpoint.

Once the ability to see these vital signposts is acquired, the rest can be dropped into place. Muscles with their attendant tendons attach to the movable skeletal elements, pulling and twisting them into the myriad movements and positions of which the human body is capable.

How far you should go in learning the precise actions of each joint and the origin and insertion of every muscle in order to draw the human figure from life is a matter of personal choice. (The origin of the muscle – from which it 'arises' – refers to its fixed attachment and the insertion of the muscle to the more movable point. In fact in most cases both connections are capable of movement, but the terms

RIGHT: The nuances of the human body are both a delight and a challenge for the artist (see pages 122–123).

remain). Certainly, acquiring some knowledge of the way that the spine moves and how the thorax (ribcage) and the pelvis attach to it is very useful. Likewise, being able to recognize the main muscle groups enables better understanding, helping you to decide which of the often-bewildering plethora of forms are the most significant. Drawing is not just a matter of recording every detail of what is seen – the best drawings are made by selecting, and thereby clarifying and intensifying, the thing seen.

Although it is difficult to say with certainty how much knowledge of the internal structure is necessary to ensure good draughtsmanship of the human figure, you may find, once you have started to look at it, that it is difficult to stop. For example, there is not just one layer of muscles: in many places there are as many as three or more layers. Not only that, the topmost layer of muscles is often a thin sheet that takes its observed surface form from a more bulky muscle beneath it. In order to understand what is happening close to the surface you may need to know something about what is going on deeper down.

Muscles work by shortening and relaxing on demand; that is all they do but together with a variety of connections and working singly and in groups a large range of movements can be made. There are pulleys for the tendons, mechanisms to absorb shocks, self-lubricating hinges and amazing pieces of evolved design wherever you look around the human body.

It is true that all human bodies work in a similar way and they share characteristics that are specifically human; a human thigh bone (*femur*) is recognizably different from that of, say, an elephant or a cat, although elephants and cats both have *femurs*. The human pelvis has uniquely evolved to support our upright mode of locomotion, which is quite different from that of our close primate cousins. We all have comparatively more developed bottom muscles (*gluteus maximus*) than other primates; this is also associated with bipedal progress.

Within this quite specific set of human characteristics there is room for huge variation. Most of this variety is in the area of dimension. Every bone in the body shows variation in length and thickness between individuals, giving almost infinite combinations. Gender, race and parentage participate in the variations and so does lifestyle. Heavy work makes bigger muscles that in turn make the need for bones that are thicker and stronger. Age and state of health add their influences, as do nutrition and work-associated posture.

I have been asked why I still draw from life – why, after drawing hundreds, perhaps thousands, of figures, don't I know from memory what a human being looks like? The answer of course is that every human being is unique, and each and every one of them provides a further collection of shapes and postures that are waiting to be discovered. This book is about helping you to search out those differences and capture them on paper.

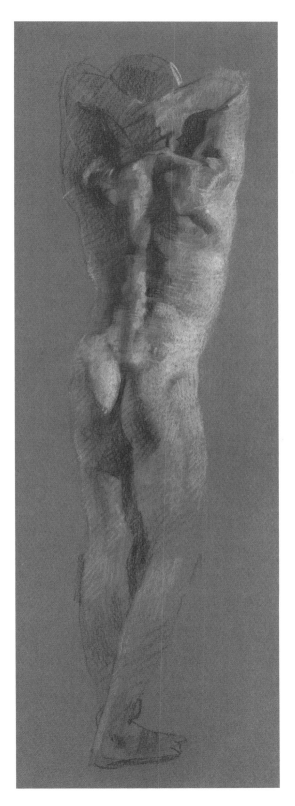

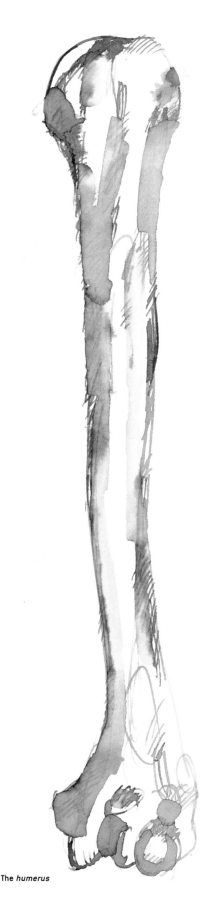

1 The Skeleton

The skeleton is the essential internal support framework for all mammals including human beings.

For the figure artist searching for the structure of the human form it is important to have an understanding of the skeleton, of how it holds together and especially the way that it moves and articulates. On its own the skeleton is a non-working structure – it's like the masts and spars of a ship – it needs the rigging to hold it together and to move it about.

So the drawings on these pages are from skeletons (or nowadays excellent plastic replicas) that have been joined together by various bolts, wing nuts and hinges to allow a simulation of the myriad movements that are possible in life. Without muscles they cannot stand up and can only be held in an upright posture by hanging from an external support stand. The following general description assumes the figure to be standing on both legs with the arms hanging down and palms turned out so that the terms upper and lower apply to their corresponding positions in the accompanying drawings.

Of course, the figure is not always in the standing posture but even so the terms upper, lower, front and back or their Latin equivalents still generally apply as if it were still upright. To avoid confusion in later, more detailed descriptions we may need here to embrace a few of the Latin names used by most anatomical textbooks. However, unless I feel that there is room for misunderstanding I shall, wherever possible, try to keep to normal usage English words, but wherever I feel that greater precision is required or maybe just to keep reminding you of the technical words, I will use the Latin. All medical terms will appear in italics.

The following are the main descriptive special terms in general use:
Upper and lower = superior and inferior
Front, side and back = anterior, lateral and posterior
Near and far = proximal and distal

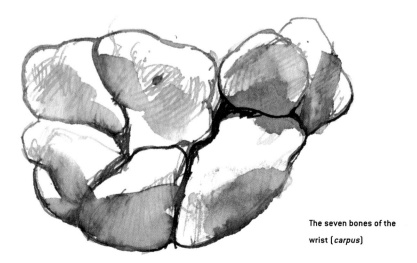

The *humerus*

The seven bones of the wrist (*carpus*)

Also, bones may be classified as long, short, flat or irregular. Long bones have a relatively narrow shaft (tubular) and two extremities (ends) that are enlarged for good connection of muscles and to suit the needs of the joint. Short bones tend to be small and clustered in groups with little movement between them – the bones of the wrist (*carpus*) and ankle (*tarsus*) are typical. Flat bones are either for protection, as those of the *cranium*, or to provide broad surfaces for muscle attachment, as the shoulder blade (*scapula*). All the rest, such as the vertebrae and the jawbone and bones of the face are called irregular.

Other special terms apply to various bumps and grooves on the surface of bones – many are self-explanatory and any that are not will be described when they occur.

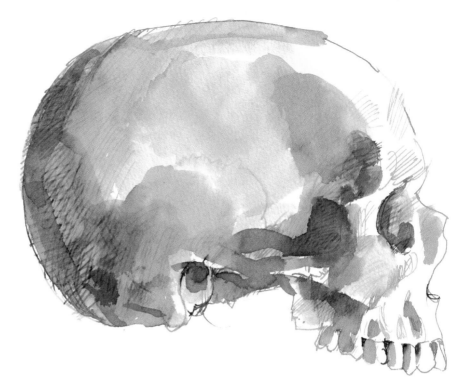

The skull

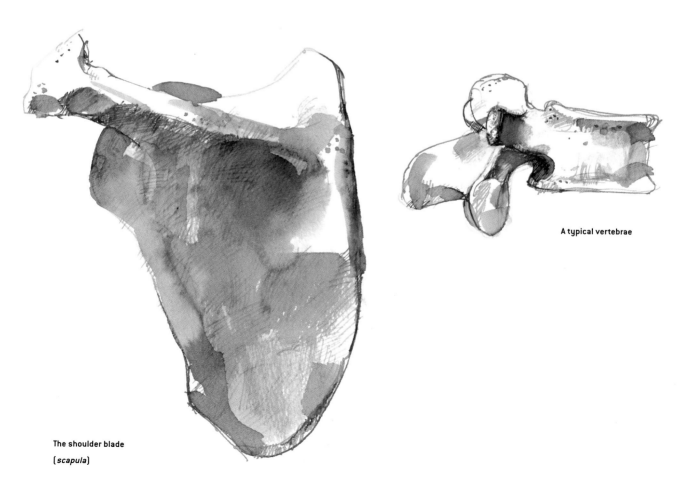

A typical vertebrae

The shoulder blade

(*scapula*)

9

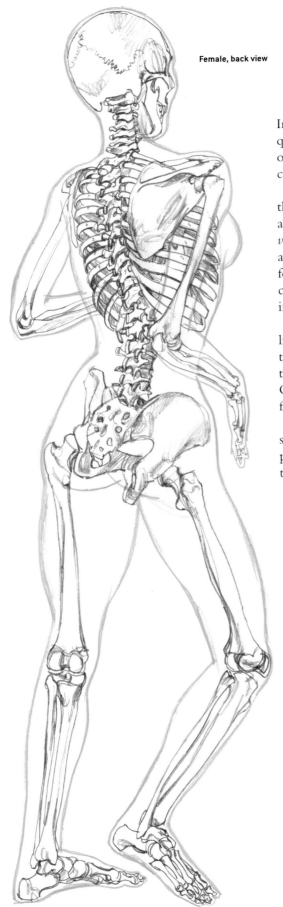

Female, back view

In many ways the human skeleton is similar to that of animal quadrupeds, many bones having the same names, but the adaptation of humans to upright gait has made necessary certain significant changes to some structures.

Probably the most important change is in the area of the pelvis that, while providing attachments for the lower (or rear) limbs, has also now to become the primary support for the upright backbone or *vertebral column*. This is a series of linked bones (*vertebrae*) that in life are held in position by complicated groups of muscles and tendons to form a column that, even at rest, incorporates several characteristic curves, but which is also capable of great flexibility, in some individuals astonishingly so.

Although the main body of the backbone is hidden from view in life, each *vertebra* has several protruding pieces of bone called *processes*: the central backwards-projecting one of these extends to just below the skin, making the line of the backbone always clearly discernible. Other *vertebral processes* provide articulation and attachment points for muscles.

Securely locked to the base of the spine and virtually on the surface from the rear view is the *sacrum*, which is itself part of the pelvis or hipbone. Much of the rest of the pelvis is deeply buried but the front and side edges are usually easily seen at the surface.

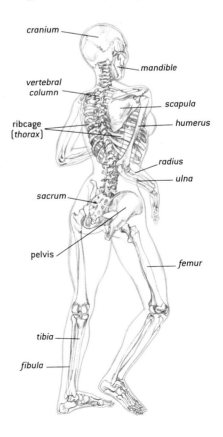

cranium
mandible
vertebral column
scapula
ribcage (*thorax*)
humerus
radius
ulna
sacrum
pelvis
femur
tibia
fibula

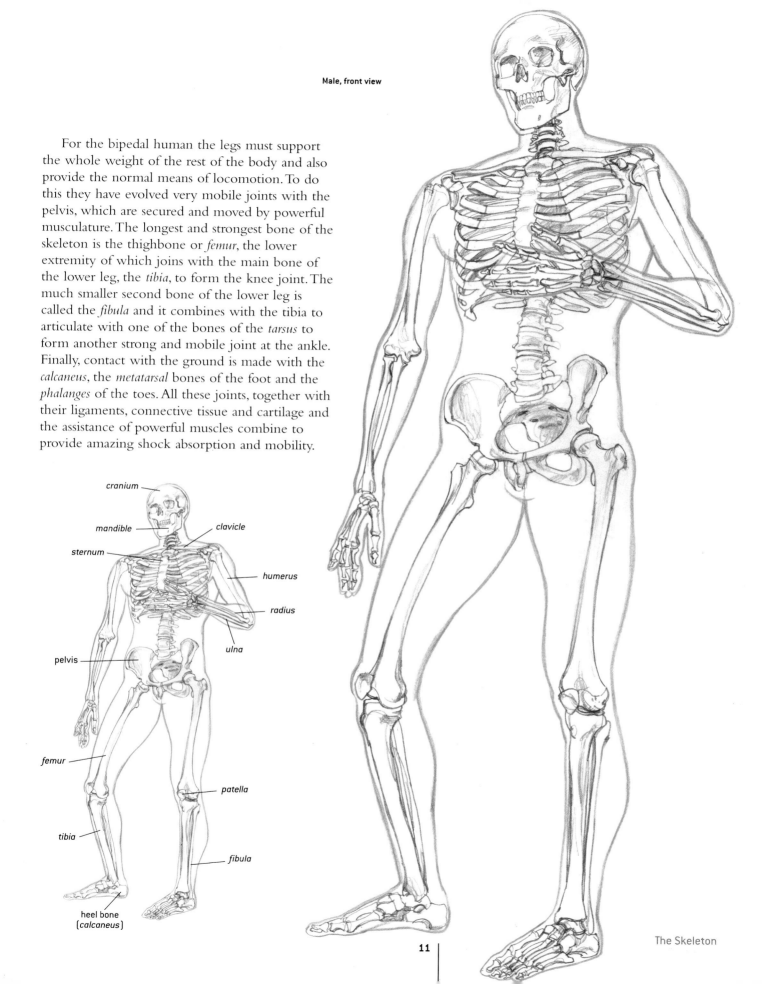

For the bipedal human the legs must support the whole weight of the rest of the body and also provide the normal means of locomotion. To do this they have evolved very mobile joints with the pelvis, which are secured and moved by powerful musculature. The longest and strongest bone of the skeleton is the thighbone or *femur*, the lower extremity of which joins with the main bone of the lower leg, the *tibia*, to form the knee joint. The much smaller second bone of the lower leg is called the *fibula* and it combines with the tibia to articulate with one of the bones of the *tarsus* to form another strong and mobile joint at the ankle. Finally, contact with the ground is made with the *calcaneus*, the *metatarsal* bones of the foot and the *phalanges* of the toes. All these joints, together with their ligaments, connective tissue and cartilage and the assistance of powerful muscles combine to provide amazing shock absorption and mobility.

cranium

mandible

sternum

clavicle

humerus

radius

ulna

pelvis

femur

patella

tibia

fibula

heel bone
(*calcaneus*)

11

The Skeleton

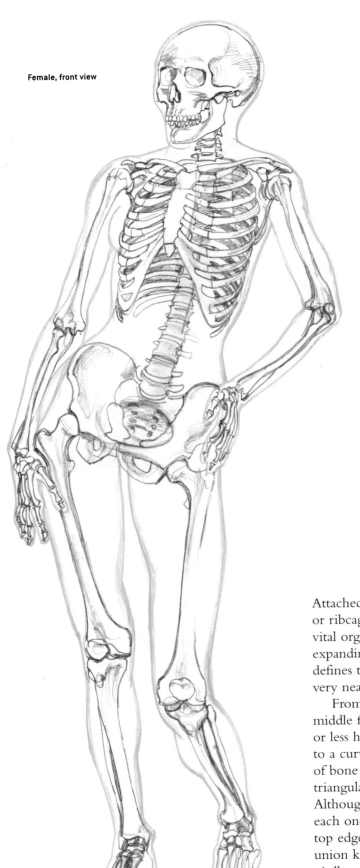

Female, front view

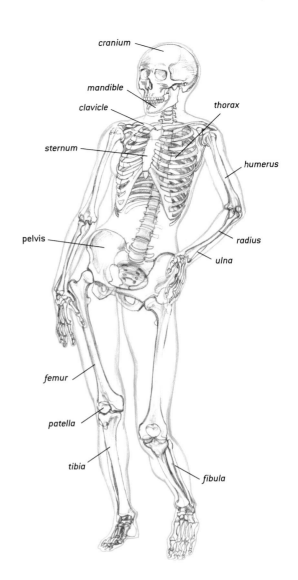

cranium

mandible

clavicle

thorax

sternum

humerus

pelvis

radius

ulna

femur

patella

tibia

fibula

Attached to the spine and supported by its upper *vertebrae*, the *thorax* or ribcage is literally a cage made of flat curved bones that protects vital organs and also works as a set of bellows, contracting and expanding to suck air in and out of the lungs. The ribcage largely defines the form of the upper body and the individual ribs are often very near to the surface.

From the top of the *sternum* or breastbone, which forms the middle front of the ribcage, the collarbones or *clavicles* extend more or less horizontally outwards to the shoulders where they each attach to a curved *process* called the *acromion*, an extension of a raised ridge of bone on each *scapula* (shoulder blade). The two *scapulae* are flattish triangular bones that lie against the upper back of the *thorax*. Although they are quite thin and flat over a large part of their surface each one also has a prominently raised ridge that extends to the outer top edges and then curves around to meet the collarbones to form a union known as the shoulder girdle. Immediately below the shoulder girdle a shallow depression in the top outer corner of each *scapula* provides articulation for a corresponding rounded top of the main arm bone, the *humerus*.

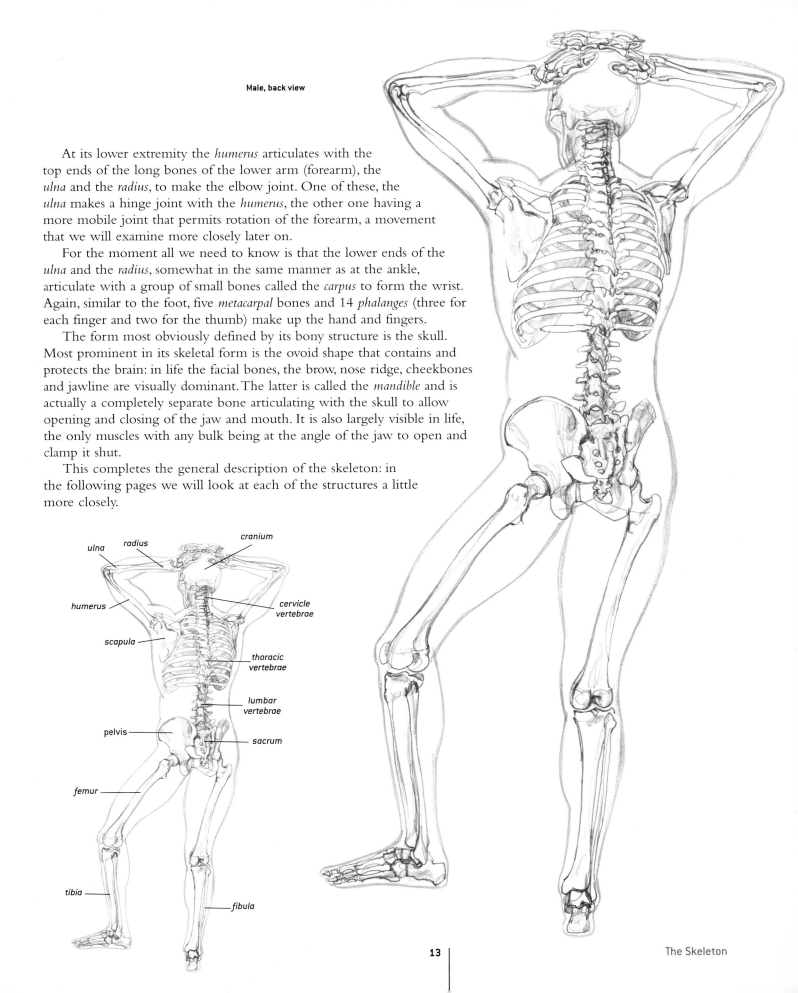

Male, back view

At its lower extremity the *humerus* articulates with the top ends of the long bones of the lower arm (forearm), the *ulna* and the *radius*, to make the elbow joint. One of these, the *ulna* makes a hinge joint with the *humerus*, the other one having a more mobile joint that permits rotation of the forearm, a movement that we will examine more closely later on.

For the moment all we need to know is that the lower ends of the *ulna* and the *radius*, somewhat in the same manner as at the ankle, articulate with a group of small bones called the *carpus* to form the wrist. Again, similar to the foot, five *metacarpal* bones and 14 *phalanges* (three for each finger and two for the thumb) make up the hand and fingers.

The form most obviously defined by its bony structure is the skull. Most prominent in its skeletal form is the ovoid shape that contains and protects the brain: in life the facial bones, the brow, nose ridge, cheekbones and jawline are visually dominant. The latter is called the *mandible* and is actually a completely separate bone articulating with the skull to allow opening and closing of the jaw and mouth. It is also largely visible in life, the only muscles with any bulk being at the angle of the jaw to open and clamp it shut.

This completes the general description of the skeleton: in the following pages we will look at each of the structures a little more closely.

ulna

radius

cranium

humerus

cervicle vertebrae

scapula

thoracic vertebrae

lumbar vertebrae

pelvis

sacrum

femur

tibia

fibula

13

As promised, we will now examine certain elements of the skeletal structure a little more closely. I will not attempt to describe everything about every bone: my priority will always be to look at those elements that influence the surface form. In some cases this may be at one remove from the actual near-surface feature of the bone itself. For example, it may be necessary to draw attention to the attachment point of a muscle on a bone in order fully to understand later in the book how a muscle works.

The Pelvis

In establishing the essential balance of a figure, especially in the standing pose, the position and shape of the human pelvis is paramount. For this reason it is worth looking at it closely.

As stated previously, from the front much of the pelvis is well below the surface, its two wings, the *ilia* (singular: *ilium*) together with the *sacrum* forming a sort of cradle for the abdomen and its sack of organs. Actually the *ilium* is the name only for the upper part of what is known as the *innominate* (hip) bone. Each hip bone includes the *os pubis* that forms the front boundary of the pelvic cup shape and the *ischium*, a deep open arch of bone, which we will encounter later as the attachment for many of the large leg muscles.

Male pelvis

ilium

crest of ilium

anterior superior
iliac spine

acetabulum

ischium

sacrum

os pubis

Female pelvis

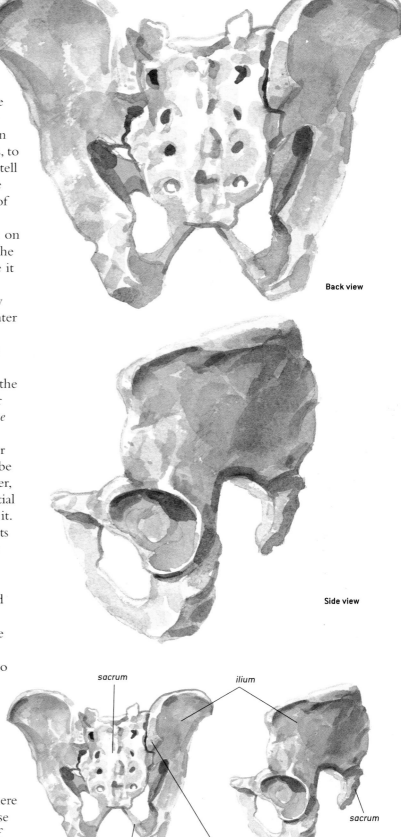

Luckily for identification by the artist, the front edge of each *ilium* is only covered by skin and is very clearly defined as it curves upwards and outwards as a groove in well-muscled subjects or a prominent edge in thin ones, to give clues about the tilt and thrust of the pelvis, which tell so much about a pose. On each of these front edges the most prominent and easily identified feature is a point of abrupt change of angle called, rather formidably, the *anterior superior iliac spine*. You will see that I have drawn on the opposite page two different versions of the pelvis. The right-hand one is a typical female pelvis. As you can see it is wider in proportion to its height, the *ilia* flatter and more open than the male. The larger opening, necessary for passage of the head of a foetus, contributes to a greater distance between the female *acetabuli* (sockets for the *femurs*) and a further widening of the appearance of the hips in life.

From the back view, inserted like a wedge between the two *innominate* bones lies the aforementioned triangular bone called the *sacrum*. Formed as it is from five *vertebrae* that are fused together to make a solid shape with four more very small *vertebrae* attached to its base (these latter named the bones of the *coccyx*) it can be considered to be more a part of the backbone than of the pelvis. However, it is very firmly fixed to the rest of the pelvis and essential to its bowl-like structure so is generally described with it. Although there can be a small degree of movement at its articulation with the *ilia*, it is virtually impossible to see evidence of it externally.

In life the *sacrum* is near to the surface in thin individuals but covered by a pad of fat in more rounded and especially female subjects. In both cases, however, there are two points that help to define the edges of the *sacrum* and therefore the tilt of the pelvis. They are not actually on the *sacrum* itself but are part of the *ilia* and so are called the *posterior superior iliac spines* (as opposed to the *anterior superior* etc. mentioned earlier). When the pad of fat is present these points appear as depressions or dimples: if the subject is thinner they are more likely to be seen as bumps.

The angle that the *sacrum* makes with the lowest *vertebra* governs the degree of natural backwards or forwards tilt of the whole pelvis and thence posture. There may be considerable variation in this angle and of course flexing or extending the lower back will alter the tilt of the pelvis. In an upright, relaxed posture most figures settle into a natural angle often characteristic of the racial type of the individual.

Back view

Side view

sacrum

ilium

prosterior superior
iliac spine

ischium

sacrum

ischium

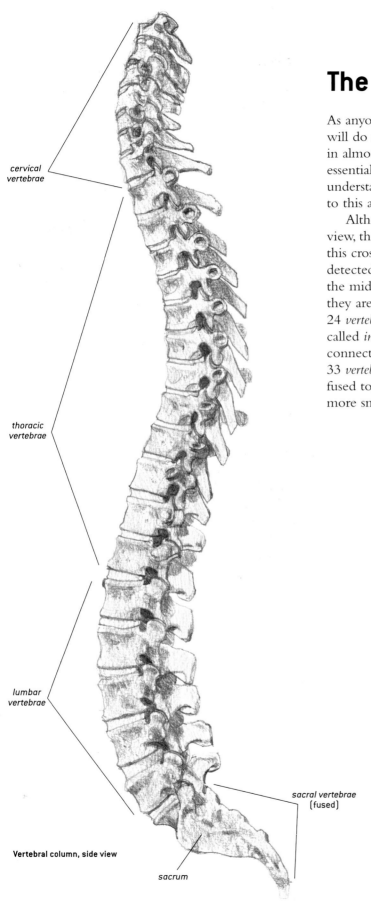

cervical
vertebrae

thoracic
vertebrae

lumbar
vertebrae

sacral vertebrae
(fused)

Vertebral column, side view

sacrum

The Vertebral Column

As anyone who has had any back strain knows (and almost everyone will do at some time in their life), the backbone or spine is involved in almost every movement of the body. Its flexibility and support is essential: finding and revealing its line is fundamental to understanding and expressing the essence of any pose. We will return to this again and again as the drawing methods are developed.

Although it is such a vital structure, most of it is well hidden from view, the major support elements running deep within the body, as this cross-section shows. As mentioned earlier, its position can be detected by reference to the line of projections that can be seen in the middle of the back. Each of these projections, *spinous processes* as they are termed, is the outwardly visible sign of one *vertebra*. There are 24 *vertebrae*, balanced on top of each other, separated by cushions called *intervertebral discs* and tied together by various types of connective tissue. Medical anatomy books will tell you that there are 33 *vertebrae* – strictly true of course, but it includes the five that are fused together to make the solid form of the *sacrum* and the four more small bones in the *coccyx*.

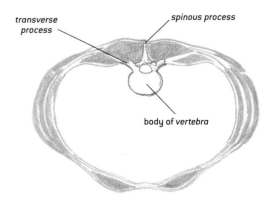

transverse
process

spinous process

body of *vertebra*

Section through abdomen,

lumbar region

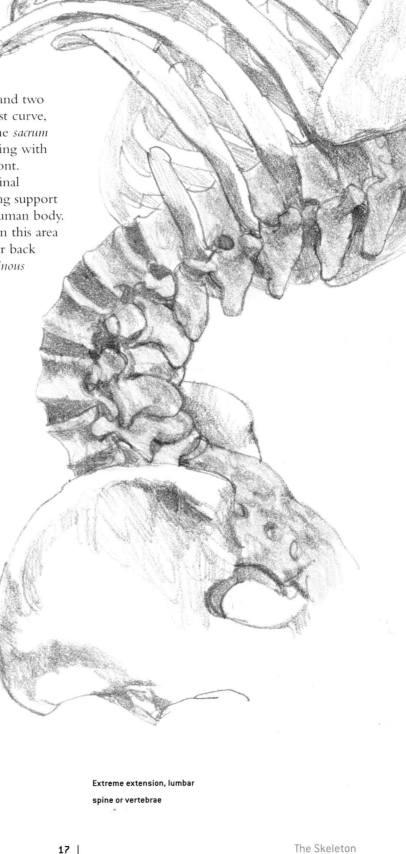

Although the human vertebral column in the normal erect posture looks to be straight and upright when viewed from the back, from the side it has three quite distinct curves, one primary (the *thoracic*) and two secondary (the *cervical* and *lumbar*). There is a fourth lowest curve, concave to the front, if you count the fused *vertebrae* of the *sacrum* and the *coccyx*, the top (*promontory*) of the *sacrum* articulating with the lowest *lumbar vertebra* at an angle tilted towards the front.

Five in all, the *lumbar vertebrae* are the largest in the spinal column and combine with the *sacrum* to give a very strong support structure that is vital to almost every movement of the human body. The consequent large and powerful muscle attachments in this area leave a characteristic groove down the centre of the lower back that can be very deep in well-muscled individuals, the *spinous processes* of the *lumbar vertebrae* often indicated by little depressions rather than the bumps that are usually visible higher up in the central line of the back.

The severity of the *lumbar* curve can be increased considerably in supple subjects: I have seen X-ray pictures of the lumbar spine of a contortionist that is so extremely extended (backwards curved) that it almost looks to be dislocated! Gymnasts also often have a pronounced *lumbar* curve when standing upright.

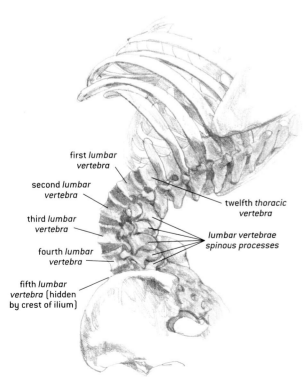

first *lumbar* vertebra

second *lumbar* vertebra

third *lumbar* vertebra

fourth *lumbar* vertebra

fifth *lumbar* vertebra (hidden by crest of ilium)

twelfth *thoracic* vertebra

lumbar vertebrae spinous processes

Extreme extension, lumbar spine or vertebrae

The Skeleton

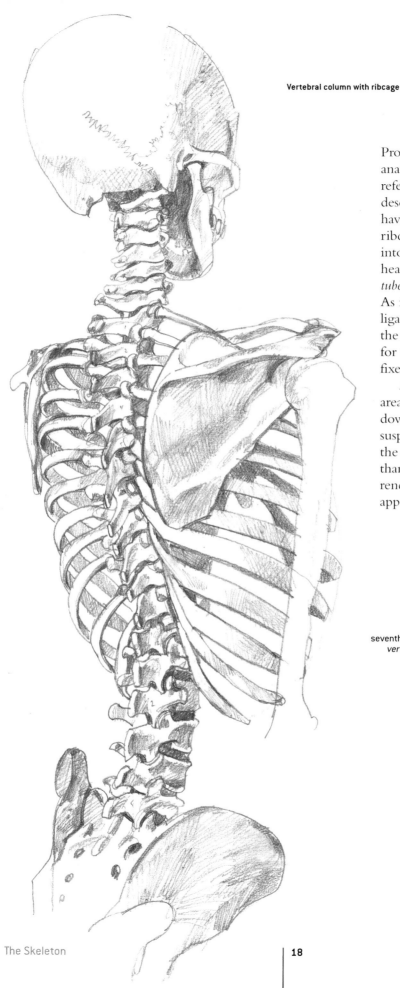

Progressing upwards, the next 12 *vertebrae* are anatomically named *thoracic vertebrae*, but often referred to clinically as *dorsal vertebrae*. This curve is described as being concave forward, its *vertebrae* having the additional function of supporting the ribcage, each of them having one, two or three facets into which fits the head and tubercle of a rib, the head being the posterior end and the tubercle or *tuberosity* being a raised eminence near to the head. As in all articulations there are many and varied ligaments and membranes, which secure the ribs to the *vertebrae*, none of which we need to know about for this book – just accept that they are securely fixed in place!

Although there is some flexibility in the *thoracic* area of the spine it is not comparable with that lower down or higher up in the neck, the presence of the suspended ribcage being a limiting factor. Ascending the column, each succeeding *vertebra* is a little smaller than the one preceding, the whole effect being to render a gradually more slender structure as it approaches the head.

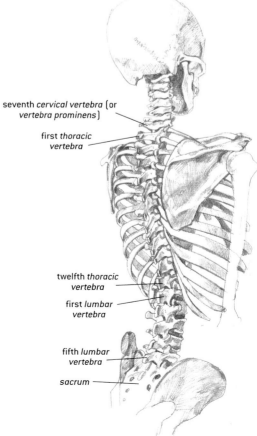

seventh *cervical vertebra* (or *vertebra prominens*)

first *thoracic vertebra*

twelfth *thoracic vertebra*

first *lumbar vertebra*

fifth *lumbar vertebra*

sacrum

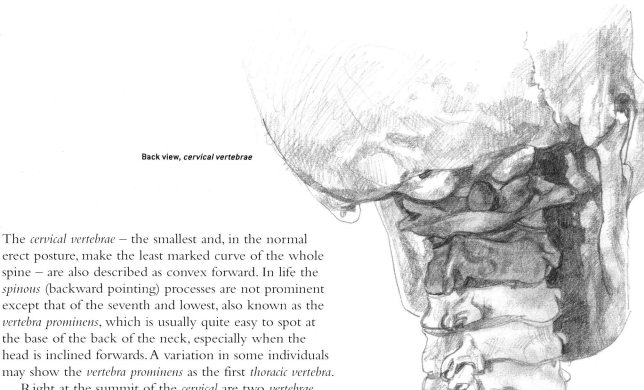

Back view, *cervical vertebrae*

The *cervical vertebrae* – the smallest and, in the normal erect posture, make the least marked curve of the whole spine – are also described as convex forward. In life the *spinous* (backward pointing) processes are not prominent except that of the seventh and lowest, also known as the *vertebra prominens*, which is usually quite easy to spot at the base of the back of the neck, especially when the head is inclined forwards. A variation in some individuals may show the *vertebra prominens* as the first *thoracic vertebra*.

Right at the summit of the *cervical* are two *vertebrae* that are specialized to support the head and to allow the various movements of nodding and turning. They have their own names, the upper one, directly under the skull being the *atlas*, so named after the Titan who in Greek mythology was supposed to support the world on his shoulders. It has no *spinous process* so there is no chance of it being detectable at the skin surface. The lower, second *vertebra* is known as the *axis* and it performs the function of a pivot upon which the *atlas* – and therefore the head – rotates. This too is deep in the neck as are the next three *cervical vertebrae*; only the *spinous processes* of the sixth and the above-mentioned seventh being visible as bumps on the skin surface.

Of course this is a somewhat simplified description of the vertebral column: in fact all the *vertebrae* have a number of other *processes* in addition to the *spinous processes*. These and similar long ones that project sideways well below the surface provide levers for muscles to manipulate the spine. There are also *processes* that project from each *vertebra* to articulate with the next. Notably each one also has a *neural arch*, which combines with the others to form a protective channel for the spinal cord. All in all, *vertebrae* have evolved to provide a wonderful combination of flexibility and strength, each one permitting a small degree of movement with the next (which adds up throughout the length of the spine), but held firmly enough to its neighbour to be highly resistant to any form of dislocation.

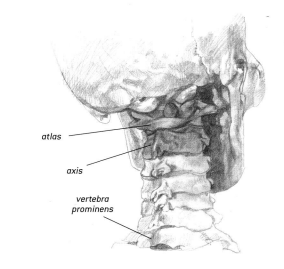

atlas

axis

vertebra
prominens

The *Thorax*

The *thorax* is sometimes referred to as the ribcage, a suitably descriptive term, as it has the appearance of a cage and it does enclose and protect the organs of the upper body.

The *thorax* is sometimes referred to as the ribcage, a suitably descriptive term, as it has the appearance of a cage and it does enclose and protect the organs of the upper body. Unlike most cages however it can be and is constantly mobile. A complicated muscular system contrives to raise and expand it or to lower and compress it, thereby alternately dragging air into the lungs and pushing it out again.

Ten of the 12 ribs are joined to the *sternum*, a flat bone at the front of the chest. It is a sword-like bone made up of three bones joined together by cartilage. The upper portion or *manubrium* is somewhat triangular in form. Below this, the *body* of the *sternum* is longer and thinner and together they provide a surface for attachment of the large muscles of the upper chest. As such the *sternum* in developed subjects is seen as a central groove: thinner musculature leaves the *sternum* easily visible subcutaneously, often with horizontal ridges where the *manubrium* connects to the *body* and occasionally showing further ridges where its previous five sections were united after puberty. The lowest, third portion is called the *xiphoid process*: it has no function but it is sometimes visible in thin subjects as a projection in the lower front opening of the *thorax*.

A short length of each rib where it joins the *sternum* is not bone but cartilage, generally rather more flexible than bone and contributing greatly to the elasticity of the whole ribcage. Each pair of ribs is attached at the back to special processes on the *thoracic vertebrae*, as previously described, and the last two pairs of ribs are not attached at the front of the body at all but are 'floating' ribs.

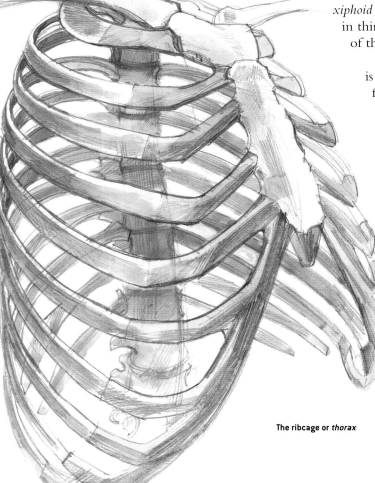

The ribcage or *thorax*

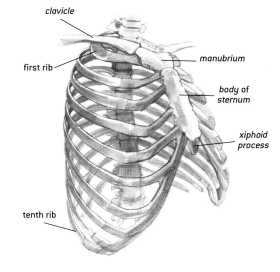

clavicle

first rib

manubrium

body of sternum

xiphoid process

tenth rib

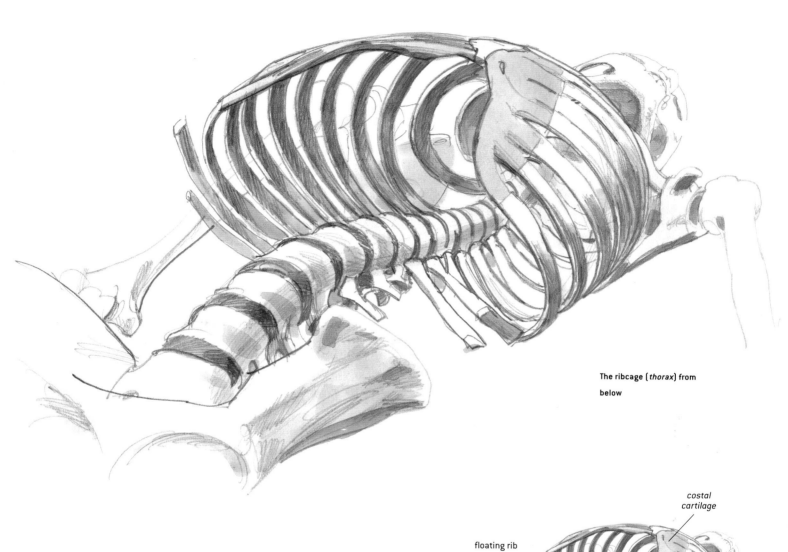

The ribcage (*thorax*) from below

costal cartilage

floating rib

twelfth rib (floating)

The lower front opening (the costal margin) of the *thorax* is formed by the cartilage of the seventh to the tenth ribs and is often a clearly visible feature in life especially during inhalation. Much of the lower ribcage itself is also discernible at the skin surface in thin subjects although possibly concealed by muscle or fat in others.

Again, there is great individual variation in the shape and form of the *thorax*. Viewed from the front it may be narrow or wide; from the side it may be shallow or deep. Generally speaking the larger the thorax the greater is the lung capacity so that you could expect athletes always to have big chests, but it isn't so simple unfortunately: there are too many other variables.

The shoulder girdle

In the upper body there is one more important skeletal system that contributes to the uniquely human shape – it is called the shoulder girdle and it is formed by two bones, the *scapula* and the *clavicle*.

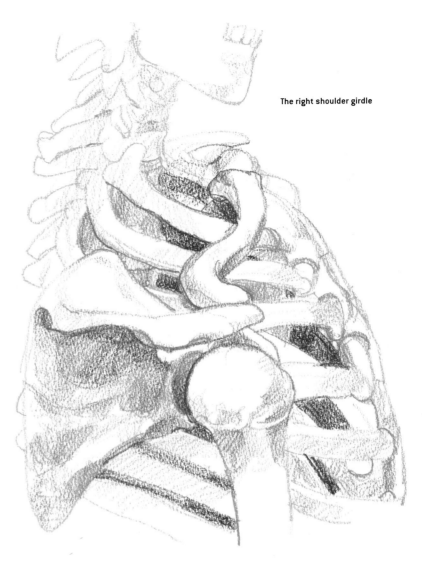

The right shoulder girdle

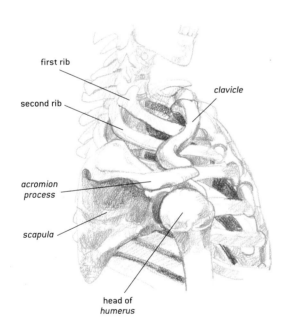

first rib

second rib

clavicle

acromion process

scapula

head of humerus

In the upper body there is one more important skeletal system that contributes to the uniquely human shape – it is called the shoulder girdle and it is formed by two bones, the *scapula* and the *clavicle*. The *scapula* (shoulder blade) has a mainly flat, triangular shape that allows it to lie on the upper back surface of the ribcage. Rising from its upper top surface is a prominent ridge, gradually elevating until it becomes more like a plate of bone and ending as a large flattened *process*, the *acromion*. This curves forward to articulate with the outer end of the *clavicle* (collar bone), a moderately long bone running nearly horizontally across the top of the first rib from its articulation with the *manubrium* of the *sternum*. The outer end of each shoulder girdle thus defines the shoulder width.

In life the outer width and the slope angle of the shoulder is augmented by muscles but the girdle itself is nearly always visible as a prominence or a trough depending on the amount of surrounding muscle or fat.

You may have noticed by now that the propensity for being either a bump or a dimple is a common tendency where parts of the bony skeleton lie just beneath the skin.

The skull

On this page I have loosely enclosed a side view of a human skull within a square. As you can see, the main body of the skull occupies at least two-thirds of the square, only a sixth of the square being filled by the jawbone or the *mandible*. This is a generalization and cannot be depended on but it is a useful starting point.

For the artist, and more especially for the portraitist, it is important to realize that the outward shape and form of each human face and head is overwhelmingly dependent on the shape and proportions of the skull. Very little lies concealed under muscle and even if there is excessive fat deposition, the shapes and positioning of the main features can still be sensed. By features I do not mean only the shapes of eyes, nose and mouth, but also and in some ways more importantly, the distances between these facial attention grabbers. There are infinite variations on this general theme and although the differences in shape and proportion are often quite subtle, we as humans are amazingly adept at subliminally sensing these patterns and thereby recognizing the individual.

The main body of the skull occupies at least two-thirds of the square, only a sixth of the square being filled by the jawbone or the *mandible*.

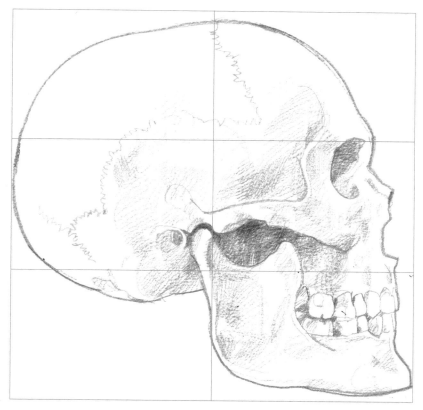

Skull, side view

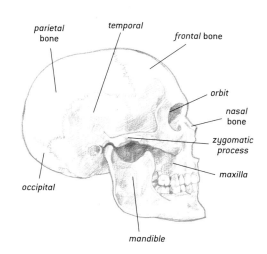

parietal bone

temporal

frontal bone

orbit

nasal bone

zygomatic process

maxilla

occipital

mandible

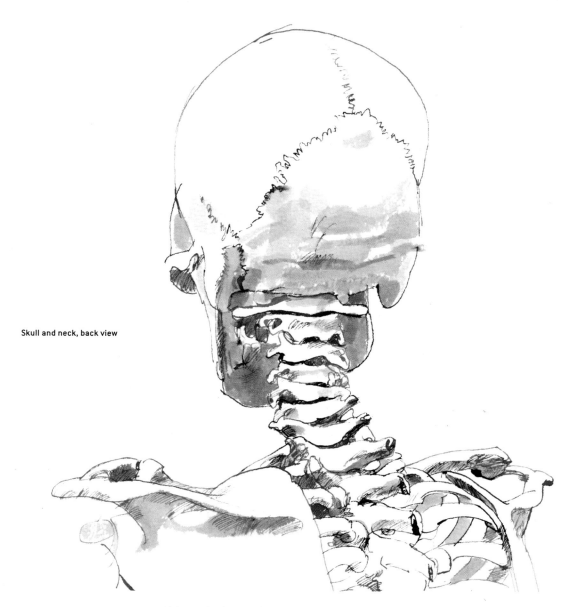

Skull and neck, back view

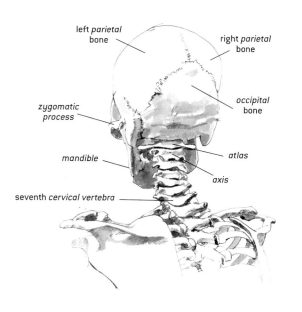

left *parietal* bone

right *parietal* bone

zygomatic process

occipital bone

mandible

atlas

axis

seventh *cervical vertebra*

Although the jawbone (*mandible*) is the only moving part of the skull the remainder is made up of 22 separate bones, between which no significant movement can occur. It could be argued that the *cranium* and face constitute the other moving part of the skull: as we have already seen, the whole head is mounted on two specialized vertebrae at the top of the *vertebral column*, the *atlas* and the *axis*, which combine to allow a great degree of rotation and nodding movement.

The main ovoid shape, normally covered by head hair in both sexes is the *cranium* that encloses and protects the brain. This back view shows how prominent it can be when devoid of hair. It is composed of eight bones, only five of which are really of interest to the artist. Most conspicuous from the front is the unsurprisingly named *frontal* bone that constitutes the forehead. Although anatomists classify it as a bone of the *cranium*, for the artist it is an important facial feature, including as it does the brow ridges and upper orbit of the eye. Combining to make the two sides and roof of the *cranium* are the two *parietal* bones and just below these at each side, areas known more usually as the temples, are the *temporal* bones. From each of the latter a slender arched ridge of bone, the *zygomatic process* curves

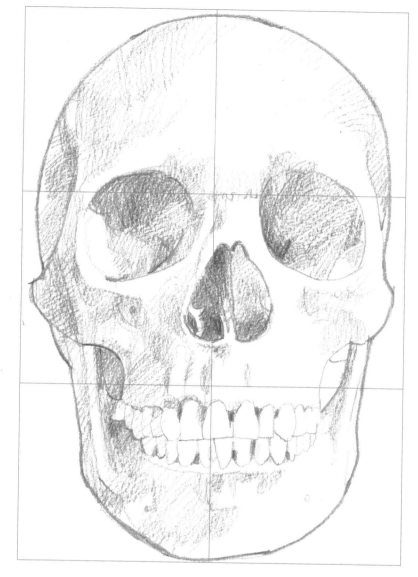

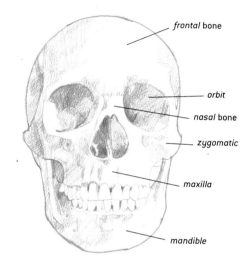

frontal bone

orbit

nasal bone

zygomatic

maxilla

mandible

The skull, front view

down and then forward to join up with the *zygomatic* bones of the face to form the very prominent and well-known forms of the face, the cheekbones.

Of the 14 bones of the face, again only seven are superficial enough to be of particular interest to the artist. The aforementioned *mandible* or lower jaw is the largest and strongest bone of the face. It holds the lower teeth and the shape of its horizontal frontal part, the *body*, its vertical parts – the *rami* – and the angle or corner of the jaw impart very particular character to the living face.

Almost as influential a feature is made up of the two nasal bones and the adjoined cartilage that together form the overall shape of the nose, a highly variable shape that contributes greatly to the character of the face in life. Lastly we have the two *maxillae* bones that hold the upper teeth and give shape to the lower front of the face.

It cannot be over-emphasized that it is the relationship of these bones of the skull to each other and their relative proportions, that, more than any other factor, including the shape of the fleshier features, establishes the uniqueness of every individual and makes them instantly recognizable.

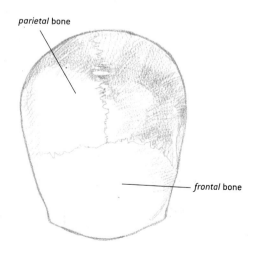

parietal bone

frontal bone

The skull, top view

25

The limbs

Unlike the skull, the long bones of the limbs do not contribute much to outer appearance in life except at their ends where they approach the surface.

Thigh

Unlike the skull, the long bones of the limbs do not contribute much to outer appearance in life except at their ends where they approach the surface. At the wrists, elbows, knees and ankles they are largely uncovered by muscle, their shapes clearly visible and providing useful signposts for the artist searching out the dynamics of a pose. To clarify this, approximate outlines have been added to some of the drawings.

The longest and deepest of the limb bones is the thighbone or *femur* that articulates with the pelvis to form the hip joint. You will have seen on the previous drawings of the pelvis, a cuplike form called the *acetabulum* (see page 14). At the upper end of the *femur* is a ball-shaped extremity called the *head* that fits neatly into this *acetabulum* to make a superbly mobile joint. This permits no less than six directions of movement: they are flexion and extension (swinging the leg forward and backward); abduction and adduction (outward and inward movement); and external and internal rotation of the leg so that the knee turns outward and inward.

The neck of the *femur* joins the *head* to the main shaft, forming an angle of approximately 130 degrees. The only portion of the top of the *femur* that is close enough to the surface to be detectable in life is the outer corner of this angle, called the *great trochanter*. This normally shows as a rounded bump that is the widest point of the hips. From this widest point the *femur* slopes markedly inwards (generally more extremely in the female) to its lower extremity that takes the form of two large eminences called *condyles*, which become the upper half of the knee joint. The *condyle* on the outside (lateral) has a projection called the *lateral epicondyle* that is nearly subcutaneous and clearly visible when the knee is flexed, often having a flattish lateral face and a sharp edge. The corresponding one on the inside is rather more covered, presenting a more rounded form when the knee is flexed.

great
trochanter

shaft of
femur

Thigh bones, seated figure

lateral
epicondyle

tibia

patella

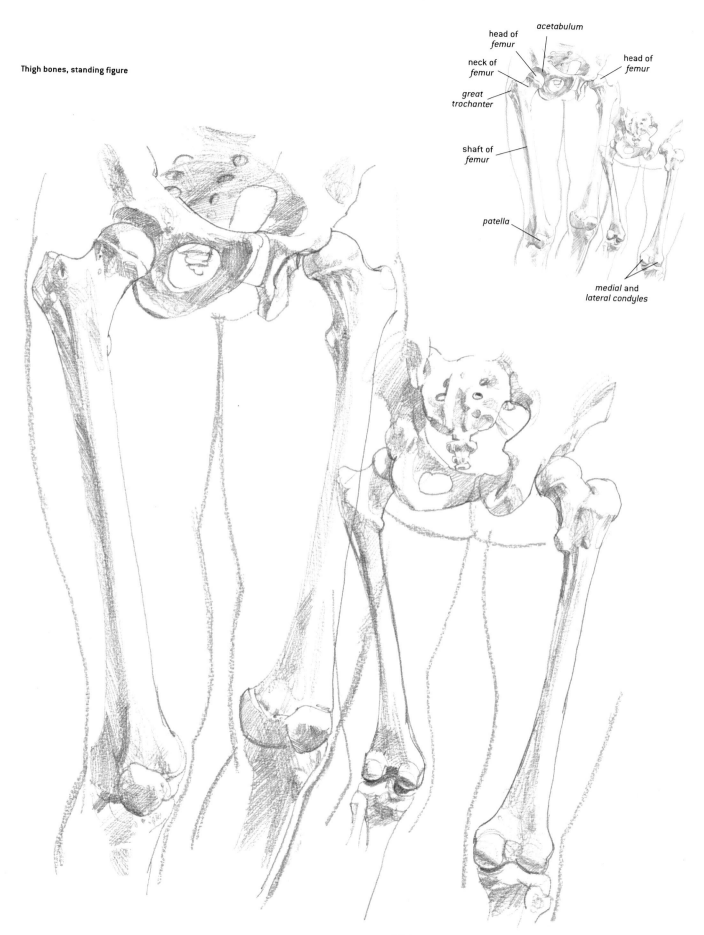

Thigh bones, standing figure

acetabulum

head of
femur

neck of
femur

great
trochanter

head of
femur

shaft of
femur

patella

medial and
lateral condyles

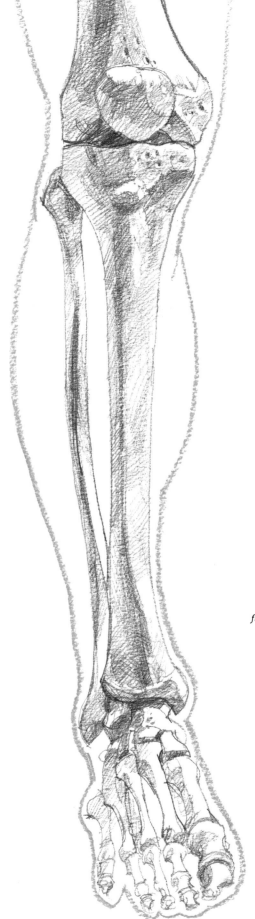

Lower leg

The lower half of the knee joint is formed by the top of the *tibia* or shinbone: at its upper end it has two smooth concave surfaces that articulate with the *condyles* of the *femur* to allow forward and backward swing but little else, just a small amount of rotation. The knee normally extends 5–10 degrees beyond a straight line with the thigh, further extension being checked by tension of surrounding ligaments. In fact the whole joint is rather more complicated than the simple hinge it appears to be, there being a certain amount of medial (inward) rotation of the *femur* at full extension for the *condyles* to lock snugly into the corresponding hollows of the top of the *tibia*.

Appearing to float on the front surface of the joint, the kneecap or *patella* is actually an ossification in a tendon, which joins the big extensor muscles of the thigh to one of the most easily recognizable forms of the knee joint, the prominent central bump called the *tuberosity* of the *tibia*. Below this the sharp front edge of the *tibia* is

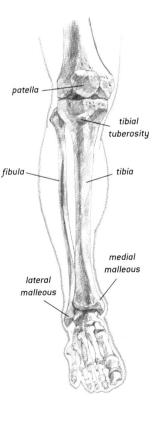

patella

tibial
tuberosity

fibula

tibia

medial
malleous

lateral
malleous

Front view, right lower leg

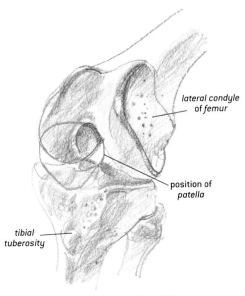

lateral condyle
of *femur*

position of
patella

tibial
tuberosity

Left knee joint

unprotected by muscle and indeed the whole medial face of the *tibia* is subcutaneous (only covered by skin), the lower end becoming the *medial malleolus* of the ankle.

Running alongside the *tibia* is a slender bone, the *fibula*. The parts of the *fibula* that contribute to the surface form are the *head*, that articulates with the *lateral condyle* of the *tibia* and the lower part of the shaft that becomes at its lower end the *lateral malleolus*, which, note well, is always lower than the *medial malleolus*.

medial condyle of *femur*

lateral condyle of *femur*

head of *fibula*

fibula

tibia

lateral *malleous*

medial *malleous*

fibula

lateral condyle of *femur*

patella

tibia

talus

calcaneus (heel)

Back view of lower legs and lateral view of lower leg and foot.

29

Foot

There are three main constituents of the foot. They are, firstly the *tarsus*, which is a tight group of seven irregularly shaped bones closely associated with the ankle. In life they combine together to make a smooth arched top to the foot with no obvious divisions, only the *calcaneus* projecting backwards to make the heel bone. The topmost bone, the *talus*, provides the principal upper surface, which articulates with the *malleoli* to permit the hinge action of *plantar flexion* and *dorsiflexion* of the foot. The second group is equivalent to the palm in the similar structure of the hand; it constitutes five bones called the *metatarsals*. Of these only the first *metatarsal* is normally easily visible in life, the prominent forms that appear on the top surface when the foot is drawn upwards (*dorsiflexion*) being the tendons of extensor muscles of the lower leg. Lastly we have the toes, the *phalanges*, of which there are two in the big toe and three each in the others, a total of 14, as in the hand.

The whole structure of the foot is a marvellously evolved system of springy arches that support weight and absorb shock, while being as light and mobile as possible. There are two main arches both having the heel bone (*calcaneus*) as their rear pillar from which both arches rise to their highest point in the *talus*. The lateral (outer) arch then descends through the *cuboid* to its support by the two outer metatarsal bones, while the more pronounced medial (inner) arch is formed by the *navicular*, all three *cuneiforms* and the three inner *metatarsal* bones. It is generally considered that there is a third arch across the foot at about the line of the junction of the *metatarsus* and the *tarsus*. In truth it is really only half an arch, combining with the medial longitudinal arch to make a sort of domelike space under the inner middle of the foot to give the typical human footprint.

Lateral view, right foot

lateral malleolus

lower end of *tibia*

talus

calcaneus

second metatarsal

phalanx

cuboid

base of fifth metatarsal

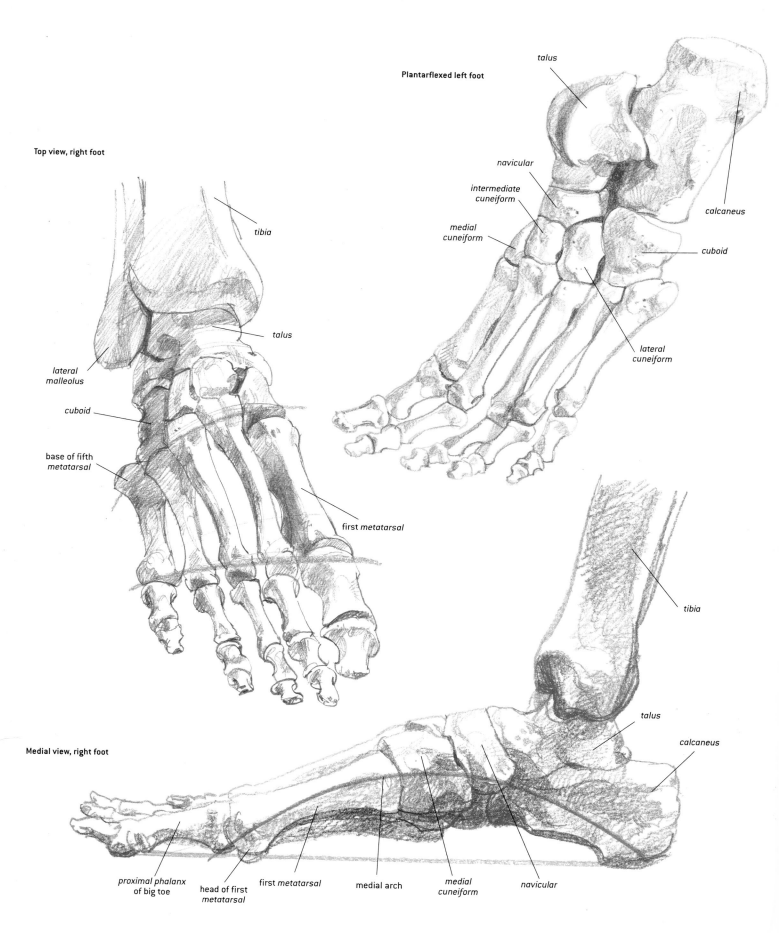

Top view, right foot

tibia

talus

lateral
malleolus

cuboid

base of fifth
metatarsal

first metatarsal

Plantarflexed left foot

talus

navicular

intermediate
cuneiform

medial
cuneiform

calcaneus

cuboid

lateral
cuneiform

tibia

talus

calcaneus

Medial view, right foot

proximal phalanx
of big toe

head of first
metatarsal

first metatarsal

medial arch

medial
cuneiform

navicular

The Skeleton

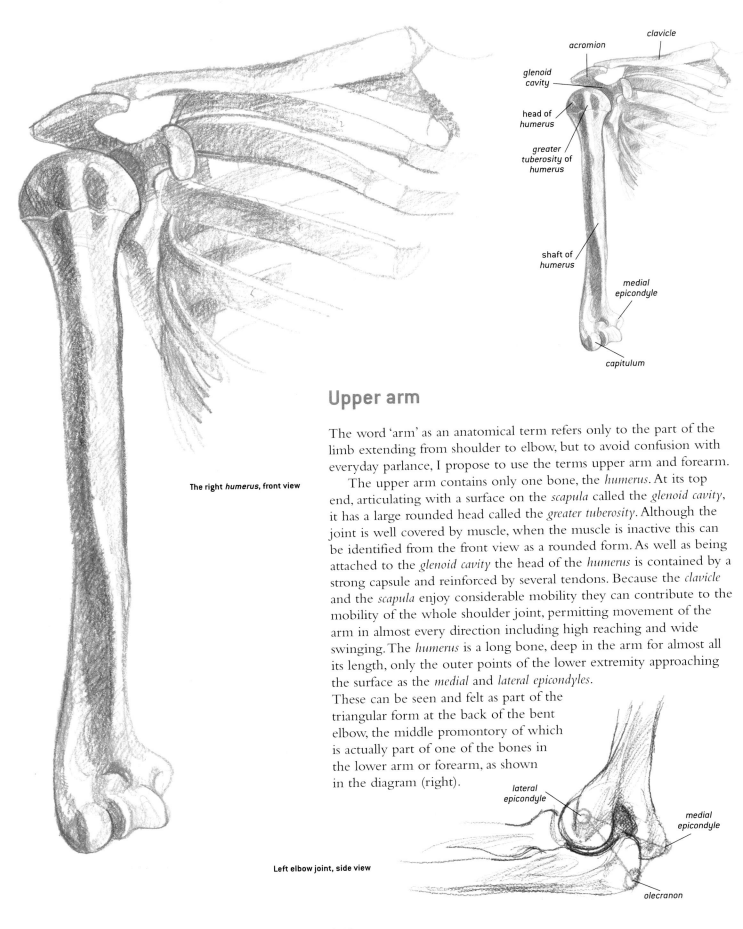

clavicle

acromion

glenoid
cavity

head of
humerus

greater
tuberosity of
humerus

shaft of
humerus

medial
epicondyle

capitulum

The right *humerus*, front view

Upper arm

The word 'arm' as an anatomical term refers only to the part of the limb extending from shoulder to elbow, but to avoid confusion with everyday parlance, I propose to use the terms upper arm and forearm.

The upper arm contains only one bone, the *humerus*. At its top end, articulating with a surface on the *scapula* called the *glenoid cavity*, it has a large rounded head called the *greater tuberosity*. Although the joint is well covered by muscle, when the muscle is inactive this can be identified from the front view as a rounded form. As well as being attached to the *glenoid cavity* the head of the *humerus* is contained by a strong capsule and reinforced by several tendons. Because the *clavicle* and the *scapula* enjoy considerable mobility they can contribute to the mobility of the whole shoulder joint, permitting movement of the arm in almost every direction including high reaching and wide swinging. The *humerus* is a long bone, deep in the arm for almost all its length, only the outer points of the lower extremity approaching the surface as the *medial* and *lateral epicondyles*.

These can be seen and felt as part of the triangular form at the back of the bent elbow, the middle promontory of which is actually part of one of the bones in the lower arm or forearm, as shown in the diagram (right).

lateral
epicondyle

medial
epicondyle

Left elbow joint, side view

olecranon

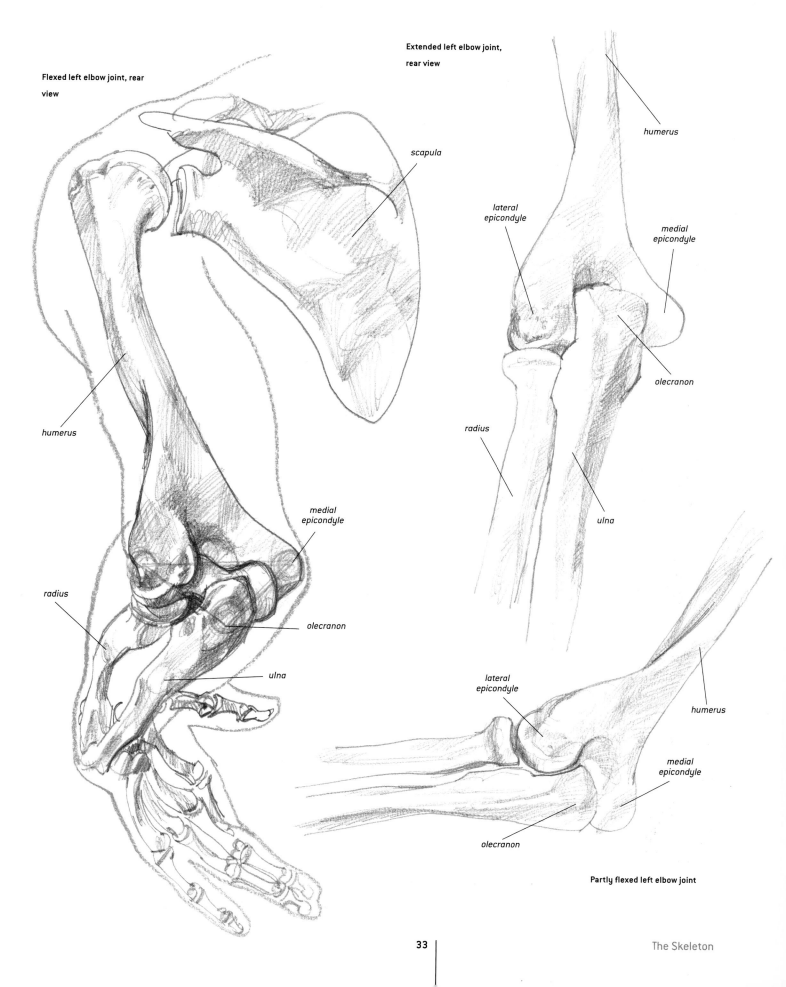

Flexed left elbow joint, rear view

Extended left elbow joint, rear view

scapula

humerus

humerus

lateral epicondyle

medial epicondyle

medial epicondyle

olecranon

radius

olecranon

radius

ulna

ulna

lateral epicondyle

humerus

medial epicondyle

olecranon

Partly flexed left elbow joint

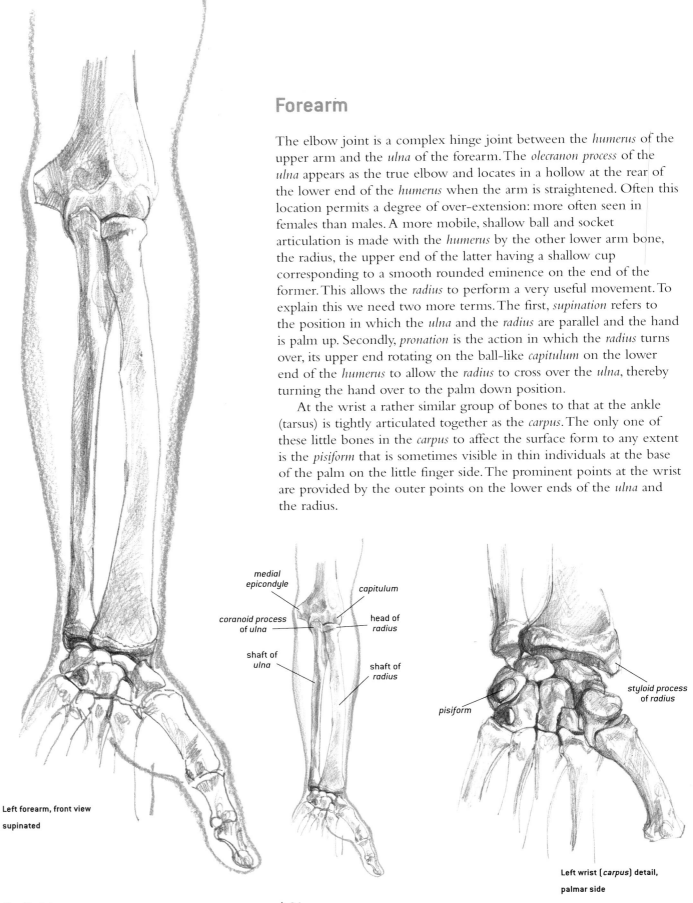

Forearm

The elbow joint is a complex hinge joint between the *humerus* of the upper arm and the *ulna* of the forearm. The *olecranon process* of the *ulna* appears as the true elbow and locates in a hollow at the rear of the lower end of the *humerus* when the arm is straightened. Often this location permits a degree of over-extension: more often seen in females than males. A more mobile, shallow ball and socket articulation is made with the *humerus* by the other lower arm bone, the radius, the upper end of the latter having a shallow cup corresponding to a smooth rounded eminence on the end of the former. This allows the *radius* to perform a very useful movement. To explain this we need two more terms. The first, *supination* refers to the position in which the *ulna* and the *radius* are parallel and the hand is palm up. Secondly, *pronation* is the action in which the *radius* turns over, its upper end rotating on the ball-like *capitulum* on the lower end of the *humerus* to allow the *radius* to cross over the *ulna*, thereby turning the hand over to the palm down position.

At the wrist a rather similar group of bones to that at the ankle (tarsus) is tightly articulated together as the *carpus*. The only one of these little bones in the *carpus* to affect the surface form to any extent is the *pisiform* that is sometimes visible in thin individuals at the base of the palm on the little finger side. The prominent points at the wrist are provided by the outer points on the lower ends of the *ulna* and the radius.

medial
epicondyle

capitulum

coranoid process
of ulna

head of
radius

shaft of
ulna

shaft of
radius

pisiform

styloid process
of radius

Left forearm, front view

supinated

Left wrist (*carpus*) detail,

palmar side

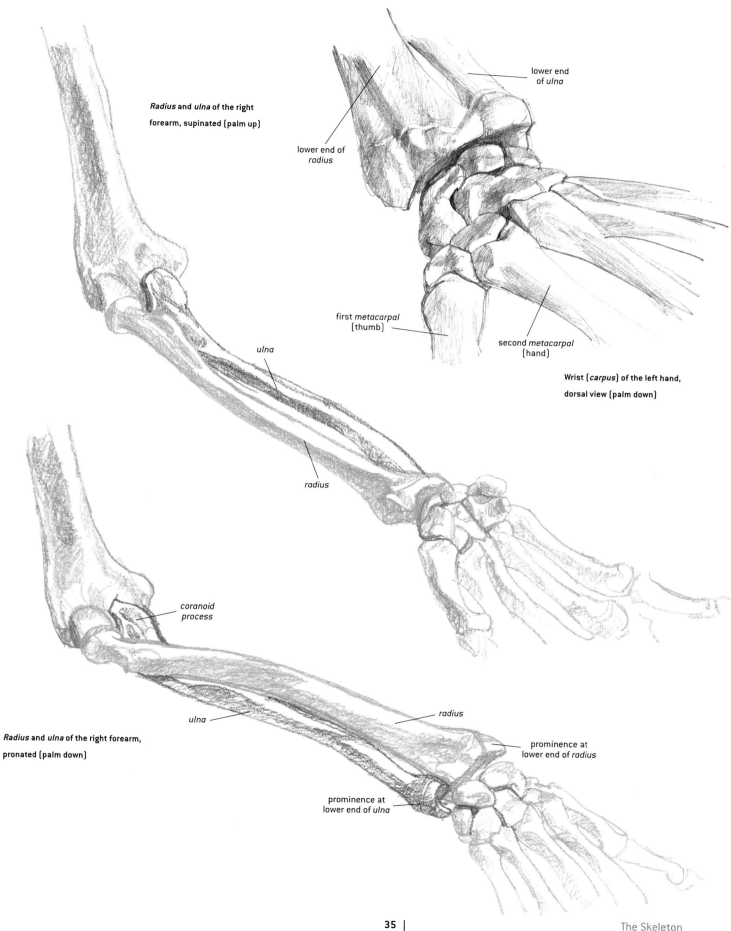

Radius and ulna of the right
forearm, supinated (palm up)

lower end
of *ulna*

lower end of
radius

ulna

radius

first *metacarpal*
(thumb)

second *metacarpal*
(hand)

Wrist (*carpus*) of the left hand,
dorsal view (palm down)

*coranoid
process*

Radius and ulna of the right forearm,
pronated (palm down)

ulna

radius

prominence at
lower end of *radius*

prominence at
lower end of *ulna*

The Skeleton

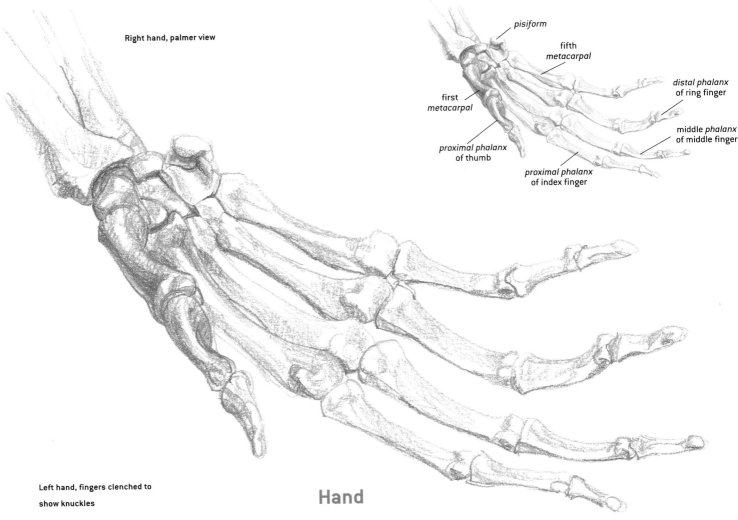

Right hand, palmer view

pisiform

fifth
metacarpal

first
metacarpal

distal phalanx
of ring finger

middle phalanx
of middle finger

proximal phalanx
of thumb

proximal phalanx
of index finger

Left hand, fingers clenched to
show knuckles

head of middle
metacarpal

head of index
metacarpal (knuckle)

Hand

Articulating with the *carpus* are five bones of the *metacarpus*, the last four of which constitute the flat of the hand with the first diverging as the beginning of the opposed thumb. They are well padded on the palm side but more visible on the back of the hand, although a pattern of veins is often the more notable feature in this area. Unlike those of the fingers, the base of the thumb *metacarpal* is easily seen at the surface. From these the fingers extend with three *phalanx* each, the thumb, like the big toe, only having two *phalanges*.

When the fingers are flexed, the articular surfaces of the *phalanges* slide over the heads of the *metacarpal* bones revealing them as the prominent knuckles of a clenched fist. All of these are sharply defined, the knuckle of the third or middle finger being the most prominent. Much the same happens at each joint of the fingers when flexed; the *proximal* (nearest the hand) *phalanges* of each joint revealing their heads as prominences, the ones between the *proximal* and middle *phalanges* being slightly grooved and those between the middle and *distal* (furthest from the hand) rather flattened and square.

Little can be detected of the bones of the hand on the palm surface, although in extreme over-extension, as seen occasionally in the hands of a dancer, the heads of the *metacarpals* reveal their presence in a composite form at the base of the fingers.

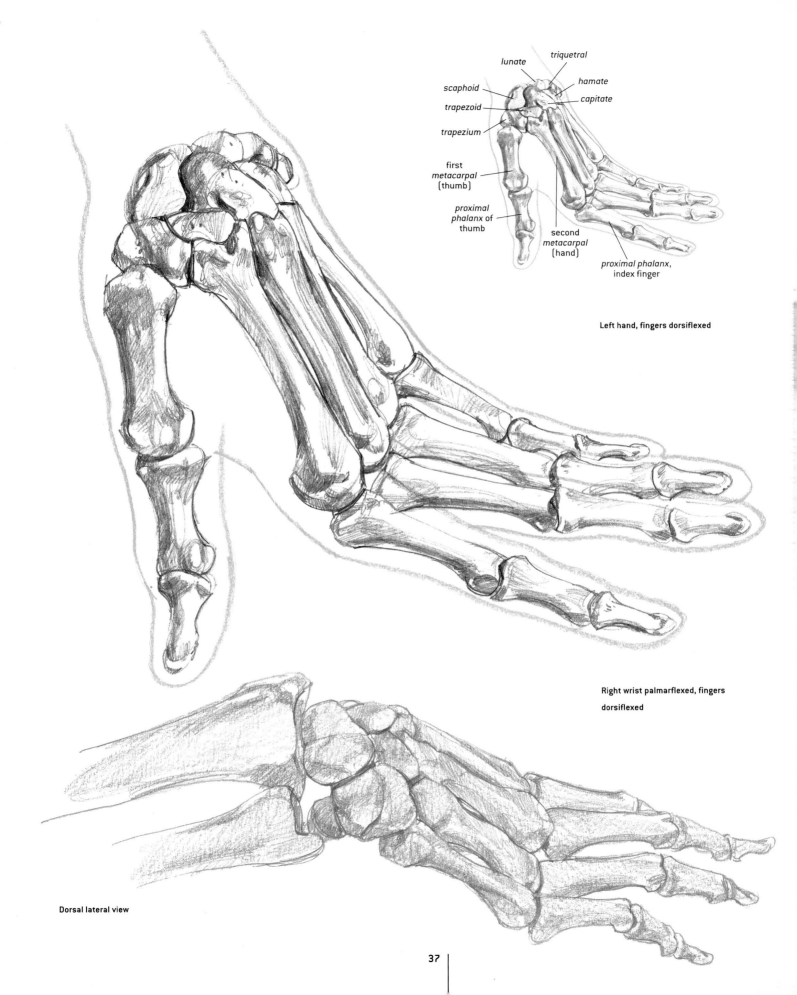

lunate

triquetral

scaphoid

hamate

trapezoid

capitate

trapezium

first
metacarpal
(thumb)

*proximal
phalanx* of
thumb

second
metacarpal
(hand)

proximal phalanx,
index finger

Left hand, fingers dorsiflexed

**Right wrist palmarflexed, fingers
dorsiflexed**

Dorsal lateral view

2 The Muscles

My primary purpose in this book is to help the artist to recognize surface features of the live human model and to judge which of these is significant, in that it reveals something of the essential internal structure. This is a kind of two-way procedure as it is only by having some knowledge of the internal structure that it is possible to judge the significance of a surface feature. Either way, all that we can see is the outer surface; for knowledge of what is underneath we have to depend on specialized studies by others.

Bones, of course, remain unchanged for long after death, so the prepared skeletons can be relied upon as true to their forms in life. Not so with the soft tissues. In researching for this book I visited dissecting rooms to see the muscles for myself. Unfortunately this was of rather limited use as the muscles so revealed had lost all the roundness and tension that can be seen under the skin of a well-defined live model. Of course it is only the muscles close to the surface that can be sensed in life, but we know from surgery on live subjects (and scans of various kinds nowadays) that although some of these muscles are very thin, they often overlay and reflect the form of deeper, fatter muscles, together contributing to the final observed form at the surface.

In addition, muscles change their form when working. They can only actively contract and passively relax, and usually their contraction moves skeletal levers. Such movements require other groups of muscles (antagonists) to relax slowly and allow this movement to take place. Muscles tend mainly to manipulate the skeleton in two ways: they either straighten or extend a limb or they bend or flex it, and this also applies to the action of straightening or bending the whole body. Muscles are therefore known either as *extensors* or *flexors*. There are, it is true, other functionally derived names, *adductors*, *pronators*, *supinators* etc., but they are mostly incorporated into the main actions of flexion and extension. Accordingly, to clarify this distinction in all these drawings of muscles, the *extensor* groups are coloured in red and the *flexors* in blue.

For convenience and clarity the muscles have also been divided into layers, three for the torso (deep, intermediate and superficial) and two for the limbs.

At this stage it should be pointed out that the positioning of muscles is described by reference to their origins and insertions. As explained on page 6, the origin (from which it 'arises') is applied to its fixed attachment and the insertion to the more movable point, although in most cases both connections are capable of movement. So where it seems to be relevant, the origin and insertion of a muscle or muscle group will be stated along with a description of its action and a drawing to show its shape. Where I have felt that it is not really necessary to know a muscle's precise origin or insertion, I will not burden you with the information.

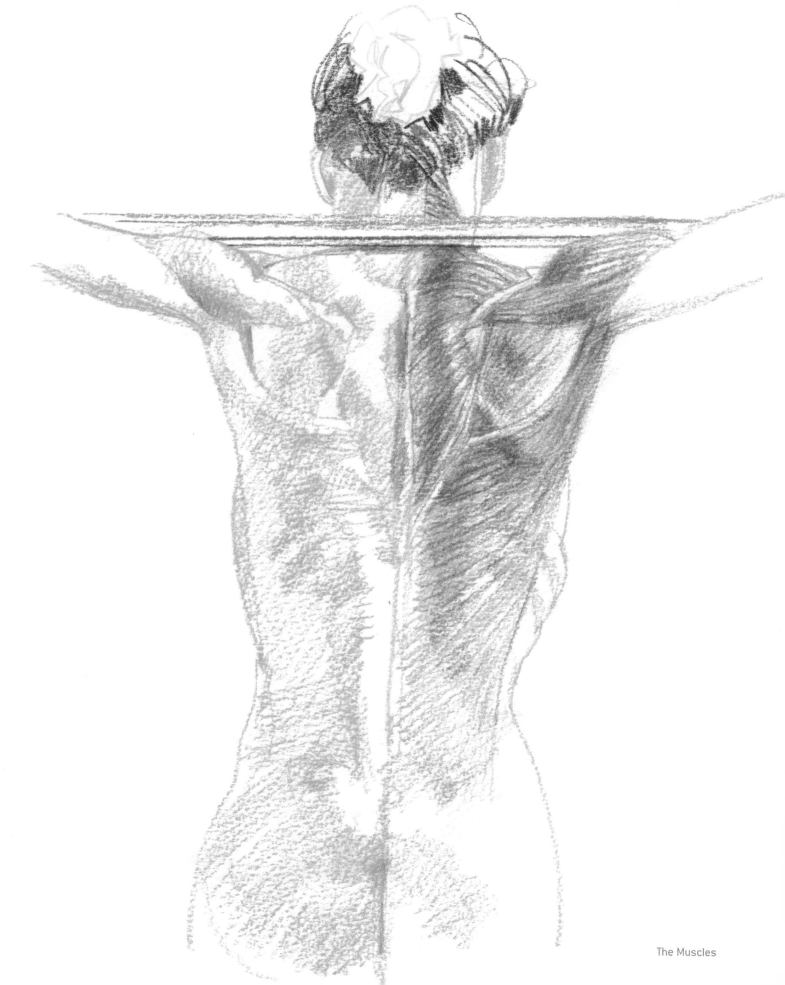

The Muscles

Deep back muscles

The deepest muscles of the back can be considered together as the *erector spinae* group.

The deepest muscles of the back can be considered together as the *erector spinae* group. The origins and insertions of the many individual muscles that make up this group are very complex and only essential for a surgeon to understand fully. For the figure artist though, what is essential to discover is the disposition of the spine, especially in the standing figure but also in sitting or even recumbent poses. Luckily it is quite easy to do this from the back view where the position and shape of the spine can be traced by the line of the *spinous processes* of the *vertebral column*.

In the lower back of an individual of normal development, this line of bumps is flanked by the two prominent rope-like forms made by the *erector spinae* group. The whole group stretches from the *coccyx* at the lower end up to the base of the skull with numerous attachments on the way. In the standing figure the two ropes are especially prominent in the *lumbar* area (more generally known as the small of the back), which is not surprising as they perform the powerful function of holding all of the upper body erect. In the middle to upper section, some of the muscles are involved in raising and depressing the ribcage and the group becomes flatter and less massive, although it still fills and overflows the hollows between the *spinal* and *transverse processes* of the *thoracic vertebrae*. At the neck the group becomes relatively slender and combines with other muscles to hold up the head and perform the various turning movements. My drawing greatly simplifies the group in the *thoracic* and *cervical* areas but as you will see in later drawings these upper sections are covered by two more layers of musculature and although they combine with the superficial layers to contribute to the surface form they do not dominate as they do in the *lumbar* area.

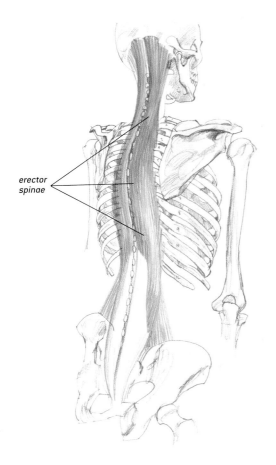

erector
spinae

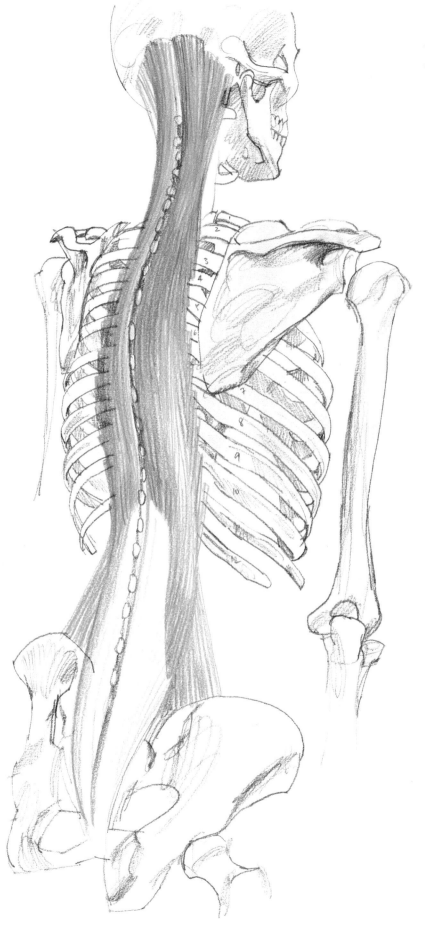

The *erector spinae* group, deep
muscles of the back

The Muscles

Front torso – deep layer

In order to describe the muscles of the trunk one more anatomical term must be introduced – *fascia, plural fasciae.*

In order to describe the muscles of the trunk one more anatomical term must be introduced – *fascia*, plural *fasciae*. The words derive from the Latin for bandage and they take a number of different forms, but all you need to know is that they perform as generally inelastic covering and separating layers, often providing attachment for muscles.

The deep muscle of the trunk is the *transversus abdominis*. It arises from the cartilages of the six lower ribs, the *fascia* of the lumbar region (that extends from the back where it encloses the *erector spinae* group and the crest of the *ilium* and inserts into a broad *fascia* in the front. From the artist's point of view this flat muscle is effectively formless, taking its shape from its effectiveness in containing the gut. As age and weight take their toll (and pregnancy, temporarily), the form in this area depends increasingly on that of the contained organs and the attendant subcutaneous fat.

In the front of the abdomen the *transversus abdominis* combines with the next layer up to form a pocket or sheath for the central abdominal muscle, the *rectus abdominis*. In a young, fit subject this is a prominent form, the renowned six-pack. The dominance of the rectus abdominis as surface form despite its relative depth in the *fascia*-formed sheath is evidence of one of the difficulties in defining the layers that I referred to earlier; it is quite deep, but because *fasciae* only cover it, it can be considered to be a surface muscle.

At this deep level the chest area is dominated by the ribcage itself; indeed in thin individuals the ribs remain as significant surface forms. In this context one other muscle must be mentioned because although a large part of it is generally hidden under other muscles, significant portions are often clearly visible as surface form. This is the *serratus anterior*. It is relatively thin, generally described as an irregularly quadrilateral muscle, but emerging as rib-like forms at each side of the chest. They are often erroneously assumed to be ribs, which they do to some extent resemble, but actually they are slips that arise from the top eight ribs radiating in a fan-like manner from the main muscle that wraps around the lateral side of the *thorax* to insert on the under surface of the *scapula*. The slips arising from the top four ribs are overlaid by the *pectoralis minor*, a thin muscle arising from the third, fourth and fifth ribs, and inserting into the *coracoid process* of the *scapula*. This small muscle is completely covered by its much bigger companion, the *pectoralis major* (see page 47), and seems to have virtually no effect on the surface form.

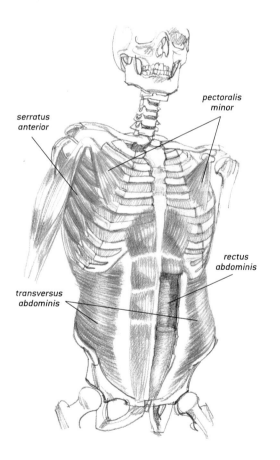

serratus
anterior

pectoralis
minor

rectus
abdominis

transversus
abdominis

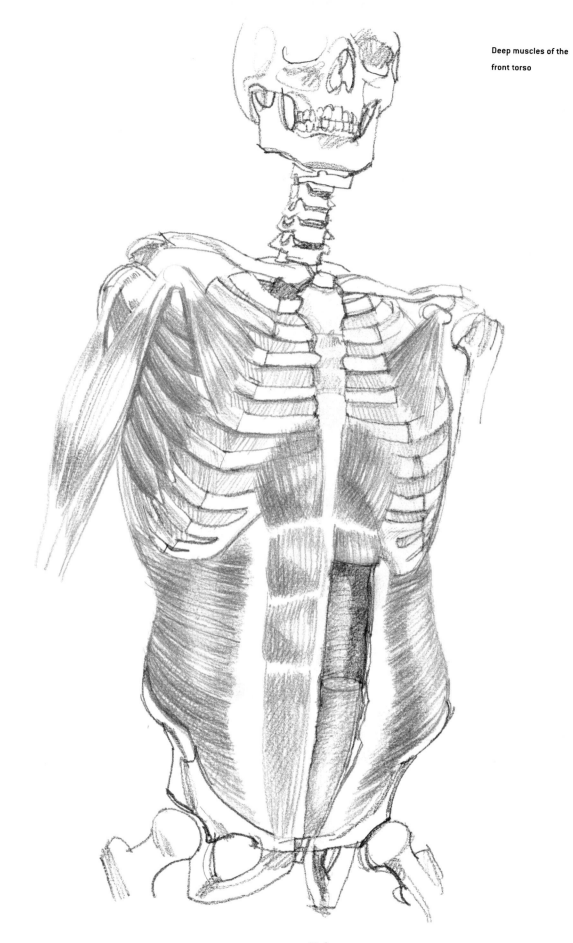

The Muscles

Back
– intermediate layer

The muscles of the back are probably the most visually misunderstood by a casual observer of the human body; the bumps and grooves visible in life do not appear to conform to the shapes of muscles as they are depicted in anatomical diagrams.

The muscles of the back are probably the most visually misunderstood by a casual observer of the human body; the bumps and grooves visible in life do not appear to conform to the shapes of muscles as they are depicted in anatomical diagrams. This is principally attributable firstly to the ubiquitous underlying presence of the *erector spinae* group making the characteristic double columns under relatively sheet-like overlaying muscles and, secondly, to the musculature surrounding and covering the *scapulae* or shoulderblades.

Floating as they do on the upper back, only articulating with the outer *clavicles*, which are also fairly mobile and otherwise maintaining position solely by muscles attached to their under and upper surfaces, the *scapulae* impart a strong influence on the surface form. Almost the whole upper surface (and the hidden under surface) of each *scapula* provides attachment for musculature, with only the spine of the *scapula* left uncovered to show as a ridge in thin subjects and a groove in the more well-developed.

Three muscles arise from the top surface of each *scapula*, the *supraspinatus* from the hollow above the scapula spine, the *infraspinatus* and the *teres minor* from the main body of the *scapula* below its spine. All three insert into the upper end of the *humerus*. A fourth muscle, the *teres major* arises from the lowest point (*inferior angle*) of each *scapula* and also inserts into the *humerus* but slightly further down the shaft. Even the under side of the scapula offers attachments for muscles, a large one called the *subscapularis* virtually filling the shallow hollow of the under side and making another attachment to the top of the *humerus*. Although this muscle is totally hidden from direct view it does tend to give bulk to the *scapula* thereby increasing its prominence on the upper back.

All these muscles attaching the *scapula* to the *humerus* must be balanced by others pulling and holding to the backbone. Again, three muscles unite to do this, arising from the upper four *cervical vertebrae* and the first four or five *thoracic vertebrae* and attaching to the internal or vertebral border. All three are rather thin and have little effect on the surface form, only the lowest one, the *rhomboideus major*, being superficial and then only in certain raised arm positions. One other significant muscle attached to the under side of the inner edge of the scapula and wrapping around the upper *thorax* is the *serratus anterior*. Its appearance as a surface form on the front side of the chest has already been described on page 42.

There are two muscles acting on the ribcage to assist with respiration: the upper one hidden under the *rhomboideus* elevates the ribs; and the lower one, the *serratus posterior*, draws the lower ribs downwards. Neither have much influence on the surface form.

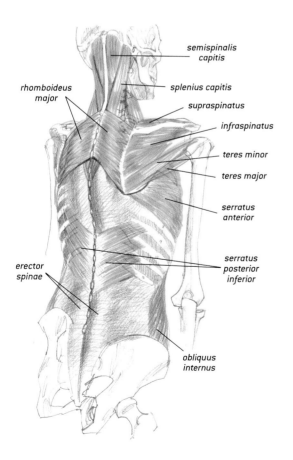

semispinalis
capitis

rhomboideus
major

splenius capitis

supraspinatus

infraspinatus

teres minor

teres major

serratus
anterior

erector
spinae

serratus
posterior
inferior

obliquus
internus

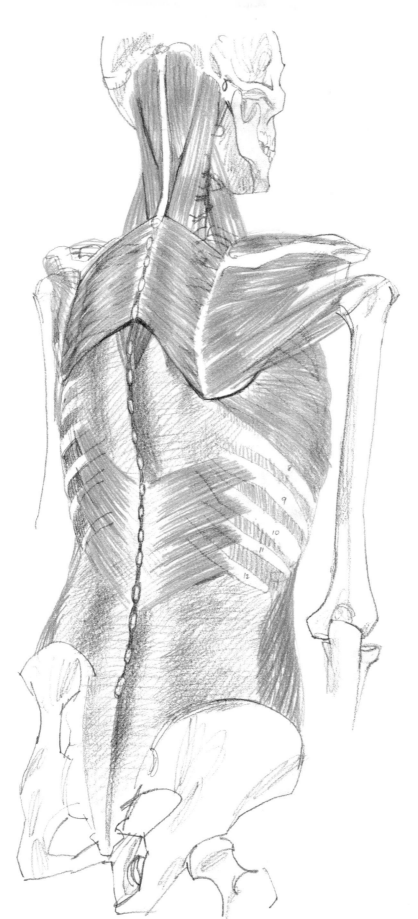

The Muscles

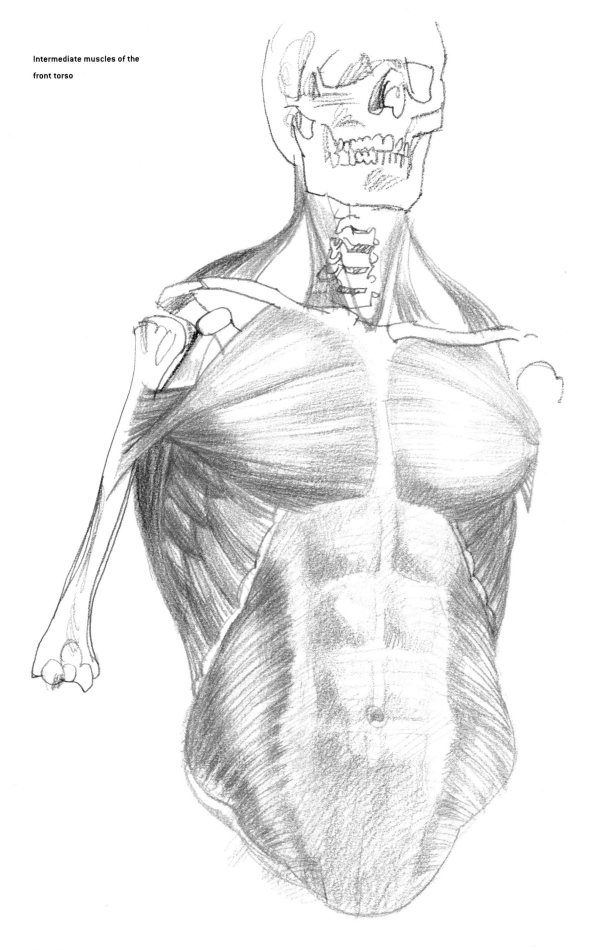

Front torso
– intermediate layer

Yet again there is a mixture here of superficial muscles and those that are one layer down from the surface.

Yet again there is a mixture here of superficial muscles and those that are one layer down from the surface. This is because there are only two layers on the upper *thorax* (unless you count the *intercostals*), while the lower torso has three.

The second layer on the lower torso is formed by the *internal oblique* that arises mainly from the crest of the *ilium* to join an *aponeurosis* (another name for a thin non-contractile sheet) in the front. As referred to on page 42, this intermediate sheet of *fascia* combines with that of the underlying *transverse abdominis* to make a long envelope that contains the upright bands of the central abdomen, the *rectus abdominis*. As was also described earlier, in a well-developed and relatively lean individual, despite the fact that it is covered by two layers of fascia, the *rectus abdominis* appears as a prominent double band of muscle at the centre of the abdomen with three horizontal intersections, which give it the unique appearance sometimes described as a washboard stomach.

The *serratus anterior* has already been shown in the deep layer drawing on pages 42 and 44.

Although the *pectoralis major* layer is actually a top surface muscle and a very prominent one, I have drawn it here in order to show its interesting insertion into the top of the shaft of the *humerus*. As you can see it appears to twist around itself before inserting as a broad tendon. The characteristics of this large muscle of the chest are described more fully on page 51.

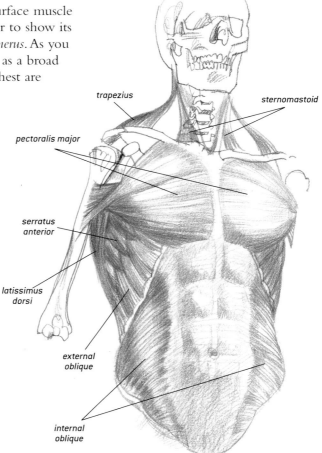

trapezius

sternomastoid

pectoralis major

serratus anterior

latissimus dorsi

external oblique

internal oblique

The Muscles

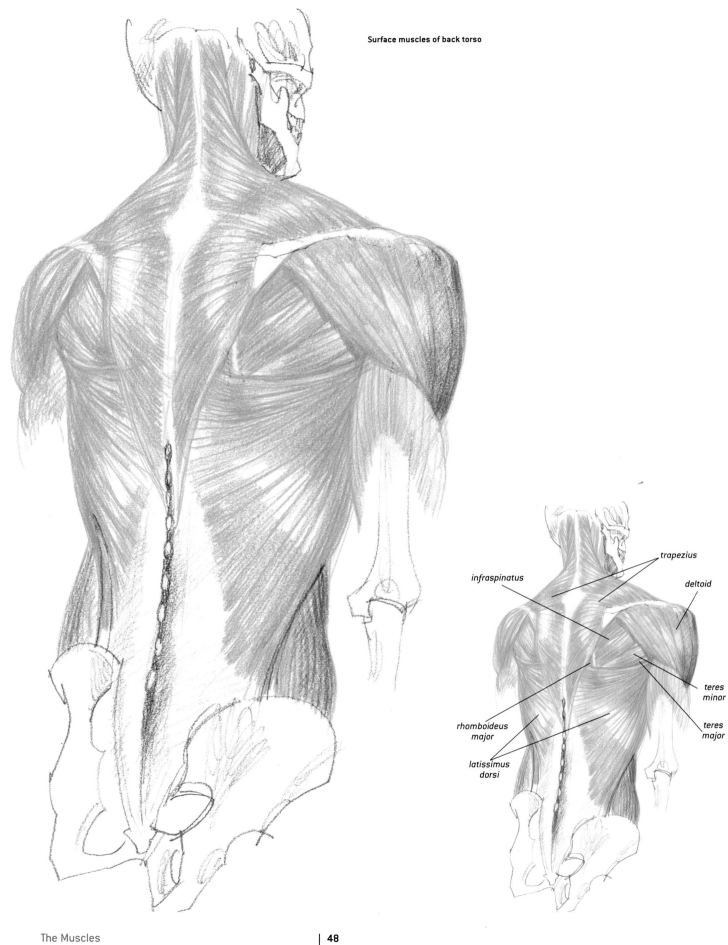

Surface muscles of back torso

infraspinatus

trapezius

deltoid

teres minor

teres major

rhomboideus major

latissimus dorsi

Back torso — top layer

There are three large superficial muscles that are mainly responsible for the forms that can be seen in the human back; they are the *trapezius*, the *latissimus dorsi* and the *deltoid*. The *deltoid* is more usually considered a muscle of the upper arm but as it is so readily visible from the back I have included it here. Moreover it extends around to the front of the body making a significant contribution to the form of the shoulder. But it is a large, powerful muscle arising at the back from the spine of the *scapula* and frequently works in unison with the *trapezius* that inserts into the opposite side of the same edge. So I have included it in this drawing of the top muscle layers of the back and will also show it later on when considering the arms in more detail (see pages 52–55).

From all views the *deltoid* is the principal form of the shoulder: from the back view its attachments to the *scapula spine* continue into the *acromion* (and on into the clavicle, but of course that is in the front view). From these extensive origins its fibres converge to form a thick tendon inserting into a rough prominence almost halfway down the *humerus*, the long bone of the upper arm. The fibres from the *acromion* are arranged in a rather complicated fashion that does not need to be considered here in detail but the effect can be seen in the way that the muscle in action often assumes a rather striated appearance (see picture on page 80–81).

The previously mentioned *trapezius* is perhaps the dominant superficial form of the back but it is often misinterpreted. Basically the shape of each one is triangular, the two together making a diamond or kite-like shape that covers a large area of the back of the neck and the shoulders. Although it is usually relatively thin, and therefore reflective of other muscles that it overlays, the *erector spinae* group in particular, it is fleshy in parts but much thinner and tendinous (thin and non-contractile) in certain areas of its insertions. At its top end it arises from the *occipital* bone at the base of the skull and then all the way down the *vertebral column* as far as the twelfth and last *thoracic*, the fibres running downwards at the top end and gradually more horizontally and then diagonally upwards to converge at its insertions, starting at the outer end of the clavicle and continuing all around the *acromion* and the *scapula spine*. From the sixth *cervical* until the third *thoracic vertebrae* it arises via a flat *aponeurosis*, loosely semi-elliptical in shape and therefore resembling a full ellipse when combined with the opposite one. The extent of this flatter area is variable and it can also be rounded out by the inner top edges of the *scapulae*. To further confuse the view, the lower fibres of the *trapezius* attach to the inner edge of the *scapula spine* by means of a small triangular *aponeurosis*, which, being very thin, is often difficult to spot.

The result of this variety of attachments is to render the appearance of the muscle in life very different from that in theoretical anatomical drawings.

There are three large superficial muscles that are mainly responsible for the forms that can be seen in the human back; they are the *trapezius*, the *latissimus dorsi* and the *deltoid*.

The Muscles

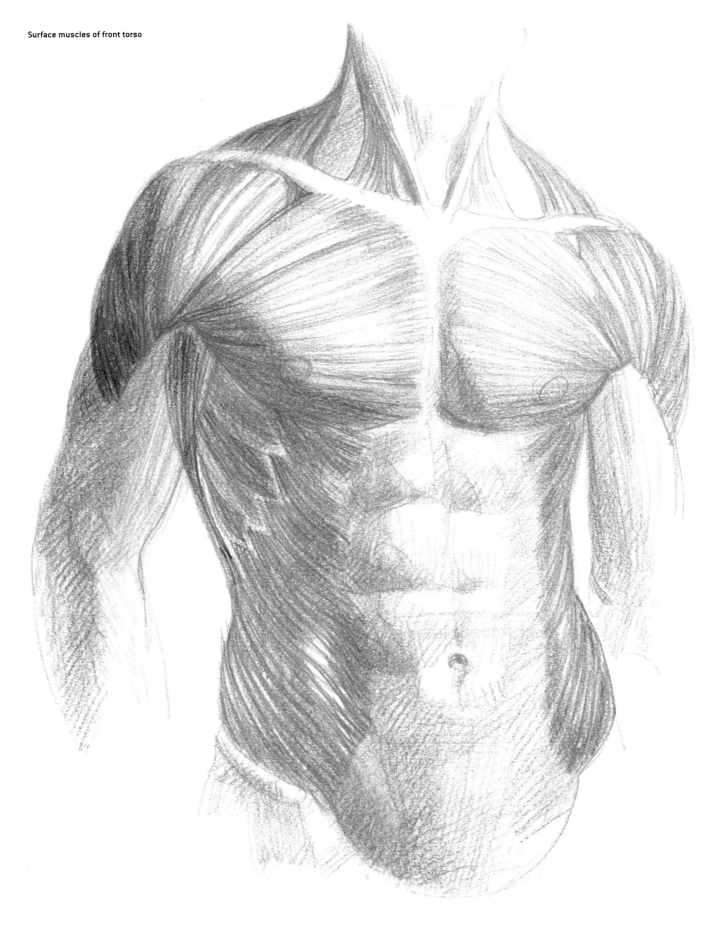

Front torso — top layer

The most prominent superficial muscle of the front torso of a well-developed male is the *pectoralis major* (on a female it is partially hidden under the breast).

The most prominent superficial muscle of the front torso of a well-developed male is the *pectoralis major* (on a female it is partially hidden under the breast).

One on each side of the upper chest, these muscles can have a clearly defined form, the lower margin being particularly sharply delineated. This is to a great extent because the insertion of the pectoral tendon in the upper *humerus* is twisted so that the lower fibres insert higher up the *humerus* and the higher fibres insert lower down (see drawing on page 47). As a result the fibres fold under each other on the front of the chest to form this relatively sharp edge. It is interesting to consider that this twist will be reversed and the fibres of the muscle therefore lined up when the arm is raised above the head – better for the early primate hanging from trees perhaps?

Layers of *fascia* and *adipose* (fatty) tissue cover the lower torso from the front view. Even under this top layer the *rectus abdominis*, featured in each of the previous layers, may, in young well-muscled subjects (and that includes female athletes), still be clearly visible as a surface form. Unfortunately, in sedentary adulthood its rectangular striated forms have often disappeared under a layer of fat, resulting in a rounded or protruding abdomen.

The only large muscle of this top layer is the *obliquus externus* (or *external oblique*), the topmost of the three oblique muscles. It arises from eight finger-like attachments to the eight lowest ribs. The upper five of these interlock with the similar fingers of the *serratus anterior* (described in the second layer) and the lower three fingers interlock in a similar fashion with the *latissimus dorsi*.

It is notable that the fibres of these three sheets alternate, the lowest layers progressing diagonally upwards towards the middle of the torso, the middle fibres lying more or less horizontally and the top ones lying diagonally downwards. While this is of no obvious relevance when considering the surface form it may be that the arrangement contributes to its strength and elasticity in the containment of the intestine. Certainly all three layers often present a smoothly rounded form quite sharply defined around the crest of the *ilium* and down to the *os pubis* (or pelvic bones, see page 14) by a ligament called the *inguinal ligament*. It is a form much admired and emphasized by ancient Greek and Roman sculptors and their emulators (see drawing, right).

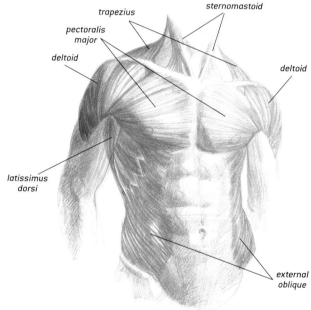

trapezius

sternomastoid

pectoralis major

deltoid

deltoid

latissimus dorsi

external oblique

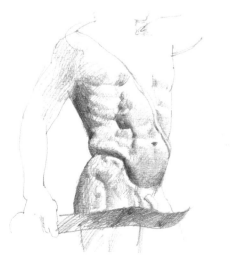

The Muscles

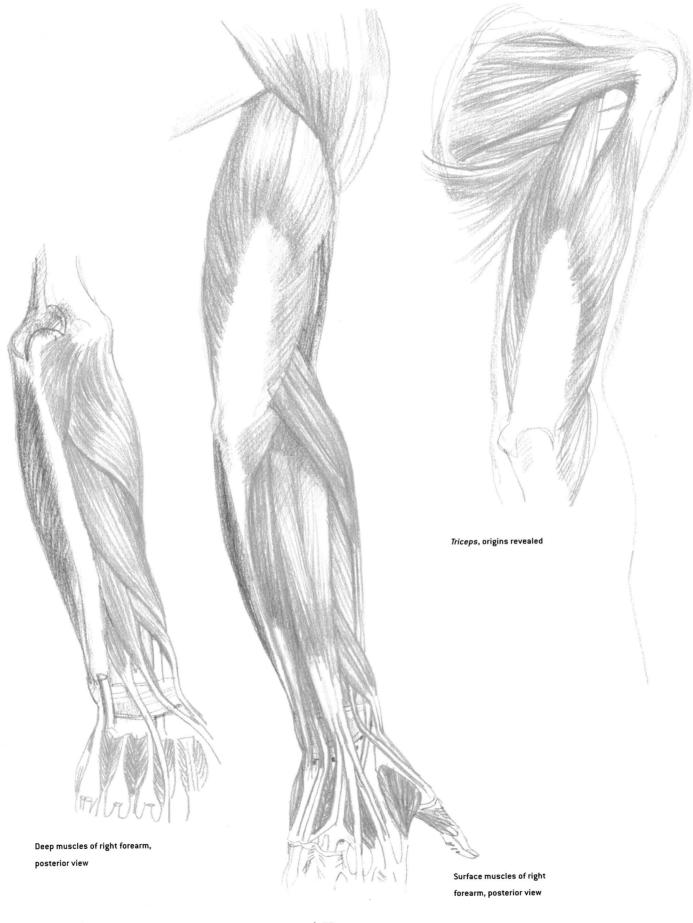

Triceps, origins revealed

Deep muscles of right forearm, posterior view

Surface muscles of right forearm, posterior view

Extensors

The only *extensor* on the back of the upper arm is the *triceps* muscle, divided as the name implies into three parts. The middle or *scapular* head, as you might expect, arises from the *scapula*, just below the *glenoid cavity* (into which the head of the *humerus* locates) from whence it descends between the *teres major* and the *teres minor* to insert in the large common tendon that attaches all the heads to the *olecranon process* of the *ulna*. The external or long head arises from high up on the shaft of the *humerus*, the fibres then converging on the common tendon. This portion of the *triceps* muscle is often the most prominent form on the side and back of the upper arm when the arm is extended, especially so under load. Lastly, the internal or short head arises from a large area of the middle and lower shaft of the *humerus*, some of its fibres inserting in the *olecranon* and some converging to attach to the common tendon.

On the posterior surface of the forearm (back of the hand upwards), the *extensors* are tightly grouped. The four deepest are the *extensor indicis*, the *extensor pollicis longus*, the *extensor pollicis brevis* and the *abductor pollicis longus*. The first of these arises from the shaft of the *ulna* and culminates as a tendon for the index finger. The other three, although their origins are deep, emerge from beneath their covering surface muscles to become superficial and very visible as tendons for the thumb, the hollow so formed being affectionately known as the anatomical snuffbox.

Also on the top of the forearm is the *supinator*, a muscle that overlays the extensors but is in its turn covered by surface muscles. It curves around the arm from the elbow joint and helps to turn the arm to a palm-up position (supinated).

A very prominent shape on the forearm is made by two muscles that arise from the lower shaft of the *humerus* wrapping around the front of the arm and then, as tendons, diving under the thumb tendons. The upper one, the *brachioradialis* (above the *supinator*) is in company with and almost indistinguishable from the *extensor carpi radialis longus*. Both are fleshy for about two-thirds of their length and then tendinous, the former inserting into the lower end of the *radius* and the latter into the base of the *metacarpal* bone of the index finger. Partially under these two and much less prominent in life lies the *extensor carpi radialis brevis* that arises from the *lateral epicondyle* of the *humerus* and inserts as a tendon at the base of the middle *metacarpal*.

Two quite meaty muscles provide the main bulk of the outer or posterior surface of the forearm. They both arise from the *lateral epicondyle* of the *humerus*, the larger of the two, the *extensor digitorum*, descending to a tendon that divides at the wrist to insert in the back of all four fingers. The other one is the *extensor carpi ulnaris* and its tendon inserts into the base of the *metacarpal* bone of the little finger.

The arm

The only *extensor* on the back of the upper arm is the *triceps* muscle, divided as the name implies into three parts.

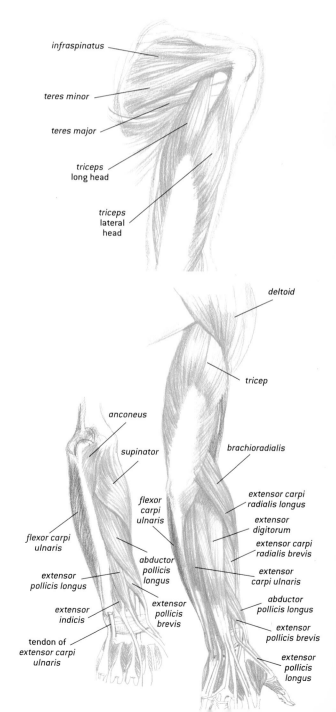

infraspinatus

teres minor

teres major

triceps long head

triceps lateral head

deltoid

tricep

anconeus

supinator

brachioradialis

flexor carpi ulnaris

flexor carpi ulnaris

extensor pollicis longus

extensor indicis

tendon of extensor carpi ulnaris

abductor pollicis longus

extensor pollicis brevis

extensor carpi radialis longus

extensor digitorum

extensor carpi radialis brevis

extensor carpi ulnaris

abductor pollicis longus

extensor pollicis brevis

extensor pollicis longus

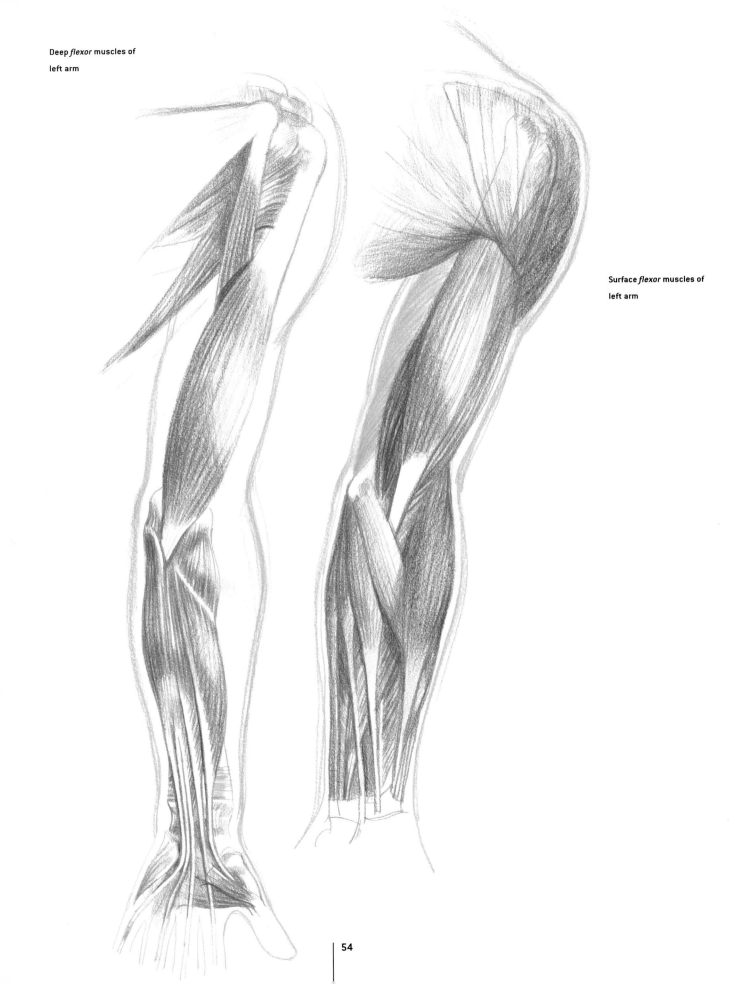

Deep *flexor* muscles of
left arm

Surface *flexor* muscles of
left arm

54

Arm *flexors*

On the front side of the arm, the facing side when the arm is *supinated*, i.e. with the palm facing forward, are the muscles that act to bend the arm, the *flexors*, although the deepest *flexors* in the lower arm are only active in flexing the hand rather than the whole arm. The larger of these two deep *flexors* is the *flexor digitorum profundus* that arises from the upper three-quarters of the shaft of the ulna and also from a membrane (*interosseous membrane*) between the *ulna* and the *radius*. Although it is so deep, entirely covered by superficial muscles, it is very fleshy in its main body and contributes to the surface form of that part of the forearm. At its lower end it divides into four tendons that finally insert into the last *phalanges* of the four fingers. Its deep companion, the *flexor pollicis longus*, arises from the shaft of the *radius* and ends in a tendon that inserts into the base of the *distal phalanx* of the thumb.

The three true *flexors* on the surface of the forearm are the *flexor carpi radialis*, the *palmaris longus* and the *flexor carpi ulnaris*. They all arise from a similar area on the *medial epicondyle* of the *humerus* and descend as their names imply into insertions on the *radial* (thumb) side, the centre of the palm and the *ulna* or little finger side. A prominent form that we have already seen on the *extensor* side is made up of two muscles, the *brachioradialis* and the *extensor carpi radialis longus*, that sweep over to the *flexor* side of the forearm then act as an *extensor* of the wrist and a *flexor* of the elbow. Finally, crossing from the *humerus* just above the *medial epicondyle* and inserting into the middle of the outer surface of the *radius* is the *pronator teres*.

On the upper arm the deepest flexors are the *coracobrachialis* and the *brachialis*. The former arises from the *coracoid process* (of the *scapula*) and descends to insert in the middle of the shaft of the *humerus*, the latter arising from a large area of the shaft of the *humerus* and descending to insertion via a thick tendon into the *coronoid* process at the top of the *ulna*.

Superficial to both of these and one of the best-known muscles of the upper arm is the *biceps*. Its name derives from the fact that it has two heads, one arising from the *coracoid process* on the underside of the *scapula* (in common with the *brachialis*, see above) and the other from the *glenoid* cavity of the *scapula*, the tendon wrapping over the head of the *humerus*. Both heads then descend to combine in a common tendon inserting into the *tuberosity* at the top end of the *radius*.

Remember that, as stated at the beginning of the muscles section, I am simplifying my descriptions of the origins and insertions of many of these muscles where, from the point of view of an artist, the full details are irrelevant.

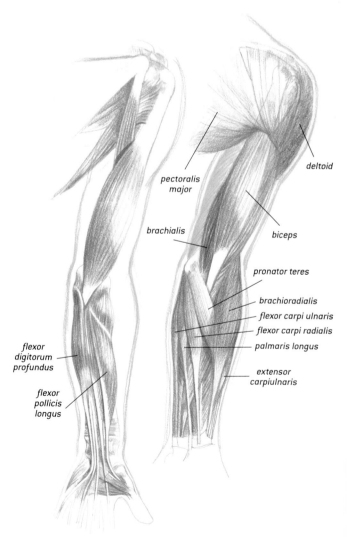

deltoid

pectoralis
major

brachialis

biceps

pronator teres

brachioradialis

flexor carpi ulnaris

flexor carpi radialis

palmaris longus

extensor
carpiulnaris

flexor
digitorum
profundus

flexor
pollicis
longus

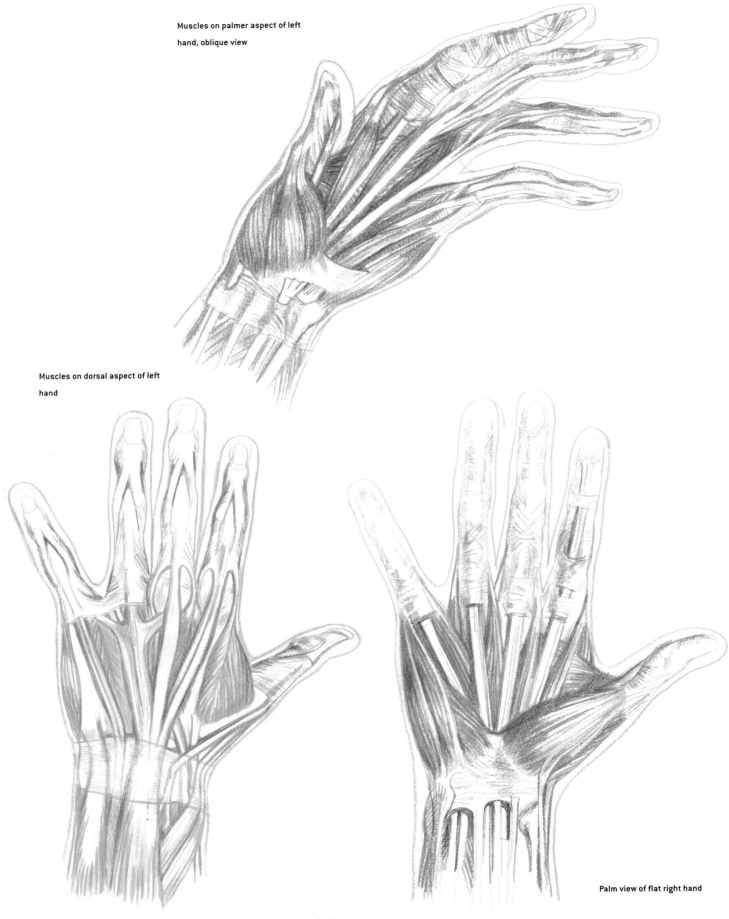

Muscles on palmer aspect of left
hand, oblique view

Muscles on dorsal aspect of left
hand

Palm view of flat right hand

The hand

From the point of view of the artist the visible anatomy of the hand is mostly confined to the back of the hand and fingers.

From the point of view of the artist the visible anatomy of the hand is mostly confined to the back of the hand and fingers. The palm of the hand is covered by a *fascia* that holds down the tendons and protects the vessels and nerves underneath and by so doing largely conceals them. Nevertheless, two main muscle groups can be detected beneath this *fascia*, which produce respectively a swelling at the base of the thumb called the *thenar eminence* and along the little finger border of the palm, known as the *hypothenar eminence*. The thumb flexors consist of a group dominated by the *abductor pollicis* that arises from the annular ligament and two of the wrist bones (the *scaphoid* and the *trapezium*) to insert into the first joint of the thumb, the base of the first *phalanx* and on the *ulnar* (little finger) side the *abductor digiti minimi* dominates.

Once again it must be stressed that many of the anatomical drawings I have made here are simplified versions of reality in order to clarify the features that are detectable at the surface. For example, the tendons that activate the hands and feet are retained at the wrist and ankle respectively by *retinaculae*, thickened bands of tissue that form a kind of wrap-around bandage that have little or no effect on the surface form, so have been only lightly indicated in order to show the tendons that are often visible under the skin. Similarly, the *synovial* sheaths that lubricate the passage of these tendons at the wrist and ankle have been omitted. While they are anatomically practical, making extreme changes of direction possible, they are virtually undetectable at the surface.

On the back of the hand and especially the back of the thumb, the tendons of the *extensor* muscles are often the dominant forms. The tendons of the large *extensor digitorum* radiate to all the fingers and the *extensor digiti minimi* inserts into the little finger, giving it two tendon attachments. Beneath these tendons are several muscles called *interossei* that link and cover the metacarpal bones but are visually just filling in the gaps between the tendons. The *first dorsal interosseus* is larger than the others and can be seen in the web space between the thumb and the index finger. On the other edge the *abductor digiti minimi* can be seen, although its bulk is principally on the *palmar* side (see above).

Veins may be even more prominent on the back of the hand, although of largely unpredictable distribution.

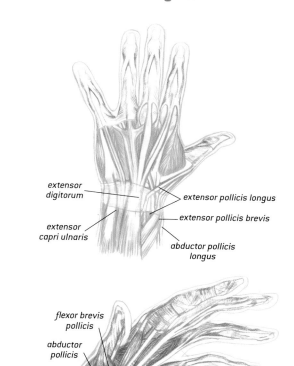

extensor digitorum
extensor pollicis longus
extensor pollicis brevis
extensor capri ulnaris
abductor pollicis longus

flexor brevis pollicis
abductor pollicis
opponens pollicis
abductor digiti minimi

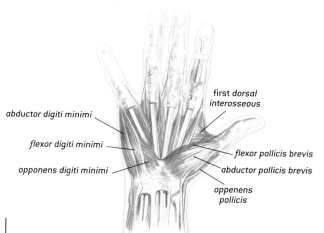

abductor digiti minimi
first dorsal interosseous
flexor digiti minimi
opponens digiti minimi
flexor pollicis brevis
abductor pollicis brevis
oppenens pollicis

The lower limb

In order to allow the human body to stand and move on two legs, groups of muscles have developed in the lower limb so that they are now prominent.

In order to allow the human body to stand and move on two legs, groups of muscles have developed in the lower limb so that they are now prominent. Such groups are the *gluteal* muscles of the buttock, the muscles of the front of the thigh (the *quadriceps*) and the muscles of the calf (*gastrocnemius*). Unlike in the forearm where the *radius* can turn across the *ulna* for 180-degree rotation, the two bones of the lower leg, the *tibia* and the *fibula*, permit only a small amount of rotation while the actions of *flexion* and *extension* dominate.

In this context there is a nomenclature anomaly that should be mentioned now. Although the action of *extensor* muscles on the shin to pull the foot upwards should be called *extension* it is now more generally known as *dorsiflexion* and the contrary action where flexors point the toes is called *plantarflexion*: this may appear rather confusing, but you can see the reason for it – applying the term *extension* to the action of bending the foot backwards just doesn't seem right even though it is performed by *extensor* muscles.

The drawing on the left (opposite) shows the outer side view of a fully extended right knee joint with the *flexors* of the calf shortening to point the toes, producing full *plantarflexion*. In the other drawing the inside view of the left leg is also shown with full knee extension but with the foot *dorsiflexed* to a balance with the calf *flexors* as in a standing position. Both drawings describe only the superficial muscles of the leg from the side views. In the following pages I will look in more detail at other views and deeper layers, first concentrating on the thigh and then the lower leg and foot.

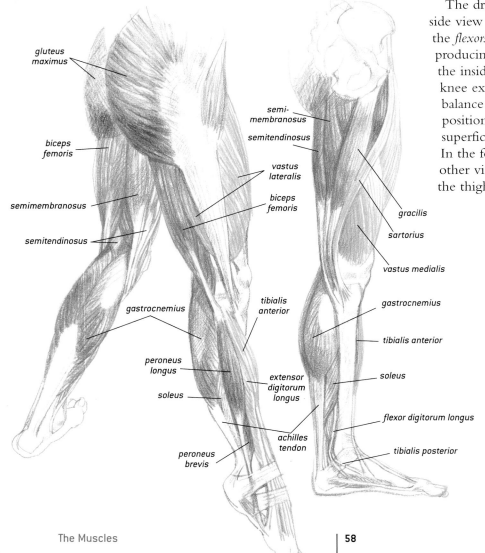

gluteus maximus

biceps femoris

semimembranosus

semitendinosus

gastrocnemius

peroneus longus

soleus

peroneus brevis

semi-membranosus

semitendinosus

vastus lateralis

biceps femoris

tibialis anterior

extensor digitorum longus

achilles tendon

gracilis

sartorius

vastus medialis

gastrocnemius

tibialis anterior

soleus

flexor digitorum longus

tibialis posterior

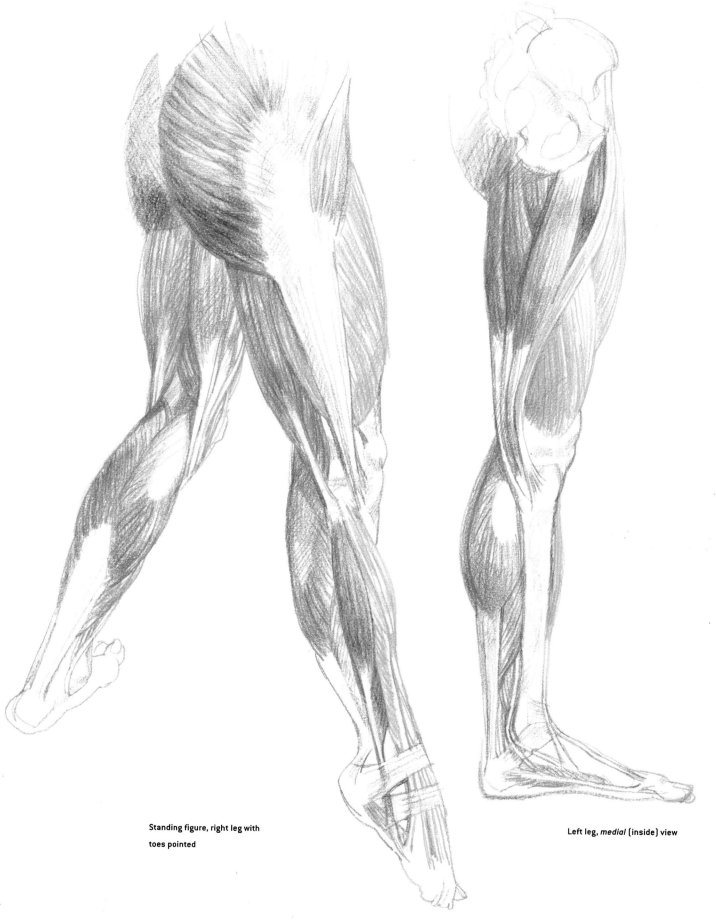

Standing figure, right leg with
toes pointed

Left leg, *medial* (inside) view

The Muscles

Thigh – front view, deep layer

Throughout this section I have tried to colour muscle groups red or blue according to their function; the *flexors* that bend the limb being rendered in blue and the *extensors* that straighten it in red. But sometimes muscles are encountered that do not fall so readily into either of these two classes. For example, the *deltoid*, the large muscle of the shoulder, is primarily an *abductor* but is a prominent form with the *extensors* on the back and also wraps around to join with the *flexors* on the front. In this case I have resorted to allowing its colour to modulate from red through purple to blue on the front.

But now in the legs we encounter another group, the *adductors*, that cannot be classed with either *flexors* or *extensors*. It is a large and powerful group of muscles acting on the *femur* or thighbone, the longest and strongest bone in the human body, to pull the leg inwards, and as such I have coloured them in a mixture of red and blue to indicate that they are not primarily involved in either *flexion* or *extension* but may be assisting in either one or the other or both. Although deep, they are not completely covered by superficial layers either from the front or back view. Indeed in some actions they are very prominent as surface form.

The major muscle of this group named, not surprisingly, the *adductor magnus*, arises from the *tuberosity* of the *ischium* (a roughened area on the deep arch of bone at the base of the pelvis, see page 15) and other areas close to this, then radiating to the extensive insertions along the *femur*.

Overlaying this from the front view is the *adductor longus*, arising from a flat tendon attached to the front of the *pubis* and inserting into the middle of the shaft of the *femur*. A third *adductor*, the *adductor brevis*, arises from a similar area on the *ischium* to sweep diagonally across to a shorter insertion in the upper shaft of the *femur*. It is not shown in this drawing as it lies under the *pectineus* muscle, which, although it is not classed as an *adductor*, seems to contribute to the overall form of the group.

All three *adductors*, while principally exerting a powerful inward pull on the legs, also have a role in rotation of the thigh and to some extent contribute to *flexion* of the thigh on the pelvis.

Also shown on this drawing are two muscles that are only marginally superficial, the major parts of their bodies lying inside the pelvis. I include them only because they both descend to insert into the *lesser trochanter* of the *femur* and thus complete the inner thigh form of the *adductor* group.

iliacus

psoas major

pectineus

adductor
longus

adductor
magnus

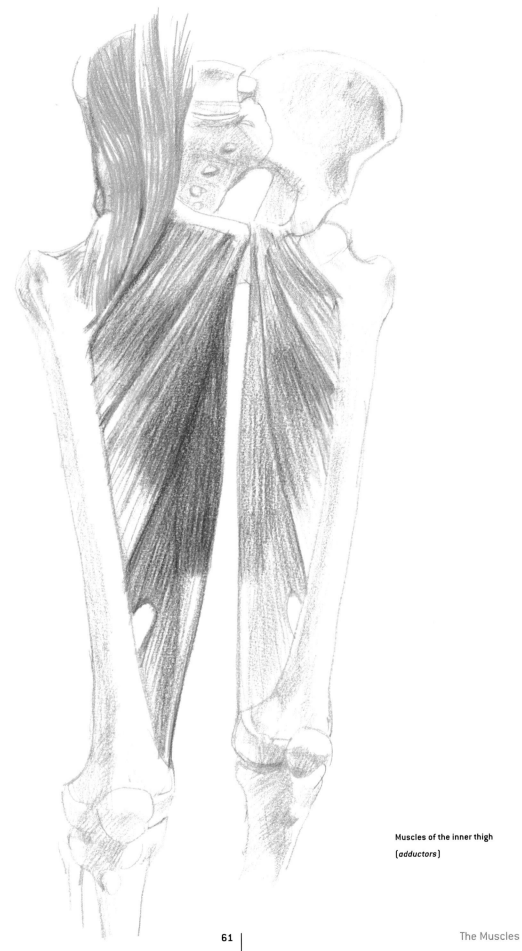

Muscles of the inner thigh

(*adductors*)

The Muscles

Thigh – front view, top layer

The front of the thigh is dominated by three big *extensors*. They are the *vastus medialis*, the *vastus lateralis* and the *rectus femoris*. There is a fourth, the *vastus intermedius*, hence the name *quadriceps* that is applied to the whole group.

The *vastus lateralis* is the largest muscle of this *extensor* group. It arises by a broad *aponeurosis* (broad, ribbon-like tendon) descending from extensive attachments along the length of the *femur* swelling to a large fleshy mass before attaching to another flat tendon that inserts into the outer border of the *patella* (kneecap). On the inner side the *vastus medialis* arises from adjacent areas of the shaft of the *femur* inserting into the inner border of the *patella*. Not visible in this drawing, the *vastus intermedius* lies underneath the *vastus medialis*, arising from the front upper two-thirds of the shaft of the *femur* and joining the common tendon of the *quadriceps* to insertion into the *patella*. In the centre the *rectus femoris* arises by two tendons, one attached to just above the *acetabulum* (socket for the head of the *femur* in the pelvis) and the other just in front of this on a spine on the edge of the *ilium*, then combining and terminating in a broad *aponeurosis*, which narrows to join with the other three *quadriceps* in a tendon that inserts into the *patella*. To some extent the *patella* can be considered to be enveloped by this tendon as it continues below it to its final insertion in the *tuberosity* of the *tibia*, a prominent bump an inch or two below the kneecap.

From the front view the *quadriceps* are framed by two long forms. Their inner margin is delineated by the *sartorius*, a very long ribbon of muscle that sweeps elegantly down and around from the front corner of the pelvis that is so prominent in life, the *anterior superior spine*, via an *aponeurosis* into the inner top surface of the *tibia*. On the outer (lateral) side, from the adjacent crest of the *ilium*, the *tensor fascia latae* descends to join the *iliotibial tract*, which continues to insertion in the *lateral tuberosity* of the *tibia*.

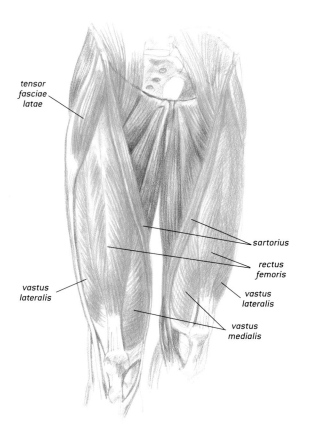

tensor
fasciae
latae

sartorius

rectus
femoris

vastus
lateralis

vastus
lateralis

vastus
medialis

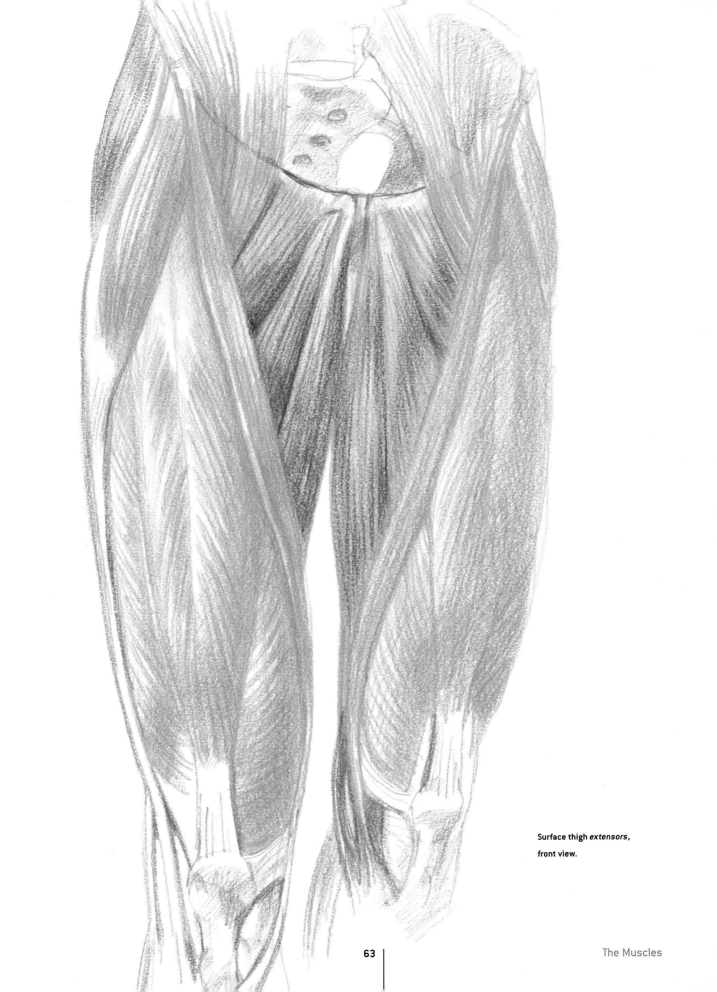

Surface thigh *extensors*,
front view.

The Muscles

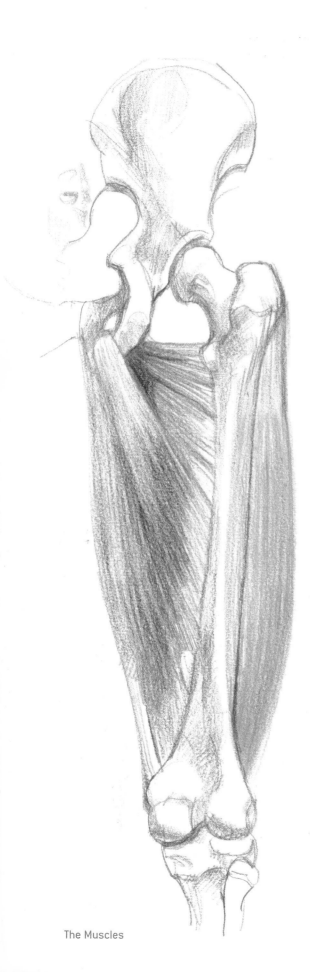

Thigh – back view

From this view the deep layer shows the same group of *adductors* as in the front view but now the whole extent of the *adductor magnus* obscures the other two.

Making up the main bulk of the thigh from this view are the thigh *flexors*. When they are activated in pulling the lower leg up towards the thigh these *flexors* make a visibly dominant form on the back of the leg.

The nearest to the outside of the thigh in this group is the *biceps femoris*. It has two heads, hence the name. The long head arises from the *ischial tuberosity* (on the back arch of the *ischium* at the base of the hip bone) by a tendon that it shares with the *semitendinosus*. The short head arises from halfway down the shaft of the *femur* then combines with the long head as a strong outer hamstring tendon that is easily visible in life. Next to the *biceps femoris* on the medial side of the thigh, three muscles arising from a similar area are the aforementioned *semitendinosus*, the *semimembranosus* and the *gracilis*. All three combine at insertion to form the inner hamstring.

At the top of the thigh and above in the hip area are the three *gluteus* or buttock muscle layers. The deepest of these, the *gluteus minimus* lies immediately below the middle layer, the *gluteus medius*. They both arise from the outer surface of the *ilium* and insert via a tendon into the *great trochanter* of the *femur*. By filling the concavities of the outer wings of the pelvis these two provide the base for the large fleshy muscle of the *gluteus maximus*, the characteristic human form that assists bipedal locomotion. Quite coarse in structure, with fibres clustered into bundles and separated by deep grooves, it is normally smoothed off in life by a covering of subcutaneous fat. It tends to be an *extensor* in action, straightening the thigh in relation to the trunk and also helping to steady the hip and prevent excessive rotation and *flexion* when walking, running, climbing stairs etc.

adductor magnus

vastus lateralis

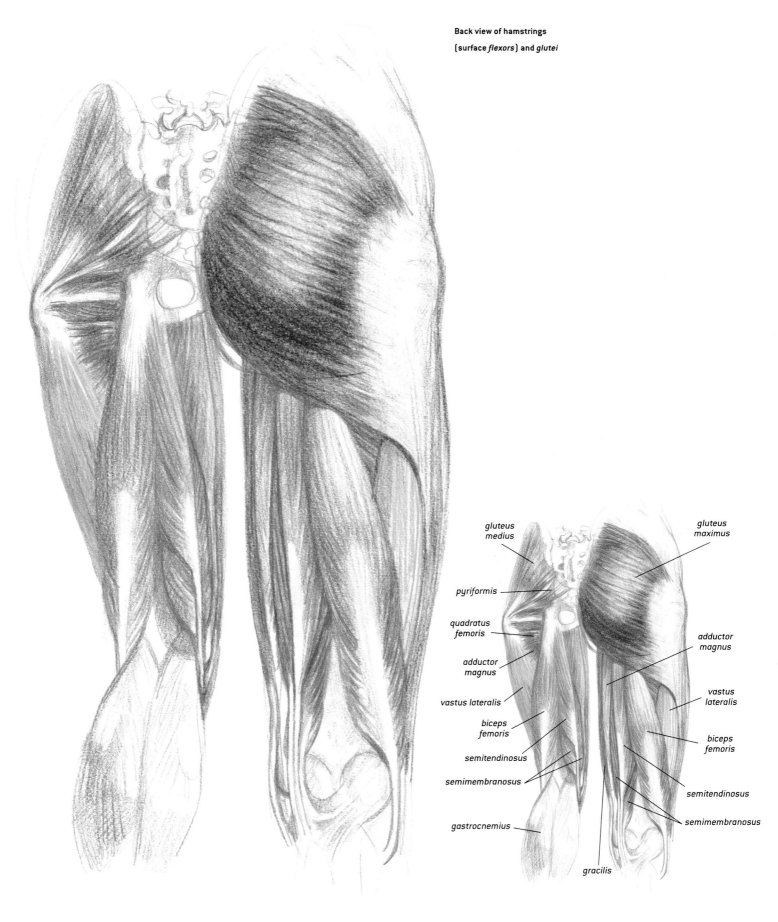

Back view of hamstrings
(surface *flexors*) and *glutei*

gluteus medius

gluteus maximus

pyriformis

quadratus femoris

adductor magnus

adductor magnus

vastus lateralis

vastus lateralis

biceps femoris

biceps femoris

semitendinosus

semimembranosus

semitendinosus

semimembranosus

gastrocnemius

gracilis

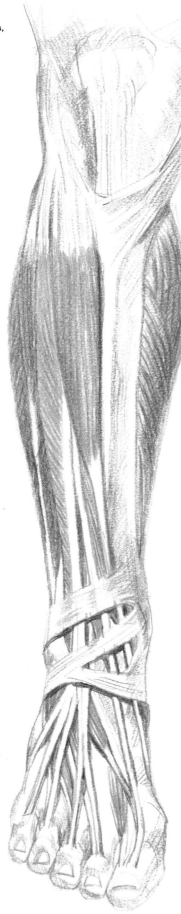

Lower leg – front view

From the front view, the tibia or shinbone divides the *extensors* on the outer side from the *flexors* visible on the inner side (although the latter are actually acting on the back of the calf). It is not covered by muscle for most of its length, which incidentally and not surprisingly renders it vulnerable to being accidentally and painfully hit. The main *extensor* muscle the *extensor digitorum longus* arises from the outer *tuberosity* of the *tibia* and the upper three-quarters of the shaft of the *fibula*, its tendon emerging from underneath the *retinacula* at the ankle to radiate to its insertions in the four smaller toes. The big toe has its own muscle and tendon, the *extensor hallucis longus* that arises from the middle of the shaft of the *fibula*. The whole foot is extended or *dorsiflexed* by the *tibialis anterior*, which arises from the *lateral condyle* and almost half the length of the *tibia*, crossing over to the medial (inner) side to insert into the *cuneiform* bone of the *tarsus* and the base of the first *metatarsal* bone. The *tibialis anterior* is also an *invertor* of the foot, which means that its action raises the medial side of the foot, transferring weight to the lateral edge.

Often prominently visible on the lateral side of the lower leg, especially when the leg is extended and the foot *plantarflexed* (toes pointed) is the *peroneus longus*. Its origin is from the head and upper two-thirds of the shaft of the *fibula* from whence the fibres descend vertically to end in a long tendon that runs behind the *lateral malleolus* (outer ankle) in a groove shared with the tendon of the *peroneus brevis* and then dives under the foot to the medial side where it inserts into the base of the first *metatarsal* (big toe).

The *peroneus brevis* arises from the lower two-thirds of the shaft of the *fibula*; its tendon passes around the *lateral malleolus* with that of the *peroneus longus* and passing forward to insertion in the base of the fifth *metatarsal* (little toe) bone on its lateral side.

Both these muscles are primarily active in steadying the foot and maintaining balance and therefore are not to be classed as either pure *extensors* or *flexors*: accordingly I have coloured them with a mixture of red and blue.

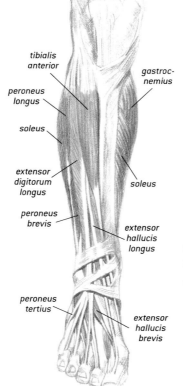

tibialis
anterior

peroneus
longus

soleus

extensor
digitorum
longus

peroneus
brevis

peroneus
tertius

gastroc-
nemius

soleus

extensor
hallucis
longus

extensor
hallucis
brevis

66

Right lower leg surface muscles,
medial view

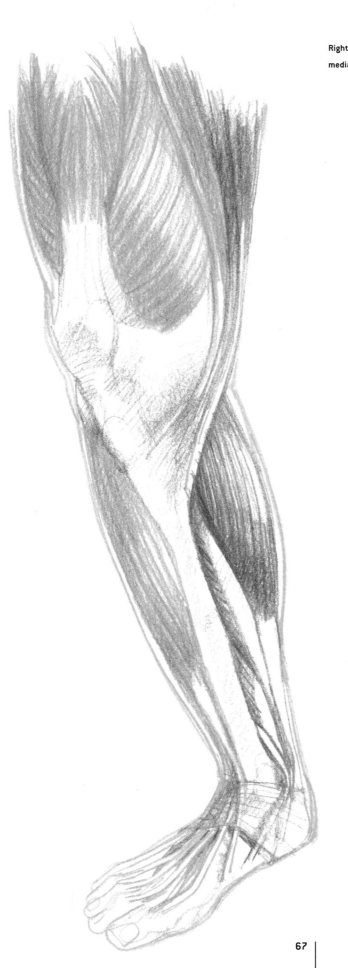

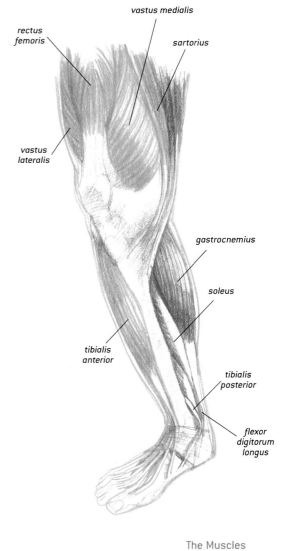

rectus femoris

vastus medialis

sartorius

vastus lateralis

gastrocnemius

soleus

tibialis anterior

tibialis posterior

flexor digitorum longus

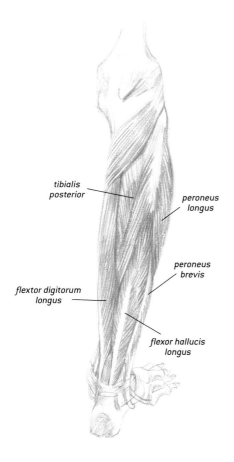

tibialis
posterior

peroneus
longus

peroneus
brevis

flexor digitorum
longus

flexor hallucis
longus

Lower leg – back view, deep layer

From the back view the muscles of the calf are almost exclusively *plantarflexors*. The drawing on the left opposite shows the deepest layer and already the calf is beginning to acquire its final shape. In the middle is the deepest muscle of all, the *tibialis posterior*. This arises from the whole of the membrane that connects the *tibia* and the *fibula* (the *interosseous membrane*) and also from extensive areas of both bones. Via a series of sheaths and complex interconnections it finally inserts under the arch of the foot on the inner side. Next to it on the medial (inner) side is the *flexor digitorum longus* arising from the middle of the shaft of the *tibia* and inserting in a similarly complicated manner under the foot and as four tendons into the four lesser toes. On the other side of the *tibialis posterior* is the *flexor hallucis longus* that arises from the posterior surface of the *fibula* and surrounding areas to join a long tendon that passes around the *medial malleolus* (inner ankle) through several sheaths and tunnels to insert into the base of the big toe. Finally, on the lateral side of the calf are the *peroneus longus* and *peroneus brevis*. These two are visible from the front and back as well as on the lateral side and have already been described on page 66.

Lower leg – back view, second layer

The penultimate layer on the back of the lower leg is almost entirely filled by the *soleus*, a wide, flat muscle that largely defines the shape of the calf. It arises from extensive areas including the head of the *fibula* and some of the shaft of the *tibia* and is attached to a broad *aponeurosis* under the whole of the muscle, which gradually thickens and narrows to join the tendon of the *gastrocnemius* that overlays it and become the famous Achilles tendon, a very prominent form at the back of the heel. On this layer, because it is there, I have drawn a little muscle with a remarkably long tendon: it is called the *plantaris* and has no discernible effect on the surface form.

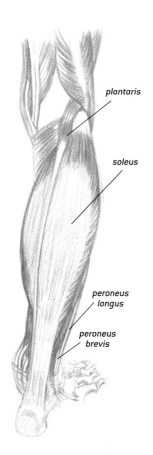

plantaris

soleus

peroneus
longus

peroneus
brevis

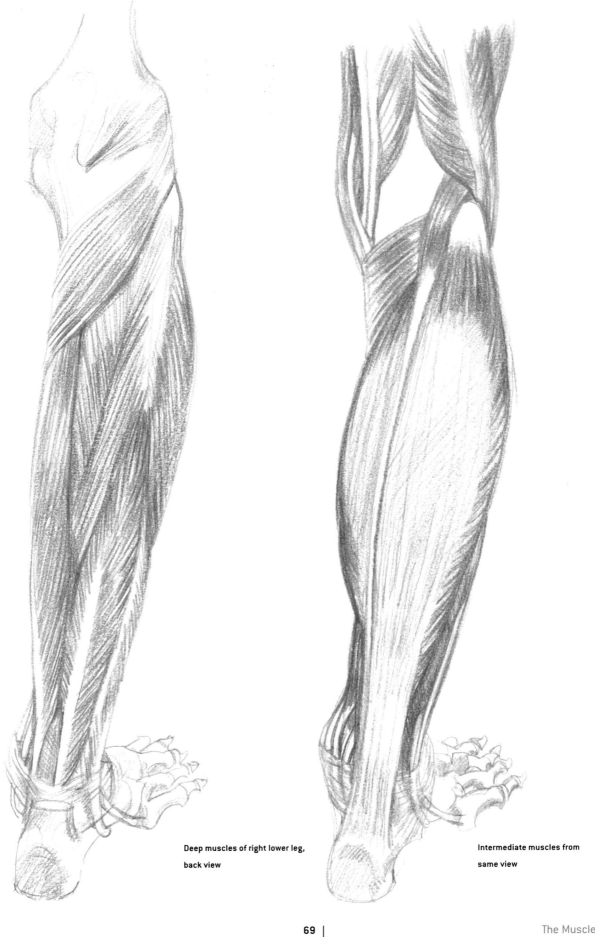

Deep muscles of right lower leg,
back view

Intermediate muscles from
same view

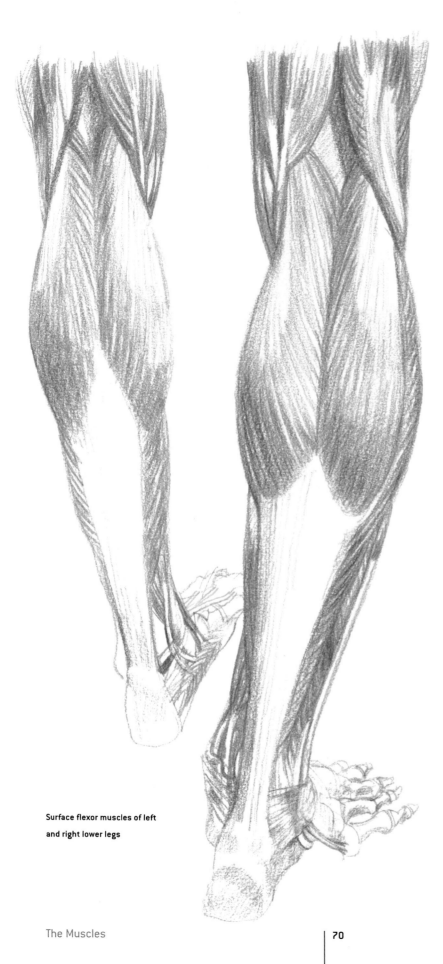

Lower leg – back view, superficial layer

The only muscle left to describe now is the *gastrocnemius*, a muscle universally recognized and popularly known as the calf muscle. It has two heads, which arise by strong tendons from both *condyles* of the *femur*. As the two heads descend they spread and their centres become *tendinous*, producing somewhat flattened areas before swelling into two lozenge-shaped forms of normal muscle fibres. This is harder to describe verbally than to draw so I refer you to the drawings here. As you can see, the two heads then combine with each other and that of the *soleus* beneath, to make a very substantial tendon, the aforementioned Achilles tendon, that inserts into the middle of the posterior part of the heel bone or *calcaneus*.

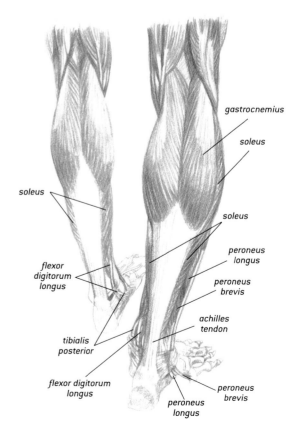

Surface flexor muscles of left and right lower legs

The foot

In the skeleton section on pages 30–31 I described the strong arches of bone that make the foot such a strong and springy structure. The muscles that act upon this structure add little to the surface form, only the tendons on the upper side showing when active. There are many muscles in the foot, several layers in fact, but they are almost all on the *plantar* (sole) side and they are hidden under a thick *aponeurosis* and also very thick skin and are therefore of little interest or importance for the figure artist.

Most of my drawings of the lower leg also delineate the tendons as they attach to the foot, so for this reason I am only offering two versions of the superficial anatomy of the foot in the standing position from the medial and lateral views.

There are many muscles in the foot, several layers in fact, but they are almost all on the *plantar* (sole) side and they are hidden under a thick *aponeurosis* and also very thick skin and are therefore of little interest or importance for the figure artist.

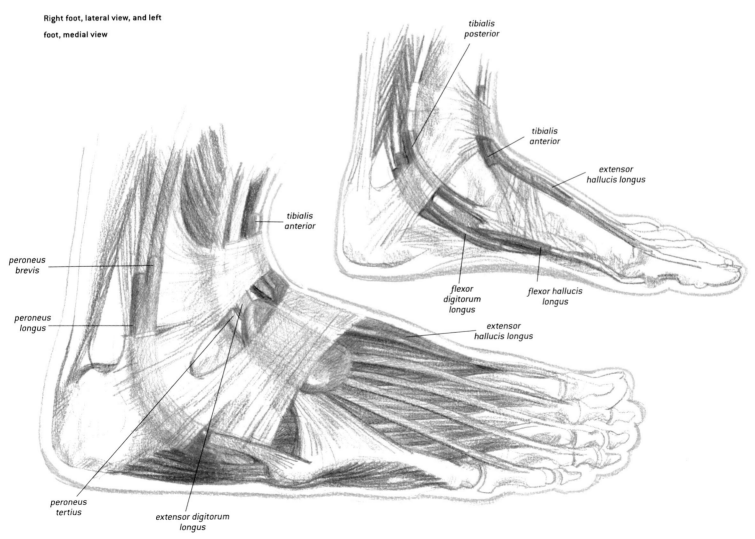

Right foot, lateral view, and left foot, medial view

tibialis posterior

tibialis anterior

extensor hallucis longus

tibialis anterior

peroneus brevis

peroneus longus

flexor digitorum longus

flexor hallucis longus

extensor hallucis longus

peroneus tertius

extensor digitorum longus

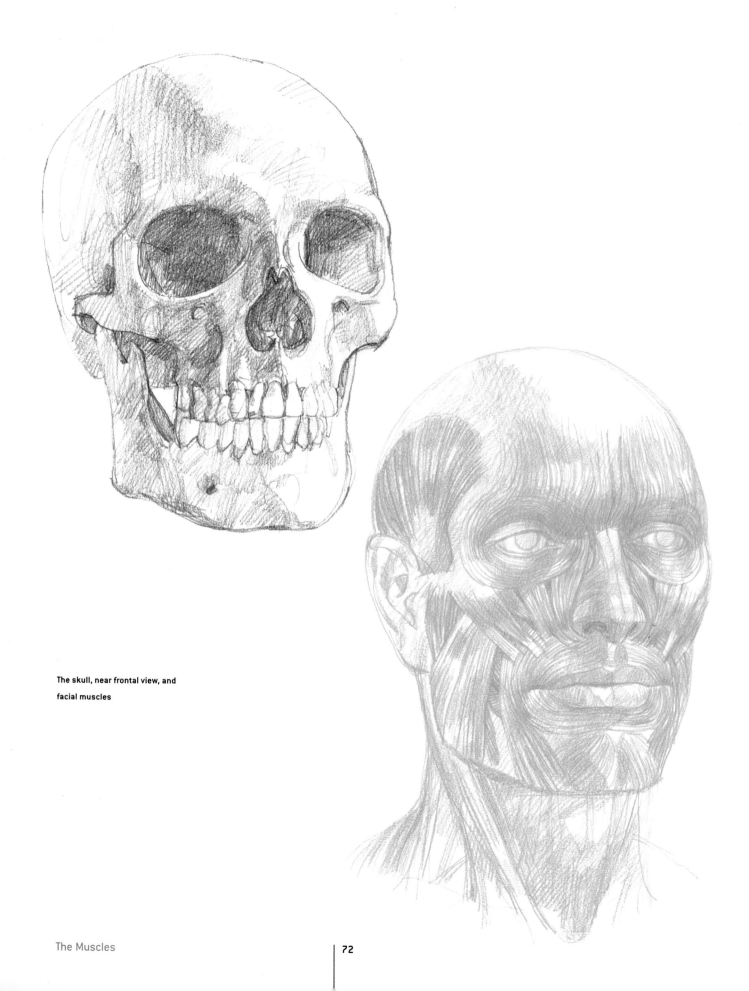

The skull, near frontal view, and
facial muscles

The head, more than any other part of the human body, takes much of its form from the bony structure.

The head, more than any other part of the human body, takes much of its form from the bony structure.

Relatively thin layers of *fascia* and fat cover the *cranium*. Even the overall form of the facial areas, although overlaid by a quite complex pattern of muscles, is largely reflective of the skull beneath. Of course eyes, nose, mouth and ears are additional forms but their positions relative to one another are dictated by the underlying skull, just as surely as is the shape of the other tissues. This has particular relevance when searching for a likeness in a portrait, when it is often thought that the first task is to draw the features precisely, whereas in fact the initial requirement is to place them accurately. As proof of this consider looking at a familiar face in the background of a photograph that is blurred enough to render the details of the features indecipherable; almost always recognition is instant, as the pattern is unique to that individual. We will return to this principle in the drawing section.

Returning now to anatomy, the top drawing opposite is of a real (as opposed to a plastic replica) human skull. As with many skeletons available for medical study, it is of unknown provenance. Anatomists who are much more knowledgeable than I am may be able to identify its ethnicity, but it is an interesting exercise to clothe such a skull in typical musculature and make a guess at the shapes of eyes, nose and mouth. The second drawing shows my attempt at re-creation of the unknown face. Of course specialist knowledge would be needed for accurately predicting the features, especially the shape of the nose and mouth but I can be fairly sure that my combination of skull-defined proportion and guesswork has arrived at a type of head defined by that skull. His (her?) nose may have been broader (although its bone started quite thin) and the lips may have been thinner, but the long face, the lantern jaw and the prominent cheekbones are all there in the bone structure.

There is no particular significance in my choosing to draw these muscles in red – coding by colour for *extensors* and *flexors* is not relevant as applied to the head. In fact the only muscle of the face with any bulk is the *masseter* that powers the lower jaw. It arises from the *malar process* of the *maxilla* (upper jaw) and two-thirds of the *zygomatic arch* and inserts at the angle of the lower jaw or *mandible*.

All of the following act upon the mouth: the *levator labii superioris aleaqu nasi;* the *zygomaticus minor* and *major;* the *levator anguli oris;* the *depressor labii inferioris;* and the *depressor angular oris.* They all pull on the mouth in various ways to make the variety of expressions of which it is capable. Wrapping around the mouth is the *orbicularis oris,* the primary action of which is closing the mouth.

Around each eye are two more orbital muscles, the *orbicularis oculi.* The outer, called the *orbital* portion, acts as a sphincter in closing the eye firmly and in so doing also pulls on the skin of the temple,

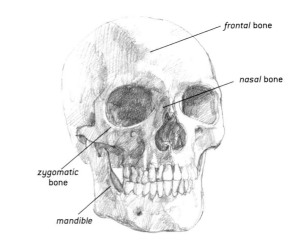

frontal bone

nasal bone

zygomatic bone

mandible

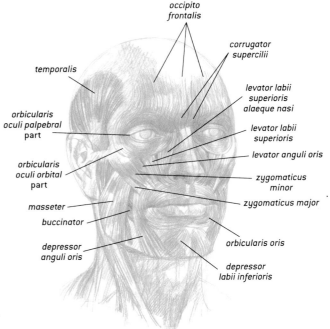

occipito frontalis

corrugator supercilii

temporalis

levator labii superioris alaeque nasi

orbicularis oculi palpebral part

levator labii superioris

levator anguli oris

orbicularis oculi orbital part

zygomaticus minor

masseter

zygomaticus major

buccinator

orbicularis oris

depressor anguli oris

depressor labii inferioris

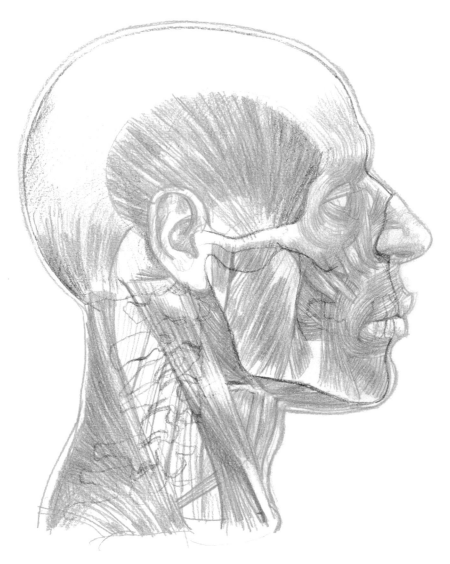

Side view, facial muscles

forehead and cheek to form folds from the eyelids, the well-known 'crow's feet'. The inner one, called the *palpebral* portion, is composed of thinner skin and takes its form from the eyeball upon which it lies. The last muscle that I will mention (there are several other smaller, less significant ones) is the *corrugator supercilii*, a small muscle between the eyebrows that pulls them together and downwards in a frowning or suffering expression.

The side view of the head shows all the same facial muscles and also the full extent of the temporal muscle. This fan-shaped muscle rather neatly fills the hollow at the side of the skull above the *zygomatic arch* to round out the form of the temple. It descends through the gap between the *zygomatic arch* and the side of the skull into a tendon that inserts into the *ramus* of the mandible to assist in the action of closing the mouth.

You have already seen the muscles at the back of the neck, those that hold the head erect (pages 48–49). The drawing opposite of a head thrown back is to show the muscles at the front of the neck.

By far the most dominant form in the front and side views of the neck is the *sternomastoid*, in fact from the point of view of the artist it is almost the only one, so prominent is it, especially when the head is turned or thrown back. It arises by two heads, the medial head being rounded, often cord-like and the lateral head arising from the inner third of the *clavicle* being much flatter and wider. As the two heads combine

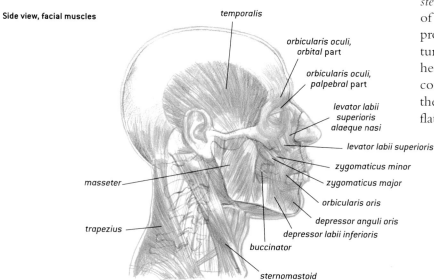

temporalis

orbicularis oculi, orbital part

orbicularis oculi, palpebral part

levator labii superioris alaeque nasi

levator labii superioris

zygomaticus minor

zygomaticus major

orbicularis oris

depressor anguli oris

depressor labii inferioris

masseter

trapezius

buccinator

sternomastoid

and ascend, the muscle is fatter and rounder, becoming flat again as it inserts into the *mastoid process* at the base of the skull just behind the ear.

In the middle of the neck, under the chin, is a small bone that I have not so far mentioned: it is called the *hyoid* bone and it is suspended from *processes* on the *occipital* bone of the skull by two ligaments. It acts somewhat as a sling to provide attachment for muscles at the front of the neck and under the chin. Although I have drawn and named some of these muscles they have less influence on the surface form than the larynx that underlies them and rounds out the throat in this area. Part of the larynx, the thyroid cartilage, is larger in the male than in the female throat: in fact there is little difference between the sexes until the end of puberty after which it grows to become in the male the prominence popularly known as Adam's apple. Its shape is rather sharp edged, two flattish sides projecting forward to an edge with a slightly notched top.

There is one extensive muscle that I have omitted entirely. It is called the *platysma* and is a thin sheet covering the whole of the front of the neck, ascending from as far down as the top of the *pectoralis major* over the *clavicles* and up to above the jawline. In life it is virtually invisible at rest and rarely seen in action and then usually only momentarily. It can be prompted to appear by assuming an expression of extreme anguish or fear. I do not recall ever having seen it represented in a figure drawing.

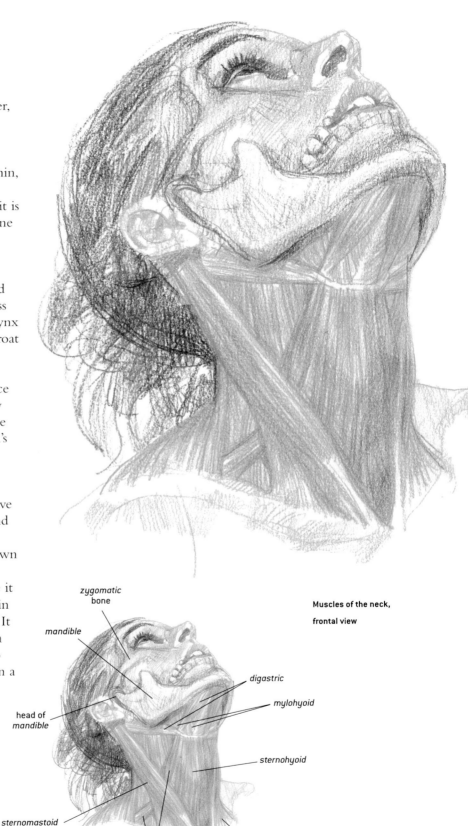

Muscles of the neck, frontal view

zygomatic bone

mandible

head of mandible

digastric

mylohyoid

sternohyoid

sternomastoid (right)

omohyoid

sternomastoid (left)

The Muscles

3 Surface Form

In this section we will look at human anatomy as it can be sensed in life. The models have been asked to adopt poses that will accent one or more muscle groups and/or surface skeletal forms.

One of the most confusing areas for figure artists with an interest in anatomy is the upper back. The combination of bulky deep muscles, sometimes almost paper-thin superficial muscles and mobile *scapulae* upon the springy cage of the *thorax* make the view difficult to reconcile with most anatomical diagrams. For this reason many of the anatomical analyses in this section will be concerned with this tricky area.

The colours used in the drawings in this section have no significance – they are solely for variety.

Hands pulling apart

The action requires activity in the upper arm extensors and the deltoid muscles of the shoulder, but from the back view the trapezius shows the most prominent activity.

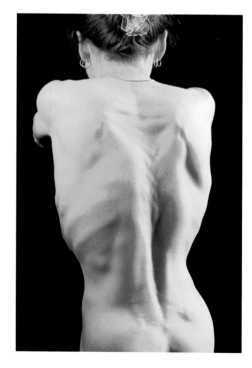

In this photograph the standing model is holding her arms out straight in front, hands clasped together but exerting force as though to pull her arms apart. The action requires activity in the upper arm *extensors* and the *deltoid* muscles of the shoulder, but from the back view the *trapezius* shows the most prominent activity.

The edges of this large muscle are often thin and difficult to detect and since its fibres can act independently it needs different actions to reveal its full extent. Here the middle and lowest parts of the muscle are very taut and active, securing the *scapulae* in place against the pull of the arms. It is probable that the upper fibres are somewhat active too, but it is not obvious in this light.

Stage 1

In this analysis the first marks needed are to identify the inner edges of the *scapulae*, which are clearly seen. Not so visible but just as important are the *scapula spines*, which can be sensed by very slight changes of form running diagonally up towards the bony protuberances at the shoulder that mark the position of the *acromion* (although the bump visible here just by the model's left shoulder is more likely to be the slightly enlarged extremity of the *clavicle* where it projects slightly higher in its connection with the *acromion*).

Stage 2

Then, from the theory, we can put in the shape of the *scapulae spines* and the fibres of the very active *trapezius* muscles that radiate from them. Less relevant to this particular action, the *erector spinae* is active in holding the figure erect. Layers of fascia and sheets of muscle obscure its borders but its form is unmistakable in this pose and is shown by adding contrasts of light and shade.

At each side of the base of the spine in this unusually well-delineated model, the two *posterior superior iliac spines* (see the pelvis on page 15) are seen as slight protuberances: on a rounder individual they usually appear as dimples.

Stage 3

From the slightest hint of a depression over the form of the right-hand *erector spinae* the lower edge of the *trapezius* can be deduced and since the other side mirrors it, the complete lower borders can be drawn in. Of course we know from theory that the form of the *erector spinae* is overlaid by the broad sweep of the *lattisimus dorsi*, but in this view its upper border is not visible. This upper border should curve outwards from beneath the *trapezius* and then up to its insertion in the neck of the *humerus*, but in common with many of the muscles of the torso, it is very thin and except when it combines with the *teres major* to make a significant form under the raised arm, its edges are often almost invisible. In this model the shapes of individual ribs can even be sensed through it and the three layers beneath it.

In this type of analysis it is debatable whether known but fugitive features should be included, but although this is primarily a study of the *trapezius* I have made some light indications of the upper *lattisimus* borders and also the inner, or in this case lower, edge of the *deltoid* muscle.

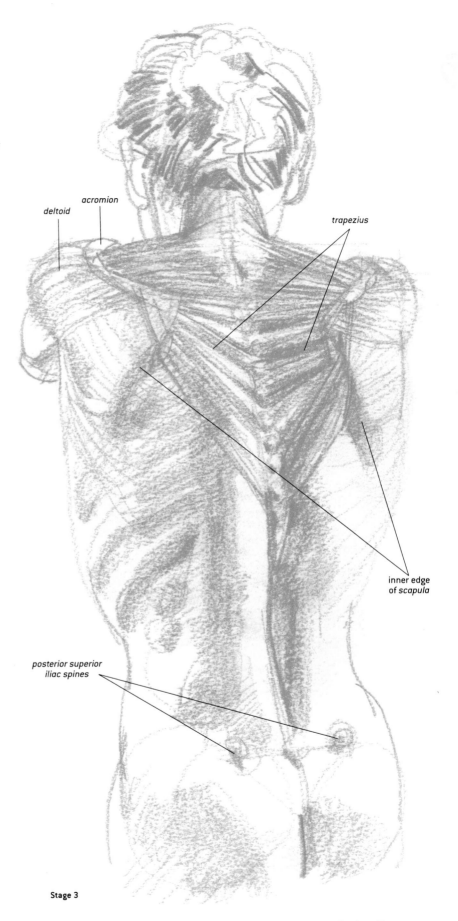

deltoid

acromion

trapezius

inner edge
of *scapula*

posterior superior
iliac spines

Stage 3

Hands pushing together

In this dramatic photograph the model is in an almost identical pose to that on page 76, but in this case her hands are being strongly pressed together instead of pulling apart.

In this dramatic photograph the model is in an almost identical pose to that on page 76, but in this case her hands are being strongly pressed together instead of pulling apart. Most notably here, all the activity in the *trapezius* is concentrated in the lowest part of the muscle, which is acting powerfully, leaving pronounced hollows on each side of the active fibres. This action beneath the surface not only locates the *scapulae* but also seems to be pulling them towards the centre of the back.

Precisely *why* the muscles act in this way is not our concern as artists: we only need to observe and hopefully to comprehend how their appearance changes in different situations.

To make the anatomical drawing, the very clearly defined inner borders of the scapulae are the first features to be fixed and from these the directions of their spines can be deduced. The rest follows in a similar sequence to that of the previous drawing, using the given light and shade to give form and a combination of theory and observation to clarify the anatomy. As before, there is little indication of the lattisimus and deltoid borders, which can only be guessed at.

The model here has well-developed *trapezius* muscles,

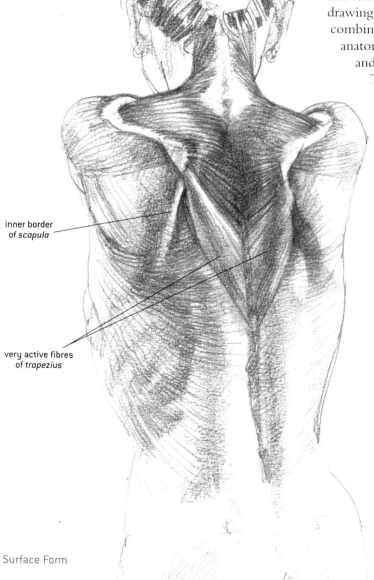

inner border
of *scapula*

very active fibres
of *trapezius*

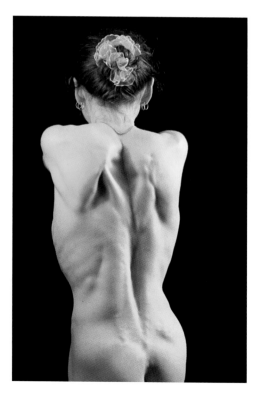

the top fibres of which are fully operative in this lifting pose. Also working hard are the *deltoids* as they pull on the upper arms to raise the weight in his hands. The *erector spinae* muscle group is active in the lower back to hold the trunk upright and the *scapulae* are slightly outward rotated and lying flat on the ribcage.

Stage 1

On each side of the central line of the spine the triangular-shaped tendinous areas combine to form a diamond shape at the base of the neck. The medial edges of the *scapulae* are very visible: less obviously the lines of the *scapulae spines* can be traced. Clearly seen at the base of the *vertebral column* are the two *anterior superior iliac spines*.

Stage 2

The powerful contraction of both the upper and lower fibres of the *trapezius* muscles can now be shown, the lower margins of which are sharply defined. It is noticeable and quite strange that the horizontal centre fibres of this muscle remain comparatively flat, thereby giving even greater prominence to the two slabs of muscle that are pulling downwards on the medial ends of the *scapulae spines*. First indications of the strongly contracting *deltoids* are drawn and a guess made at the line of the upper border of the *lattisimus dorsi*, that we know just covers the lower angles of the *scapulae*.

Lifting

The model here has well-developed *trapezius* muscles, the top fibres of which are fully operative in this lifting pose.

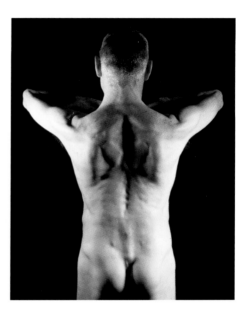

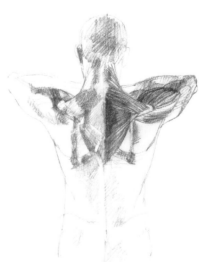

Stage 1 Stage 2 Stage 3

Surface Form

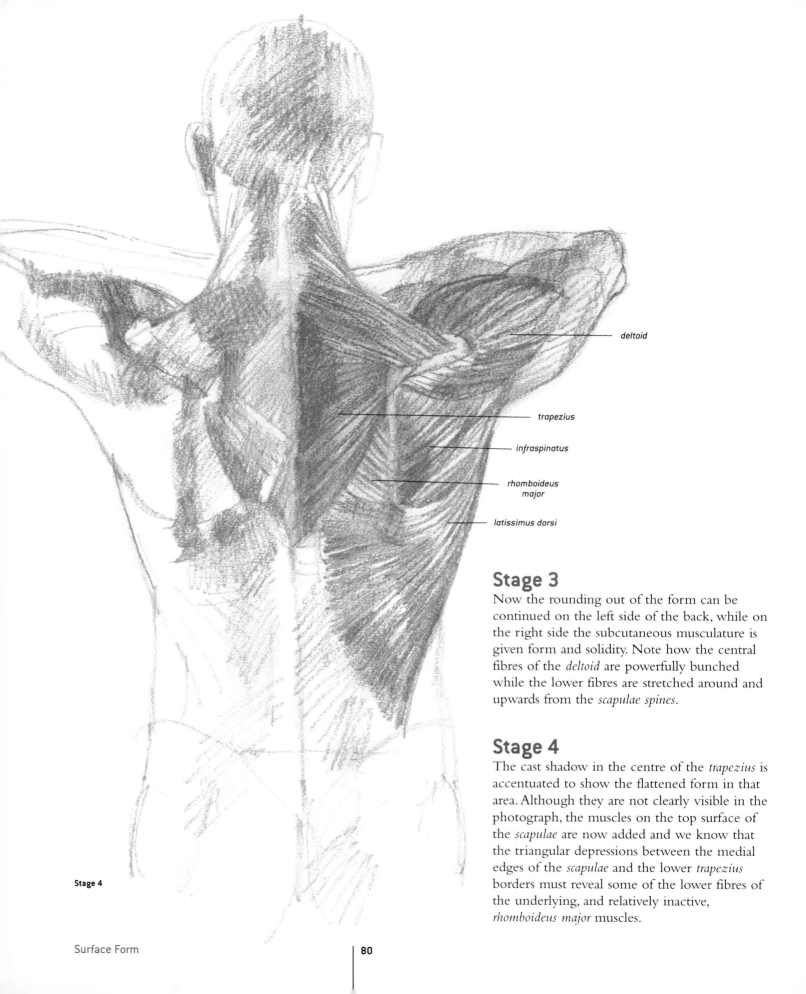

deltoid

trapezius

infraspinatus

rhomboideus
major

latissimus dorsi

Stage 3

Now the rounding out of the form can be continued on the left side of the back, while on the right side the subcutaneous musculature is given form and solidity. Note how the central fibres of the *deltoid* are powerfully bunched while the lower fibres are stretched around and upwards from the *scapulae spines*.

Stage 4

The cast shadow in the centre of the *trapezius* is accentuated to show the flattened form in that area. Although they are not clearly visible in the photograph, the muscles on the top surface of the *scapulae* are now added and we know that the triangular depressions between the medial edges of the *scapulae* and the lower *trapezius* borders must reveal some of the lower fibres of the underlying, and relatively inactive, *rhomboideus major* muscles.

Stage 4

Pushing down

This time the model is pushing downwards on a pole that he is holding in front of him.

This time the model is pushing downwards on a pole that he is holding in front of him. The action has raised the lower angles of the *scapulae* so that they jut out from the surface of the ribcage. Note that the twin columns of the *erector spinae* are now relaxed, to be replaced by some curious forms that seem to be promoted by tension in the lower fibres of the *latissimus dorsi*. This illustrates how the back is always an interesting area, even if it is not always possible to identify with absolute certainty every shape that can be seen.

The stages follow a similar course to those in the previous analysis. Note the prominence of the upper part of the *trapezius*. Although the lower angles of the *scapulae* appear to escape from the embrace of the *latissimus dorsi*, in fact this is not possible, some fibres of the *latissimus dorsi* sometimes actually attaching to the *scapulae*.

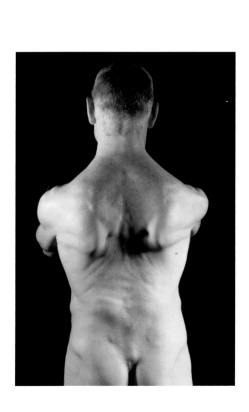

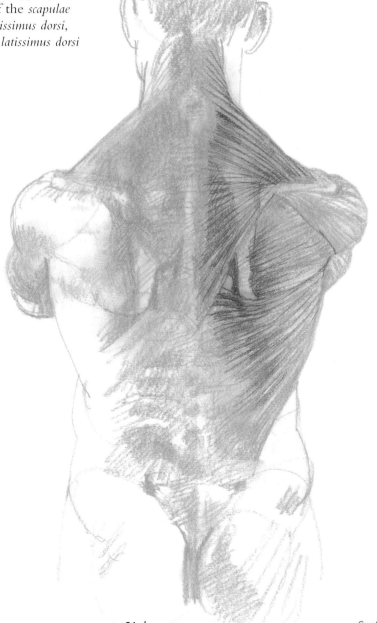

Scapula rotation

This comparatively relaxed pose shows the two trapezius muscles and the left-hand deltoid inactive and therefore seeming to be much as they appear in most anatomy diagrams.

This comparatively relaxed pose shows the two *trapezius* muscles and the left-hand *deltoid* inactive and therefore seeming to be much as they appear in most anatomy diagrams. In contrast to the flaccid left *deltoid*, the active right *deltoid* by performing its main function of *abduction* is lifting the right arm to above shoulder height. Raising the arm to this degree always involves rotation of the *scapula* and this can be seen clearly from the form made by the medial border and also the line of the *scapula spine* that is much steeper on the right side. Although not the primary interest in this analysis, it is interesting to note the activity of the *gluteus* muscles on the weight-taking left side in contrast to the relaxed form on the right side.

Stage 1

As ever in standing back views, the first line to be sought is the direction of the *vertebral column*. It is always the key to the balance of the pose and in this case provides the starting point for the analysis of the upper back.

You will see that I have drawn an inverted triangle at the base of the *vertebral column*: the upper points of the triangle indicate the two *posterior superior iliac spines* that are often visible either as depressions or, in thinner subjects as here, as slight protuberances. The lower point indicates the beginning of the cleft of the buttocks, the tilt of this triangle shows the degree of tilt in the sacrum and therefore of the whole pelvis, as it adapts to the weight-bearing left leg. Once the

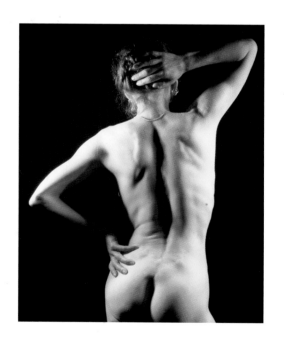

Stage 1

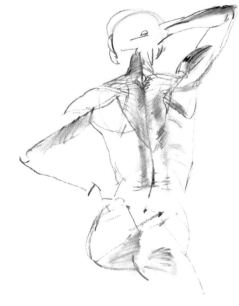

Stage 2

relationship of the pelvic tilt and the compensating curve of the vertebral spine have been established, the medial edge and the spine of each *scapula* can be indicated. There is some rotation on the left side from the position of a *scapula* when the arm is completely at rest but it is much less than the rotation to be seen on the other side where the arm is raised high.

Stage 2

The complete shape of the *trapezius* has been sketched in: note the bunching of the upper fibres of the right side as they assist the *deltoid* in raising the arm. From its fairly rounded form in this photograph, the left-hand *trapezius* could be judged to be active, but I think that this is just the result of it being pushed out by the medial border of the *scapula* on that side. There is just a hint of a line showing the beginning of its lower border as it passes over the left *scapula* and from this I have guessed at the other lines of the lower borders of this muscle.

Also visible in the photograph is the right half of the diamond-shaped flat area that delineates the tendinous area between the two wings of the *trapezius* at the base of the neck. Protruding into this area is a bump, which denotes the long *spinal process* of the seventh *cervical vertebra*.

Stage 3

There is a change in direction of the outline of the back just under the left *axilla* (armpit): this gives the clue to where the *latissimus dorsi* curves around the *teres major* towards its insertion in the upper *humerus*. Since we know that its upper edge usually clips the lower point of the scapula, the rest can be surmised with confidence. Now it is just a matter of sketching in the directions of the muscle fibres and filling out the observed forms. As in the previous analysis (of the same model) the ribs can be seen through the thin sheet of *lattisimus dorsi* until they disappear under the twin columns of the *erector spinae*.

seventh cervical

deltoid

trapezius

scapula spine

rotated scapula edge

posterior superior iliac spines

Stage 3

Twisting

Here we have a more active pose in which most fibres of a muscle on one side of the body are quite different in action and shape from those of its twin on the other side.

We have seen in the previous analyses how in certain actions some fibres of the same muscle can be active while others remain relatively quiescent. Here we have a more active pose in which most fibres of a muscle on one side of the body are quite different in action and shape from those of its twin on the other side. The model, with arms held at shoulder height, is swinging her hands, locked together, to one side. As you can see, several muscles are involved in this action, most notably the *trapezius* and *deltoid*.

Looking first at the right-hand upper back and arm, the *deltoid* muscle here is strongly contracted in lifting the arm and retaining it in the raised position. Then immediately to the left of the deltoid, another prominent bunched muscle form can be seen. This, perhaps surprisingly, is the *trapezius*. I say surprisingly because, as I said in the introduction to this section, this is a muscle represented in many anatomical diagrams as a relatively flat sheet. By the action of shortening, the *trapezius* is pulling the shoulder and arm backwards. Nearly always there are other, deeper muscles involved in the action and they may be contributing to the form of the surface muscle, but this is not something we need to be concerned with in this case. This is not a predicted action – this is an observed form that is clearly active and dynamic and must be drawn with appropriate vigour.

On the left side of the upper back the *trapezius* is stretched as it pays out, allowing the arm from the tensed *deltoid* to be pulled across the body. It is now more nearly a flat sheet, only bulging as it stretches over the edge of the left *scapula*.

spine of *scapula*

medial edge of *scapula*

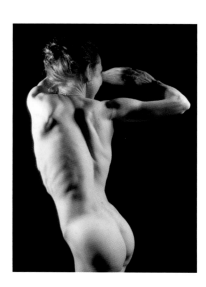

There is a basic difficulty in analysing the front of the torso, which is that the abdominal muscles are not really superficial. As you will know from the first part of this book, the two bands of muscle called the *rectus abdominis* are enclosed under what are technically two layers of tissue. However, in dissection this is effectively just one layer called the *rectus sheath* and in a muscular individual with little or no overlying fat, these muscles with their characteristic tendinous intersections make a very prominent surface form.

The model in this photograph is a body builder. This means that by lifting progressively heavier weights in a carefully organized programme of exercises and diet he has sculpted his body into a form that does not occur naturally. It could be argued that since muscles develop in response to the demands that are put upon them, no muscle development is natural, but in my opinion the massive musculature achieved by body builders is at the extreme end of the spectrum of normality.

In this pose the abdominals, together with the *obliquus externus* and the *serratus anterior*, are being strongly tensed (note his facial expression) and as a result the opening of the *thorax* is virtually obscured.

Although this analysis is primarily to show the abdominals, the surrounding muscles of the torso are needed to provide the context: note the unusually large *latissimus dorsi* and upper arms. It is not easy to see the precise disposition of muscles in the armpits here but the large combined form of the *teres major* and *latissimus dorsi* ascends between the medial head of the *triceps* and the short head of the *biceps* to its insertion in the upper *humerus*, the *pectoralis major* then ascending medially to its similar insertion.

Now the forms that are really the subject of this exercise, the *rectus abdominis* muscles, are solidified. Note the position of the lowest horizontal division by the *umbilicus* (belly button). There is occasionally a fourth division just below this one and all may be angled slightly or even not quite in line across the two muscles.

Abdominals

The abdominal muscles are not really superficial.

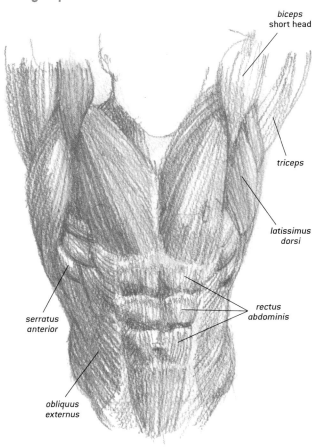

biceps
short head

triceps

latissimus
dorsi

rectus
abdominis

serratus
anterior

obliquus
externus

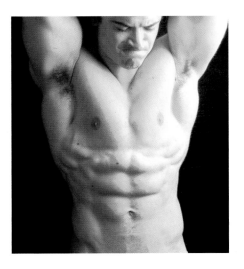

Pectorals

The twin muscles of the *pectoralis major* are unmistakable.

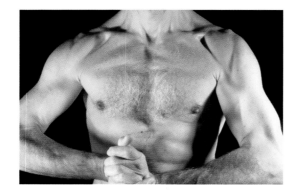

Prominent forms in the upper front torso of the male, the twin muscles of the *pectoralis major* are unmistakable. As such there is less need for an anatomizing exercise to identify them but it is interesting to see how in action the fibres separate and straighten. In the female, of course, the pectorals may be much obscured by the breasts.

I have drawn attention earlier (page 51) to the way that the *pectoralis major* twists upon itself before inserting into the upper shaft of the *humerus*, the action of which produces the sharp lower border often evident in life.

The photograph shows how the action of pressing hands together in front makes the fibres of the pectorals spring into sharp relief. The upper fibres arising from the *clavicle* can be clearly seen, as can the triangular space between these fibres and those of the medial border of the *deltoid*. This hollow is often as visible as it is here, although it is not always evident on anatomy diagrams.

From the almost horizontal *clavicles* the upper borders of the *pectoralis* are drawn downwards at an angle of about 45 degrees. Then from the outer borders the fibres radiating to the *clavicles* and the *sternum* can be indicated, after which it is just a matter of rounding out the forms and adding the *deltoids* and some of the neighbouring, less active muscles.

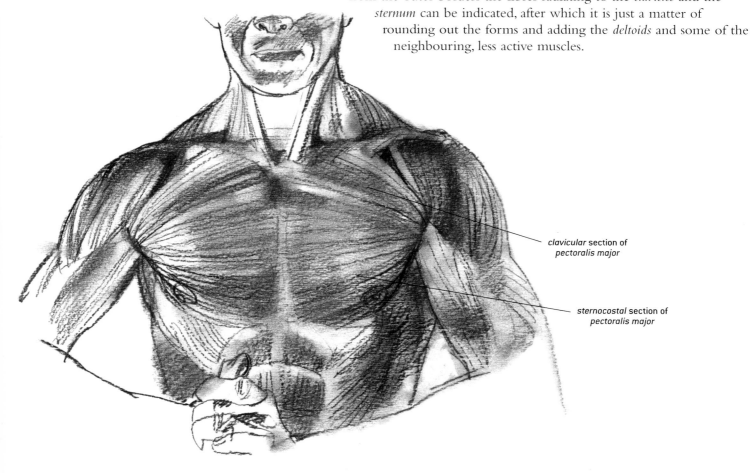

clavicular section of
pectoralis major

sternocostal section of
pectoralis major

Arms – *biceps*

On this page we look at two very

different arms.

On this page we look at two very different arms, one perfectly good and serviceable but rather slender, and the other belonging to the same body builder featured on page 85. Both arms are active, the slender one tensioned by a lifting action and the other in the fully flexed demonstration pose.

Analysis 1

The only sharply defined muscle in this view of this subject is the *biceps*. Its emergence from beneath the *deltoid* and *pectoralis major* is clearly seen and so is the medial edge of its tendon as it descends to its insertion in the *radius*. Although the forearm has no sharp definition, I have made an informed guess of the expected superficial *flexor* musculature.

Analysis 2

Most of the muscles on view in this picture are *extensors* and yet the bulging biceps still catch the eye. For some reason it has long been the muscle most favoured to demonstrate masculine strength and it certainly can be exercised and developed to an extreme degree.

 Much of the bulk of the *biceps* in this picture is hidden from view on the far, medial side of the upper arm and from this view its almost ball-like form is framed by an enormous *deltoid* and the almost equally huge form composed of the *brachioradialis* and the *extensor carpi radialis longus*.

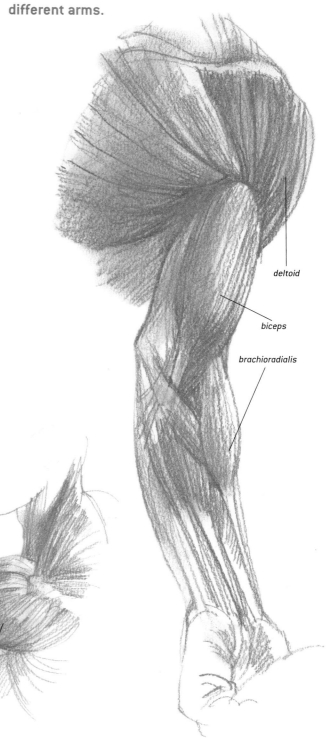

deltoid

biceps

brachioradialis

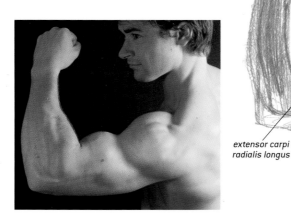

biceps

extensor carpi
radialis longus

brachioradialis

deltoid

Surface Form

Arms – *triceps*

As with the *biceps*, so with the *triceps* – identification is not usually very difficult.

As with the *biceps*, so with the *triceps* – identification is not usually very difficult. Remember that there is only one muscle on the back of the upper arm albeit one with three heads, the long, the medial and the lateral. In life the belly of the lateral head often looks quite short and it may be the most clearly defined form on the back and side of the upper arm. All three heads combine in a broad common tendon, the lateral edge of which is clearly visible in this photograph.

The triceps emerging from beneath the *deltoid* – and attaching to the elbow – are more clearly seen in the illustration than the photograph, however the shadow suggests where the fibres of the *deltoid* bunch together before inserting into the *humerus* and the edge of the *deltoid* can be deduced. Once that is decided the medial and long head of the *triceps* can be shown emerging from beneath it, their fibres converging on the common tendon and proceeding down to insertion in the *olecranon*.

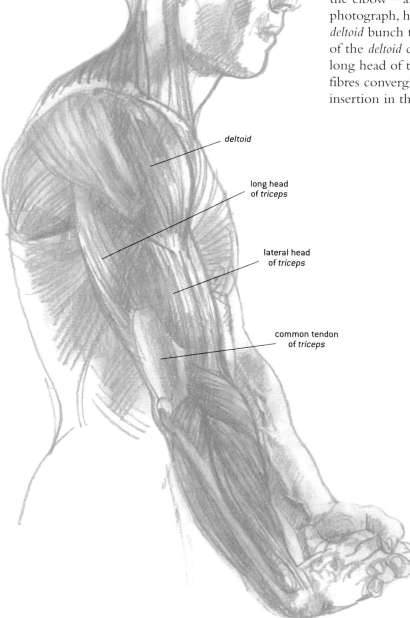

deltoid

long head
of *triceps*

lateral head
of *triceps*

common tendon
of *triceps*

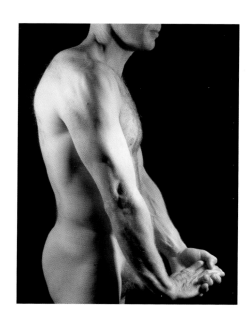

Standing on tiptoe needs maximum effort from the muscles of the calf. In order to lift the weight of the body, two heads of the *gastrocnemius* and the *soleus* underneath them combine to pull powerfully on the famous Achilles tendon, the thickest and strongest tendon in the human body. Less obviously, the thigh *extensors* are also involved in this action and just visible on the outer side of the right leg is the rounded form of the active *vastus lateralis*.

Although the thigh *flexors* with their hamstring tendons are not primarily active, they are contributing to the overall solidity of the whole thigh.

The prominent shapes of the two calf muscles are clearly seen as they shorten to pull on the Achilles tendons. By the knee a sharp shadow is evidence of the edge of the *iliotibial tract* and a similar vertical shadow almost directly below it on the calf indicates the division between the *peroneus longus* and the *tibialis anterior*. The latter, although a *flexor*, is a prominent form in this view, its tendon disappearing from sight as it is passes to the medial side. The tendon of the former, the *peroneus longus* is also strongly visible as it is conducted around the *lateral malleolus* downwards to its insertion in the lateral side of the *plantar flexed* foot. The two heads of the *gastrocnemius* are then drawn in. Straddling them, the hamstring of the *biceps femoris* on the lateral side of the knee joint and those of the *semitendinosus*, *semimembranosus* and *gracilis* on the medial side.

As the figure drawing section of this book approaches I shall from now on refer to these groups of tendons as the outer and inner hamstrings respectively: as you can confirm by feel of your own thigh, the three tendons on the medial side are effectively one form.

Detailing continues with the addition of the *soleus*, reinforcing the form of the Achilles tendon. The left leg is analysed in the same way including the addition of details not actually visible in this photograph because they are in the shadowed side of the foot. These are the tendons of the *flexor digitorum longus* and the *tibialis posterior* passing around the *medial malleolus* down to their insertions in the side of the foot and also the tendon of the *tibialis anterior* emerging from the lateral side.

Leg *flexors*

Standing on tiptoe needs maximum effort from the muscles of the calf.

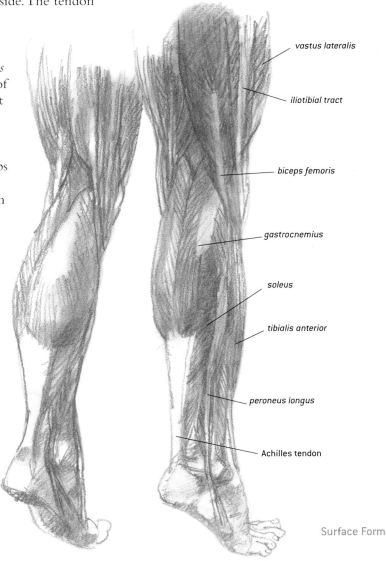

vastus lateralis

iliotibial tract

biceps femoris

gastrocnemius

soleus

tibialis anterior

peroneus longus

Achilles tendon

Leg *extensors*

The calf of the *dorsiflexed* leg shows the action of the *extensor* muscles

In this photograph, the calf of the *dorsiflexed* leg shows the action of the *extensor* muscles pulling the foot up towards the shin while the *quadriceps* are tensed to straighten the knee joint.

Although the action is not as powerful as that of the calf *flexors* in the previous analysis where the whole weight was easily borne on tiptoe, it is quite possible to support the body with only the heels in contact with the ground. As you can see, the muscles and tendons of the calf are well defined but the thigh *extensors*, while being quite developed, have a relatively smoothed-out appearance. This is not unusual in female subjects where there tends to be some deposition of subcutaneous fat.

Before tackling the detailed musculature it is necessary to establish the angle made between the calf and the thigh. The nature of the knee joint is such that when the whole limb is extended and straight as here, the calf and thigh have almost the same direction but are offset from each other. Preparatory to searching out the separate forms of the front of the extended leg, the clearly visible tendon of the *extensor digitorum longus* to the right of the outer ankle (*lateral malleolus*) has been indicated, as has the equally clear tendon of the *tibialis anterior* as it dives over to the medial side of the foot.

Continuing upwards from its tendon, the prominent body of the active *tibialis anterior* can now be put in. Then just behind the *lateral malleolus* the tendon of *peroneus brevis* and *longus* can be followed up to its belly where it is catching a little light within the shadowed side of the calf. Emerging from between the two is the aforementioned *extensor digitorum longus*, its tendon splitting to insert in the four smaller toes. If you look closely at the photograph you can see signs of the *retinaculum* that secures the tendons at the ankle. Note that from this view the *tibialis anterior* obscures the front of the *tibia* itself.

rectus femoris

vastus lateralis

peroneus brevis and *longus*

tendon of *tibialis anterior*

tendon of *extensor digitorum longus*

Leg, lateral view

In this pose the model is pulling on her right heel against the ground, thereby tensioning the thigh *flexors* and giving a strong outline to the *iliotibial* tract and the tendon of the *biceps femoris*.

A very sharply defined horizontal shadow by the knee indicates the lower (in this view) edge of the *iliotibial tract* and just below it another sharp line shows the tendon of the *biceps femoris*. Main outlines of both legs are then drawn and the first indications of tone put in. Although not strictly relevant in this context, the form of the thorax and breasts are suggested.

Now the *gluteus maximus*, *gluteus medius* and *tensor fasciae latae* can be drawn around the bulge of the *great trochanter*. All three insert into the *fascia lata* and then to the *iliotibial tract*. The long shadow just above the anterior (upper, in this view) border of the *iliotibial tract* shows where the *vastus lateralis* emerges from beneath it. Less obviously, it also protrudes from the posterior border to join with the *biceps femoris* in rounding out that area of the thigh.

In this pose the model is pulling on her right heel against the ground, thereby tensioning the thigh *flexors* and giving a strong outline to the *iliotibial tract* and the tendon of the *biceps femoris*.

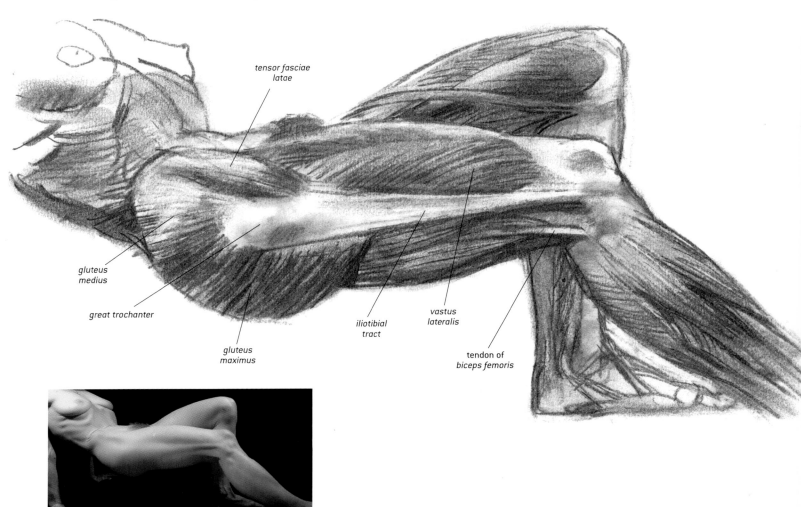

tensor fasciae
latae

gluteus
medius

great trochanter

gluteus
maximus

iliotibial
tract

vastus
lateralis

tendon of
biceps femoris

Surface Form

4 Figure Drawing

The human figure is an endlessly fascinating subject for drawing and painting, with truly infinite variations and possibilities. In the following pages I will be describing a series of projects designed to help the student in drawing the figure with precision and vigour.

It is always best to draw from life rather than from photographs. This does not necessarily mean that using photographs is completely useless. It is just that translating observed three-dimensional form into two-dimensional drawing is more than just copying. It requires selection and interpretation, and once the ability is acquired to do this from three-dimensional observation it is subsequently much easier to interpret and select from the flat photographic image.

Before trying to make detailed drawings of the figure it is advisable first to be able to see the overall shape of the subject. This sounds simple but it is not an untrained skill; indeed it is much more natural for human attention to be unconsciously attuned to the detail of facial features from which visual clues to behaviour and response can be obtained. This kind of vision is subjective vision; what is needed for observational drawing is a more objective vision, a way of looking that tries to work out what is really entering the eye so that any processing is then done consciously rather than subliminally.

Careful measuring can help us to do this and is certainly very useful, but it is prone to error. Imagining geometric shapes overlaying the observed forms is better.

Shape 1:
Pose in a square

This project is about drawing from a model in a pose close to the ground that can be contained in a very simple regular shape.

The three illustrations show stages in the drawing of a pose in which the model is seated on the floor folded in upon herself so that the whole shape can be tightly enclosed in a square.

Stage 1

The negative shapes, by which I mean the areas of the square *not* covered by the figure, are assessed and drawn at the same time as the positive shape.

Stage 1

Stage 2

Shapes within the shape are now beginning to be suggested with a mixture of line and tone.

Stage 2

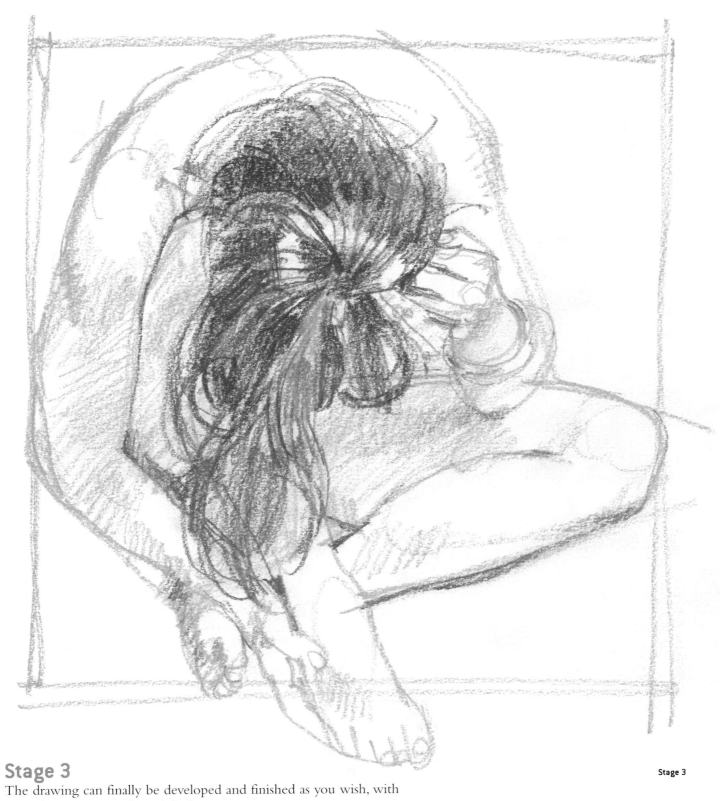

Stage 3

The drawing can finally be developed and finished as you wish, with
or without retaining the original square.

Figure Drawing

Shape 2:
Right-angled wedge

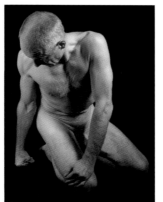

Shape 2 repeats the same exercise, this time using a rectangle as the containing shape. A triangle or even a circle could be the surrounding shape as long as the pose is stable and set close to the ground.

The next step I suggest you take towards clear visualization of the complete figure is to set your model in a pose that, while still securely based on the floor, has risen to a position where the trunk is more nearly upright.

Stage 1

This can be represented, as here, by a wedge shape in which the base is a square, while the upright plane is a rectangle, with a diagonal plane linking the two. Within this grid the basic shapes of torso and legs can be sketched. The point of the exercise is to introduce the sense of a ground plane and the angle at which the figure rises from it. This is a useful concept especially when drawing standing figures where an impression of balance is paramount.

Stage 2

The slight rotation of the trunk here can be seen as a deviation from the back plane of the simple grid. In this case you may wonder why it is useful to have the regular orange grid at all: the reason for this is that it enables you to see more clearly that there is such a deviation.

Now the arms are added – the model's right arm breaking out of the grid to contact the floor almost in line with the back line of the base and the other one almost diagonally across the front inclined plane. Noting its alignment relative to both the orange grid and the shoulders can assist in placing the head.

Stage 3

Drawing initially with charcoal need not deter you from continuing with other media: in this case the drawing was further developed with coloured pastel pencils.

Stage 1

Stage 2

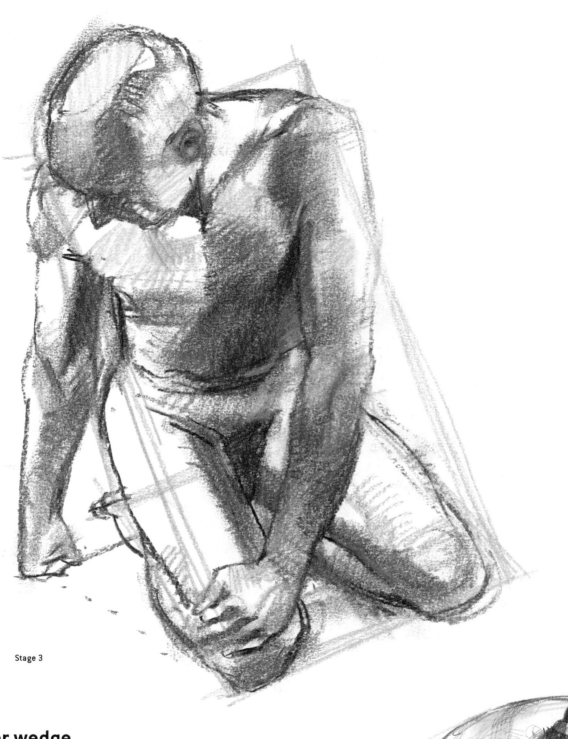

Stage 3

Another wedge

In this drawing my model is leaning forward sufficiently to rest one arm on his knees. The two imaginary diagonal planes in this case represent the general plane of the two upper arms (his left arm protrudes from this plane but curiously continues the line on one of its sides) and the angle of the back. As before, the head projects out of the wedge.

Also as before, the drawing was begun with charcoal and continued with coloured chalk.

Shape 3:
Figure in a box

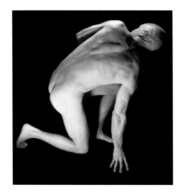

The logical next step in relating the shape of a figure to a containing geometrical form is to construct an imaginary cuboid around the pose.

This sounds more arduous than it really is. It is not essential that the geometrical shape is immaculately constructed: it is enough that by constructing it you have been conscious of the 'footprint' of the pose – its ground contact area and the angles that it makes with that plan shape. The box can be thought of as the block from which a sculptor might cut away sections to leave a simplified version of the pose before going on to carve it in detail (except, of course, that we can allow certain features to project from the box as necessary, which the sculptor cannot).

Stage 1
This stage shows the box with the first lines.

Stage 2
All of the right–hand side of the figure, including the arm and the leg, lies more or less on the same frontal plane. The dipping diagonal plane of the shoulders and upper back can now be indicated and, from this, the head pointing towards (and breaking out from) the far corner of the box.

Stage 3
Upon this basic shape, more detailed forms can now be defined.

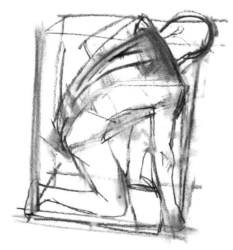

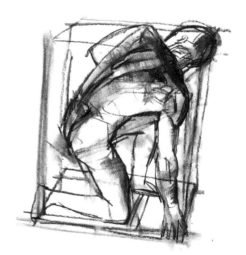

Stage 1

Stage 2

Stage 3

Stage 4

As the forms are developed and refined, the charcoal box can easily be removed.

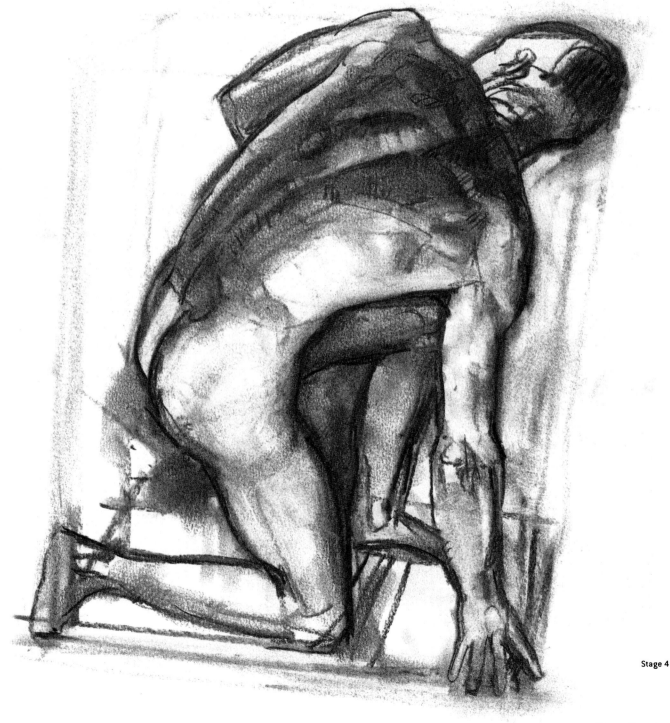

Stage 4

Figure Drawing

Weight 1

As your ability to see the overall shape and volume of a figure improves there may be a temptation to try to embellish the drawing with every means you can.

As your ability to see the overall shape and volume of a figure improves there may be a temptation to try to embellish the drawing with every means you can. You may be tempted to produce a complete outline with full light and shade, pattern, weight, rhythm, movement – all in one drawing. I think this is a mistaken endeavour: the best drawings try by selection to concentrate attention on one salient aspect of the observed reality. This and the following projects are intended to suggest how such selection can be made.

Following the theme of the last project in the Shape section, Shape 3, the torso-containing box, here can be seen to have a cut-off pyramidal section (yellow). Why is this so? Gravity is the answer: dragging the soft tissues to a wider base. It is not necessary for the model to be above average weight to see this effect; gravity has its way with all relaxed human tissue, even on the thinnest individuals.

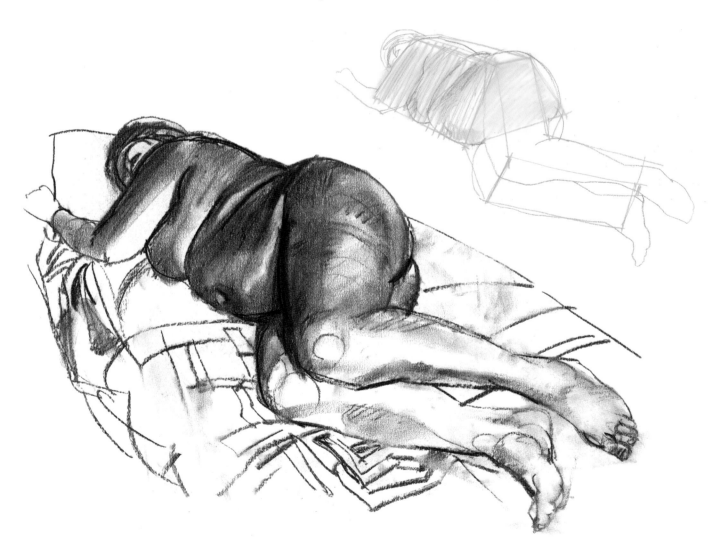

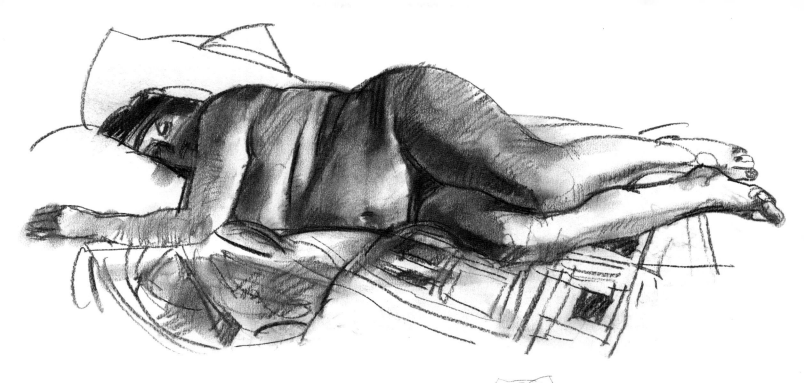

The following poses were set to emphasize this pull of gravity on the soft tissues of the body.

In the drawing above, the model is reclined on a soft bed so that she sinks into it to some degree. As any mattress should, this allows her shoulder and hip to penetrate more than her head, the midriff and legs then keeping the body aligned with less spinal curvature.

A completely different situation arises when the figure reclines on a hard surface as in the drawing below. Now the shoulders and hip cannot dent the surface and the body has to adjust to the support instead of the other way round. Note how much higher the hip is in this second situation and how much lower than the shoulder is the head, even with the support of a pillow.

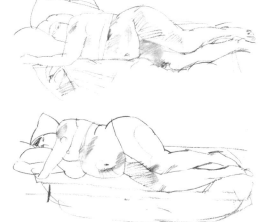

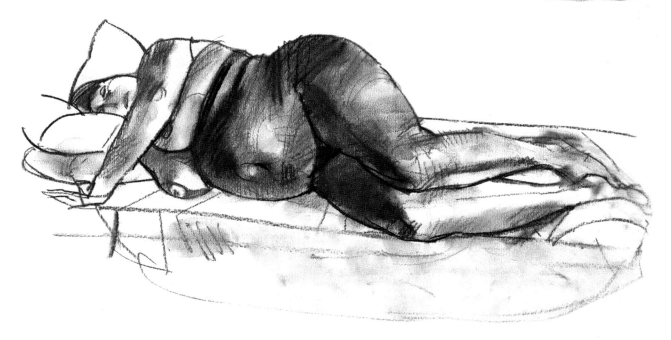

Figure Drawing

Weight 2

Even with comparatively little for gravity to work on there is still a surprising amount of displacement earthwards of any but the most firmly tensed muscles.

The model for these drawings is both young and slim and therefore might be expected to have a body with soft tissues that are very resistant to the pull of gravity. And indeed that is the case but even with comparatively little for gravity to work on there is still a surprising amount of displacement earthwards of any but the most firmly tensed muscles.

The pose in all three of these studies is fundamentally the same one but in three different orientations with the ground. First is a simple sitting position, on an upright chair in the conventional upright position, secondly the chair is laid on its side and lastly it is tipped onto its back.

In each case the model tries to adopt, as near as possible without strain, the same position in contact with the chair. The drawings are very different because gravity is successively pulling downwards, firstly from head to toe, then across the body, and then through the body front to back. If the page is rotated so that the drawings of the reclined poses are viewed as though they were sitting upright, the differences are inescapable.

Normally seated

In this drawing I have tried above all to express the usual downward pull of gravity on a seated figure. Because it is the normal view, the folds under the breasts, the rounded abdomen and the pressure bulge on the under thigh are unremarkable.

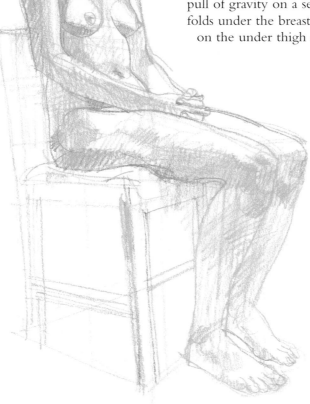

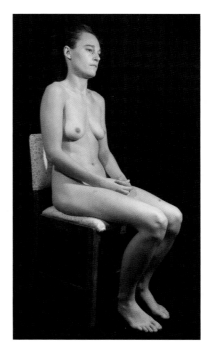

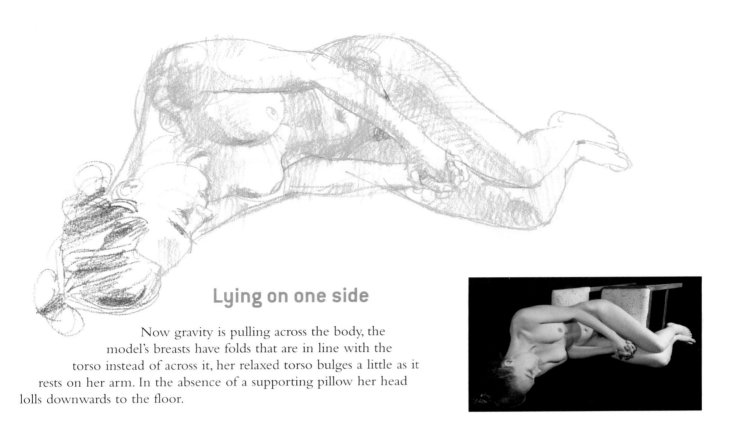

Lying on one side

Now gravity is pulling across the body, the model's breasts have folds that are in line with the torso instead of across it, her relaxed torso bulges a little as it rests on her arm. In the absence of a supporting pillow her head lolls downwards to the floor.

Lying on back

No folds at all under the gently spreading breasts, clasped hands dropped onto her almost concave abdomen, neck braced back; all these features tell the story of even weight distribution through the prone body.

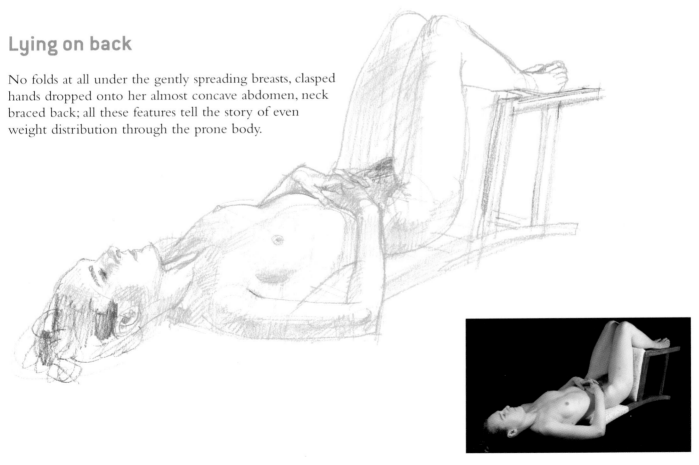

Figure Drawing

Balance 1

Most of us, I think it is fair to say, accept the ability to stand on two feet (or maybe even only one), as an everyday and unremarkable human ability. It certainly doesn't seem to require conscious thought or effort. In fact it is a trick that requires a precise coordination of a number of factors and there is a close association between weight (see pages 98–101) and balance.

A model standing for an artist must relax into a position that can be maintained without strain. To do this, his or her weight must be precisely balanced over the feet, the only contact with the ground. If there is the slightest deviation from this position of balance, gravity pulls on the overhanging weight to topple the figure. Although conscious effort is not involved, it needs constant automatic reassessment and correction.

For a drawing of the standing figure to appear convincing the artist must take notice of the way that this balance is achieved. Luckily there is a very nearly foolproof method of checking this. First draw or imagine a line descending vertically through the centre of the model's neck, note carefully where it contacts the ground relative to the model's feet and make sure that your drawing is the same. As soon as you have rendered correctly this relationship of the centre of the head and the two feet, the figure will look convincingly balanced. Not only does this help you to get the balance right, but the placing of this vertical line, the centre of balance, tells you other things about the dynamics of the pose. If, for example, the line descends right through the contact area of one heel, it indicates that that foot is the one supporting most or all of the weight of the body. In such a case it is likely that the hips will have tilted to allow the other non-weight taking leg to relax, resulting in a torso bend and maybe a countering shoulder tilt to achieve the observed positioning of the head above the weight-taking heel. Correspondingly, if the line, which we can call the centre of balance, contacts the ground equidistantly between the two feet, you will expect equal weight on each leg, no pelvic tilt and no counter swings.

All the drawings on this spread are variations on this basically balanced theme.

Weight entirely on one foot

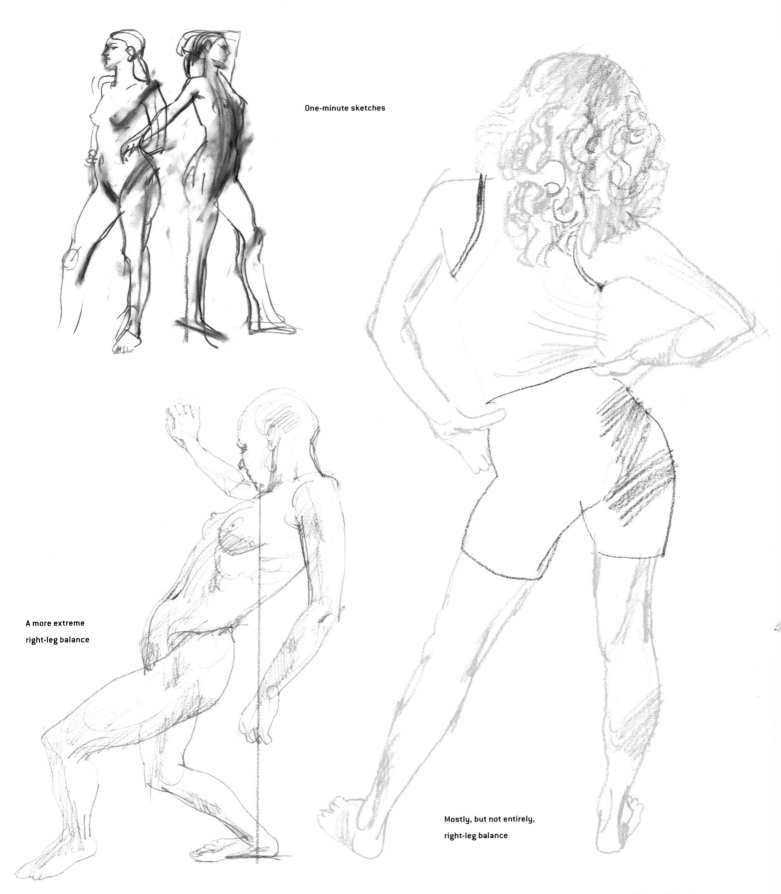

One-minute sketches

A more extreme
right-leg balance

Mostly, but not entirely,
right-leg balance

Figure Drawing

Balance 2

Here the centre of balance is seen to meet the ground at a point that is outside both of the weight-taking feet.

Continuing the balance principles of the standing figure from the previous pages, here the centre of balance is seen to meet the ground at a point that is outside both of the weight-taking feet.

When this occurs it means that the figure must be involving some additional support in order not to fall. Another alternative is that the figure is imbalanced as preparation for moving or is actually in process of falling. If neither of the latter applies, then you need to look for the extra support that is keeping the figure upright.

This figure was drawn on the reverse side of mount board, a very cheap and simple surface showing that it is not by any means always necessary to use expensive materials.

Stage 1

Oil bars were used for the initial marks here. These paint sticks, which are sometimes called pigment sticks, are made of solid oil paint contained in a skin of dry paint and paper. To use them you cut off one end with a scalpel or a similar tool to reveal paint soft enough to draw with.

The main directions of the limbs, trunk and supports were drawn and then smudged with a rag dampened with turpentine. On reasonably absorbent paper this thinned-down paint is soaked up almost immediately, rendering the surface receptive to pencil drawing.

Stage 2

Drawing into the broad under-painted shapes with a soft pencil, the first aim is to find the directions taken by the two supports, the right

Stage 1

Stage 2

leg and the left arm. Although the foot of the model's supporting leg is turned onto its outer edge, it is quite capable of carrying most of the bodyweight (try it, I did), and the left arm is locked straight and almost vertical to take up the remainder of the offset weight.

Stage 3

As the drawing progresses it is important continually to re-estimate the position of an imaginary (or drawn) vertical line through the head to the ground. A prominent feature of this pose is the model's locked right knee: without this firm support the whole structure would collapse, so it deserves to be strongly drawn. There is no need to fear making mistakes with this method – lines are easily erased with the same turpsy rag used initially to smudge the oil bar marks.

Stage 4

Balance, as discussed in the last section, is closely akin to weight so at this point I thought it necessary to introduce another medium to bulk out the forms. Once the oil bar marks are dry (and they dry very quickly as I said above), it is quite possible to over-paint with water-based paint, in this case, white gouache. This made it possible to give the figure more solidity by retrieving the light areas. Pencil can still continue to be used to cover or be covered by the newly introduced gouache.

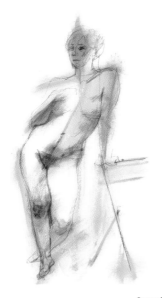

Stage 3

Stage 4

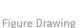
Figure Drawing

Stage 5

In this stage there has been very little additional work on the figure itself; mostly it has been a matter of cleaning up the background and rendering more clearly the outer shape of the figure. I'm not sure that it wouldn't have been better left at the fourth stage. The principal point to be made by this drawing is the sense of overbalancing checked by an external support: if further work does not continue to enhance this message then it is unnecessary and redundant.

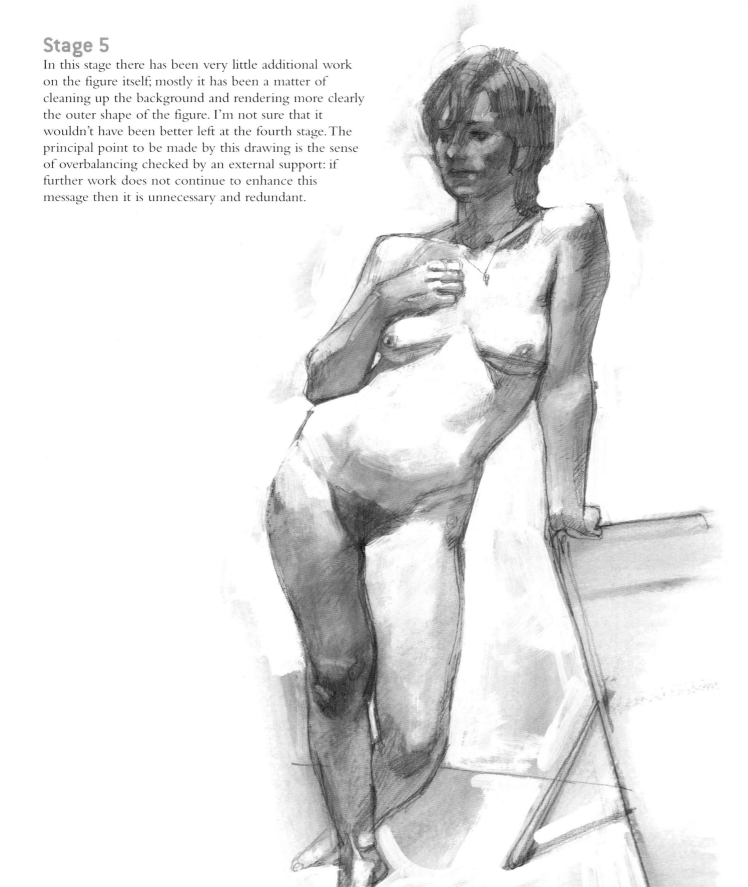

Stage 5

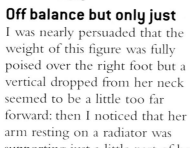

Off balance but only just

I was nearly persuaded that the weight of this figure was fully poised over the right foot but a vertical dropped from her neck seemed to be a little too far forward: then I noticed that her arm resting on a radiator was supporting just a little part of her weight and shifting the centre of balance forward a fraction.

Balance 3

Both charcoal sketches on this page were done very quickly from life: there is no time for detail in three-minute poses.

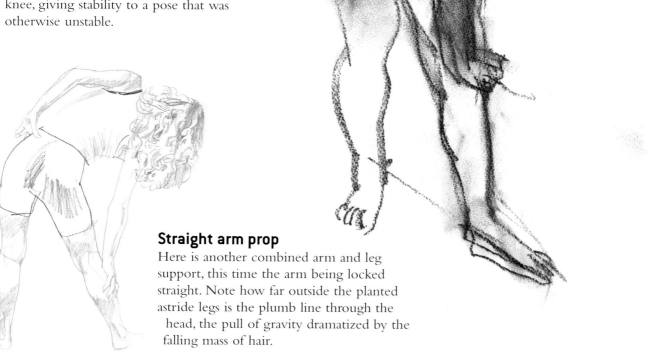

Arm on leg prop

Both charcoal sketches on this page were done very quickly from life: there is no time for detail in three-minute poses and the essence must be stated firmly. Here I felt that the most important element was the supporting prop of the arm on the forward knee, giving stability to a pose that was otherwise unstable.

Straight arm prop

Here is another combined arm and leg support, this time the arm being locked straight. Note how far outside the planted astride legs is the plumb line through the head, the pull of gravity dramatized by the falling mass of hair.

Figure Drawing

Structure 1

By drawing for structure I mean drawing, with it uppermost in your mind, the task of discovering how the forms in front of you are put together.

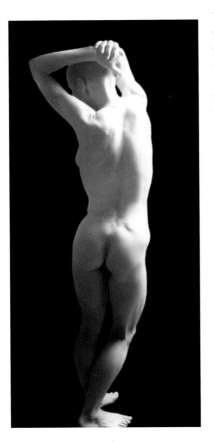

By drawing for structure I mean drawing, with it uppermost in your mind, the task of discovering how the forms in front of you are put together. Structural drawing tries above all to explain, to make sense of what is seen, maybe even to make a plan from which a sculptor could construct a three-dimensional replica.

Of course, all drawing seeks to explain, to respond to things seen and to show what interests the artist and tell what that artist discovers about the object, but emphasis on structure means that you use whatever marks you have at your disposal to render a complete explanation on a two-dimensional surface of forms that actually exist in three dimensions.

The point is that copying the fall of light and shade on the figure will not automatically do this. I remember in the life room in my early days at art school, looking at a drawing by a friend of mine, a consummate draughtsman, and querying why he had put in an area of tone on the figure that I could see was not present on the model. He replied that indeed there was no shadow there but by putting one in, he could explain a change of form that he and anyone blessed with two eyes and consequent three-dimensional vision could see but that would not be evident in the flat drawing. Inventing to explain is a concept that we all unconsciously accept every time we draw a surrounding line to depict the silhouette of an object. What does this line depict in fact? No line exists at the edge of an object: what we draw is the point or series of points to indicate where the form of the object turns away out of view. Yet we accept it, it is a language that we all can read, as humans that is – it is unlikely that any other animals can do this. So why not accept other lines in other places that may give a better or more complete explanation?

It may seem that I have given this concept of the nature of drawing undue emphasis but I find that beginners especially find it difficult to accept the principle of inventing marks where neccessary to represent forms, forgetting that they already do just that every time they draw an outline.

Stage 1

In the photograph opposite the model is standing with her weight mainly on her left heel but with some transference onto her right foot. The central line of balance and the spinal curve with counterbalancing arms are indicated.

Stage 2

Leaving in the original lines of balance, the forms and planes are searched out. Constantly re-check the position of the head above the weight-taking heel and make changes without erasing.

Stage 3

Tone and colour have been used here in order to clarify the form, not just to imitate the light and shade areas of the photograph.

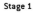 Stage 1 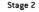 Stage 2 Stage 3

Structure 2

In this project a great deal more of the figure is in contact with the ground than in the case of the preceding standing figure. Now both hands, the right foot, the buttocks and the whole length of the left thigh are sharing the support role.

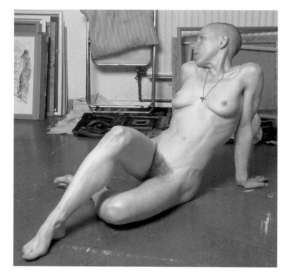

In this project a great deal more of the figure is in contact with the ground than in the case of the preceding standing figure. Now both hands, the right foot, the buttocks and the whole length of the left thigh are sharing the support role.

The drawings on the previous two pages and these two pages were made with coloured pastel pencils, a medium a little less forgiving than pencil perhaps. To make up for the slightly increased difficulty of erasure, in the initial stages of a drawing lighter colours can be used, which will be easily overpowered by later, stronger colours and tones.

Stage 1

The rectangle drawn on the floor indicates the area within which the contact points lie: all the other lines mark the first assessments of main directions and proportions.

Using warm colours for main struts and cooler blues for the internal forms, the structure of the torso and head can now be continued. The main reason for the colour choice is to provide meaningful marks that are nevertheless fairly fugitive but it has some relevance in that the local colour of the torso is usually relatively cool in life while the limbs and extremities often appear comparatively warm in colour.

Stage 2

As the analysis of the forms continues the outer edges of the torso emerge almost without looking for them, just by moving the forms from the middle outwards. By the same process the legs are gradually blocked in.

Stage 3

Now returning to the head, the angled plane of the model's cheek leads to the tilted profile. The placing of her ear is very critical in describing this away tilt of her head. The under view of her chin, the strong line of the *sternomastoid* and the angled *clavicles* all contribute to the dynamism of this head. Note also the wonderful shape of the *triceps* as they lock the straight supporting arm. The feet received some detailing at his stage too, the right one firmly planted on the floor, the left one lying on its side.

Stage 4

Moving down the body the forms are gradually solidified, their changes softened.

Note the angle of the pelvis as evidenced by the relationship of the pubic triangle and the pelvic crests, the latter marked early on at Stage 2, that seem to indicate that the model's right buttock is slightly raised from contact with the floor: whether or not this is actually so is less important than that it seems to be so and that you have drawn it as you see it. In fact, I am fairly sure that the nature of this particular pose does indicate weight supported on the left buttock and thigh. Care must be taken at this stage not to lose the strength of the original statement while giving the surface a more human, fleshy appearance.

Stage 1

Stage 2

Stage 3

Stage 4

Figure Drawing

Stage 5

Starting again at the top, the folds of the ear are drawn in and further solidifying tones applied around the head and neck.

Returning to the legs, the strongly defined kneecap form of the right leg is strengthened and the more rounded form of the left knee described.

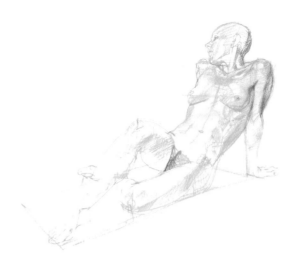

Stage 5

Stage 6

The whole figure received attention at this stage, more mainly warm tones being added to solidify and unify the forms so that they flowed into each other. Some shadow was added on the floor to anchor the figure more firmly.

Also, in this last stage, the model's jewellery, an earring and a necklace, was added. The line of the necklace, which lies closely against the skin thereby following and revealing the form, shows how some advantage can occasionally be gained by such an observation.

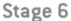

Stage 6

Summary

Having spent some time carefully analysing the structure of a figure in this way it is often possible to start again and in a fraction of the time make a much more free and spontaneous drawing. Such a drawing can be thought of as a summary of the discoveries made and can be drawn either with the same medium or using a completely different one.

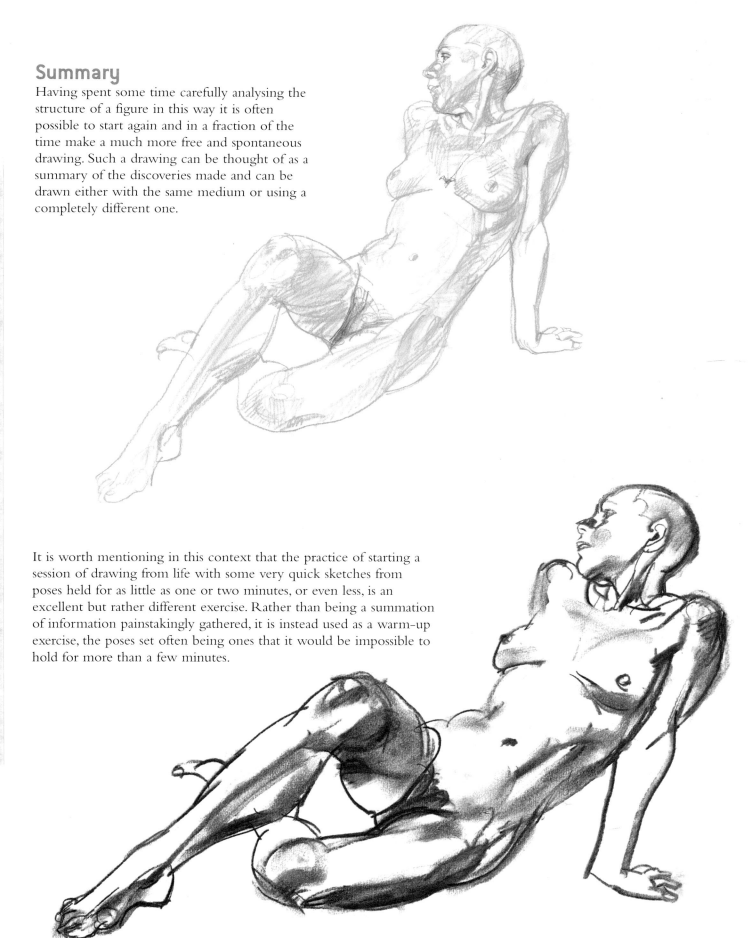

It is worth mentioning in this context that the practice of starting a session of drawing from life with some very quick sketches from poses held for as little as one or two minutes, or even less, is an excellent but rather different exercise. Rather than being a summation of information painstakingly gathered, it is instead used as a warm-up exercise, the poses set often being ones that it would be impossible to hold for more than a few minutes.

Structure 3
Foreshortening

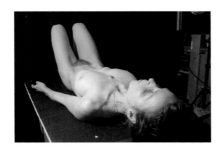

Foreshortening is the name for the apparent shortening of a long object when it is viewed from an angle.

We are so used to this effect in normal life that we hardly notice it, compensating for it subliminally so that we 'read' the object as its real, 'across the vision' length. Unfortunately this automatic translation when viewing limbs or a torso from their ends makes them more difficult to draw, as it is the unprocessed, apparently short, version of the object that must be recorded, leaving the translation to be made by the observer. So measuring is the key: that and imagining containing shapes for part or whole of the figure as in the first shape project (see page 92).

Foreshortening is exaggerated when the viewpoint is close to either the head or the feet when the perspective recession is extreme. Though it may be hard to believe, these two photographs are of the same model.

Stage 1

To make this foreshortening convincing the relative size of the head must be correctly judged: almost unbelievably, the length from crown to chin is the same as from chin to crotch. Note the perspective recession lines from shoulders to hips.

Stage 1

Stage 2

As tones are added, the interlocking forms begin to acquire solidity and credibility as a figure in space.

Stage 3

Stage 2

Further carefully applied washes clarify the form of the shoulder girdle and the rounded forms of the breasts as they lie on the thorax that plunges to the greatly foreshortened abdomen. Note that the thighs are angled up from the body and are therefore normal length relative to the lower torso.

Stage 3

Foreshortening from the feet end

Looking from the feet end, the part of the model's body nearest to the viewer is her left knee with her right knee a close second. Since her lower legs are across the view, they are not foreshortened and appear as normal length but her right thigh can be measured as being almost as wide as it is long. Drawn as such, the eye of the observer compensates and reads the thigh as of normal length. The tipped angle of the pelvis in this case matches the angle made across the knees although this does not necessarily follow.

In such extreme perspective the torso occupies a very small space in comparison with the foreground legs.

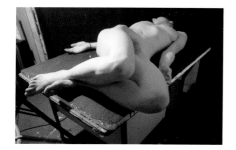

Stage 1

Stage 2

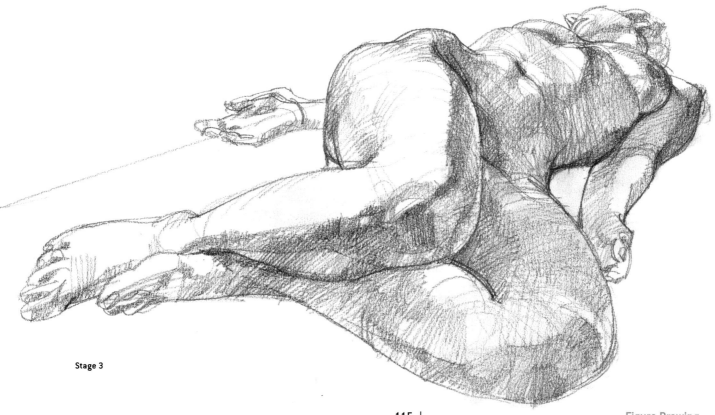

Stage 3

Figure Drawing

Composition 1

Whenever a line is drawn in a defined space, a division of that space has been made, areas to each side of the line have been modified; composition has occurred.

It may not be immediately obvious why composition is something that needs to be considered when drawing the figure. But composition is always there: whenever a line is drawn in a defined space, a division of that space has been made, areas to each side of the line have been modified; composition has occurred.

The simplest composition is a symmetrical one, a centrally placed figure looking straight out at the viewer: by definition, it is balanced and it can have impact. But done too often its predictability becomes boring. A figure also placed centrally, but turned slightly away and then looking straight out may have even more impact.

Recumbent poses present different problems and solutions. If a full-length stretched-out figure is included fully in the drawing, should there be space above or below? I am inclined to prefer a central or below-centre placing for a full-length reclined figure with space above or equidistant rather than in the lower half of the composition. But in my drawing below I think the composition is reasonably acceptable because the model's head is facing downwards and, even though her eyes are closed, attention is drawn to the lower space.

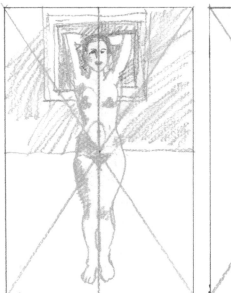

Central subject

Horizontal main element

Thus the placing of a single figure on the page does need consideration if it is to look balanced in the space. Of course, as a last resort it can be modified by judicious framing and/or by adding elements. In this drawing of a stretched-out seated figure I ran out of space at the bottom of the board. I may have elongated the figure somewhat and the head looks to be rather small, but I liked the exaggerated perspective and rather than cram the figure into the space available I added another piece of board. The diagonal composition was thereby improved and I see nothing against such a procedure when required.

When a figure is placed in context, interior or exterior, composition becomes even more important. In the drawing below the model's head is positioned a long distance from the actual centre of the composition but the converging lines of a platform in the background and a similar one in the foreground make it the virtual centre and thus arresting to the eye.

Diagonal subject

Diverting attention to 'cornered' head

Figure Drawing

Composition 2

Once a sense of composition

has been instilled and the

rules have become

instinctive, now is the time

to break those rules or at

least to play with them.

Once a sense of composition has been instilled and the rules have become instinctive, now is the time to break those rules or at least to play with them.

Some of the most successful compositions come about by pushing the limits, by not doing the obvious and safe thing. It has to be admitted, though, that fashion has a part to play: if highly asymmetric compositions have been preferred for a few years, you can be sure that a time will come for a turnaround, symmetry suddenly being the exciting and novel compositional gambit.

On these pages I have drawn diagrams that attempt to discover the principles in famous figure compositions by great artists.

Schiele was renowned for his drawings and paintings of mainly nude figures: the illustration on the left is one of his relatively rare portraits. In one sense the composition is conventional, the head right of centre and facing the open space but he has chosen to place the figure in a curious pose in which he seems to be sliding off the chair so that the his main bulk makes a strong diagonal form from bottom left to top right. This drags the eye inexorably upwards to the face propped on the supporting arm. The fact that the feet are cut off by the bottom margin of the picture, generally a very unhappy accident, is scarcely noticed.

Also by Schiele, the drawing below is one of the best known of hundreds that he produced in his short life. (He died in 1918 aged 28 in the great Spanish flu epidemic, the year after making this drawing.) My sketch shows how he has used the diagonal again so that the figure swoops dramatically into the picture from the top corner, the eye of the observer first swooping down with the figure and then abruptly reversing up from the jutting elbow to the face, her eyes looking back into the foreground space.

Portrait of Johann Harms, **1916,**
Egon Schiele

Female Nude Lying on her
Stomach, **1917, Egon Schiele**

This sketch is based on a painting by Andrew Wyeth that was one of a series of drawings and paintings called the Helga Series done over a 14-year period from 1971. Most were pencil and wash studies of the same model but this is one of the tempera and dry-brush paintings. It is a wonderful painting of which this sketch of mine gives only a pale rendering, but it does show the composition that I consider to be an essential element in its strength. The clue is in the title; the drawn shade doesn't quite fit the window and the resulting sharp slivers of light scything into the dark background give extraordinary impact to the centrally placed half figure, the face placed almost exactly in the centre of the painting.

Drawn Shade, 1977, Andrew Wyeth

Although figures appear in many of this American artist's pictures, he did not specialize in figure painting. Nearly all his paintings, however, owe much of their impact to their unique composition. This picture is typical of the way that he used strong vertical and horizontal divisions to give a feeling of strange calm, a frozen moment, the figures set within them seeming to be self-absorbed, oblivious to the viewer's voyeurism. As the red divisions in my diagram show, most of the seated figure is enclosed within a quarter of the picture area, only the head significantly breaking out into a pale enigmatic area lit perhaps by a window that we cannot see. Despite the diagonals of the edge of the bed and its shadow, pointing attention to the luggage and discarded dress of this partly undressed woman, our view is drawn to the strong contrast of her shadowed profile against the strongly lit wall.

Hotel Room, 1931, Edward Hopper

Figure Drawing

Light and Shade 1

Describing a figure solely by the interplay of light and shade without recourse to any linear edges, is another and equally valid way of drawing.

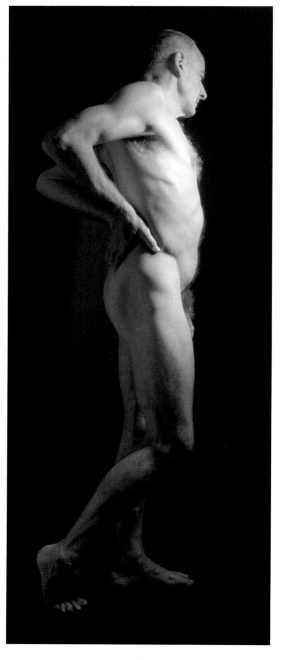

We see the world and everything in it by virtue of the light that falls upon it and which is then reflected to our eyes. Despite the absence of lines around objects we have learned the visual language that enables rendering and recognition of objects that are represented solely by linear outlines, an ability that seems, incidentally, to be uniquely human and not shared by other animals.

But on occasion the light fall on an object may be its most interesting feature. Rather than representing a figure by an outline with or without contained tone or lines of structure, describing a figure solely by the interplay of light and shade without recourse to any linear edges, is another and equally valid way of drawing.

This project is a simple introduction to the concept of representing form by copying light fall alone.

The drawing was made on board prepared with a coating of so-called 'gesso' – not a true gesso as used traditionally but a modern acrylic version. When hard dry this surface renders pencil marks unexpectedly dark, so here a hard 9H pencil was used to provide a wide range of tonality from untouched whites through pale, steely greys through to solid black.

Stage 1

Having said that depicting light and shade is different from outline drawing it may seem strange that the first marks here are outlines. But these lines are outlining tonal areas, not necessarily coinciding with the edges of the figure itself and they are soon to disappear.

Stage 2

Using the first lines as guides, the tones around the head and upper body are introduced. This surface combined with the hard pencil

Stage 1 Stage 2

gives control over subtle greys with light pressure down to dark greys as pressure increases, gradually approaching and eventually reaching dense blacks.

Stage 3

From now on it is just a matter of working down the figure, continually reassessing the tones as the surface is covered. Note that not all light areas are equally light; the right forearm, for instance, has received considerable pencil toning but still registers as a light area.

Stage 4

Unless your model is posed in a completely blacked-out room with black walls there will always be some reflected light to illuminate the darkest shadows. As many of the not-so-light lit areas were darkened, some of the not-so-dark areas were left as reflected light.

Stage 5

Having completed the tones down to the floor, all that was now needed was to knock back all the light areas a little so as to accentuate the highlights on the upper chest.

Stage 3 Stage 4

Stage 5

Figure Drawing

Light and Shade 2

Having generated a tonal drawing on a white surface now this project starts with a background colour that allows two-way progression.

Having generated a tonal drawing on a white surface, where all progress is one-way, from white to dark, now this project starts with a background colour that allows two-way progression.

The burnt-orange colour of the pastel paper can be used as a mid-colour/mid-tone base upon which both lights and darks can be added.

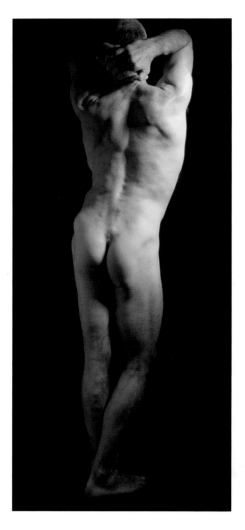

Stage 1

Stage 2

Stage 1

Pastel pencils were used here initially, the colours being creamy pink, mid-orange, burnt sienna and dark brown. Note that the colour applications are not solidified so the background makes a contribution to the observed colour.

Stage 2

With the same colours as before plus a pale blue for reflected light in the shadows, the shadows are gradually deepened and the lights solidified.

Stage 3

Now the precise shapes of the shadows in the upper back, arms and head are searched out and the most strongly lit areas are reinforced with tints of yellowy pink soft pastel. It is not useful to know the precise names of the pastels used as the nomenclature varies between manufacturers: it is best to proceed by careful trial and error.

Pastel drawings are fragile and easily smudged so they need to be protected when finished. Various spray fixatives are available but if it is applied to the finished artwork, colours are dulled. I find the best compromise is to fix the drawing a little time before it is completed and then leave the last layer without fixing.

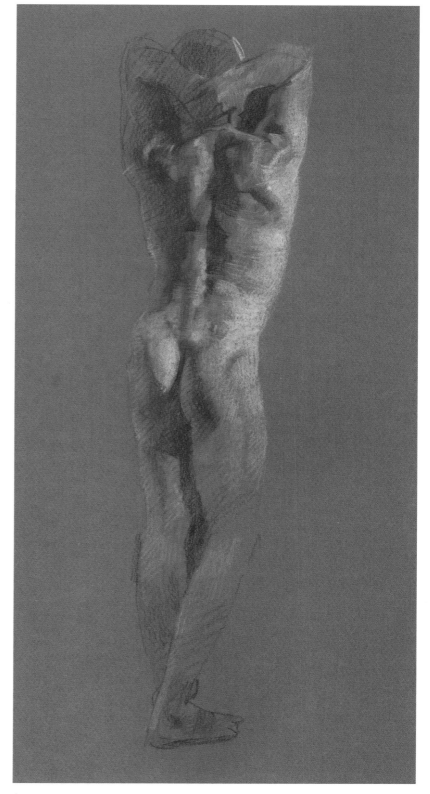

Stage 3

Figure Drawing

Light and Shade 3

The fall of light is not always direct and unhindered: it may be filtered through screens of various types — trees, blinds, lace curtains, grilles — there is no end to the possible ways in which light can be obscured.

The fall of light is not always direct and unhindered: it may be filtered through screens of various types — trees, blinds, lace curtains, grilles — there is no end to the possible ways in which light can be obscured.

Here the filter is a Venetian blind, the sun shining through it and onto the figure, making patterns that track over the forms, at the same time both concealing and revealing.

It is not an original idea; such a situation has been drawn and painted many, many times but there is always something different to see; the patterns are never the same. In this instance the blinds are not fully closed, permitting transmission of thin lines of light to wrap around the forms of the seated nude figure.

Since each slat of the blinds is pierced for the cords used to manipulate them, there is also a line of light spots to add to the pattern. In addition one window is half obscured by semi-translucent paper against which the figure appears silhouetted.

It must be admitted that lighting of this type is very difficult to paint in a live situation as the patterns of light cast on the body change radically with every shift in position of the model, even the action of breathing. So this watercolour was painted from a projected transparency. The ground was prepared with a coating of acrylic gesso. This renders the surface more or less impermeable depending on the thickness or number of coats applied resulting in a degree of unpredictability, which adds to the fun!

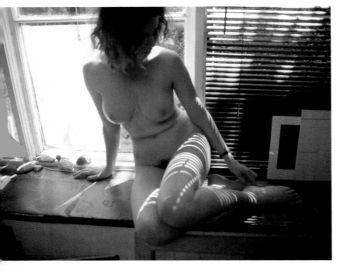

Composition sketch

The high viewpoint of this photograph rendered the perspective of the window rather extreme so the left frame has been rotated to nearer vertical. In addition a substantial part of the image was cropped at the right to make the format nearer to a square and to place the figure more satisfactorily in the composition.

Stage 1

There are various ways of working from a transparency image. You can project it onto a white screen, sit in front of it and draw as though observing the real scene. Alternatively, a tracing can be made of the projected image in pencil and transferred to the painting surface. For this rather complex pattern of light stripes I projected the image directly onto my prepared surface and drew with a brush and watercolour.

Stage 1

Stage 2

Delineating the light-fall pattern is continued and the straight lines of the Venetian blind and window frame put in with the aid of a ruler. This is a technique that is useful to acquire in which a ruler is held firmly with one edge on the picture surface so that the ferrule of the brush can be slid at a constant angle along the other edge.

Stage 2

Stage 3

Cool washes are applied over the main shadowed parts of the figure and foreground. Watercolour on this prepared surface tends to float around and to dry slowly with a slightly hard edge.

Stage 3

Figure Drawing

Stage 4

Stage 4

The washes over the knees, torso and head are modified with a wet brush and pulled together with more washes.

Stage 5

Stage 5

The wash on the too dark supporting arm is lifted off with a damp brush and further modifications made to the upper torso and face. Because the washes cannot penetrate the surface they are always easily moved and changed. Shadows of leaves on the window behind the blind are added.

Stage 6

Having left the picture for a few days, upon reacquaintance I felt that the tone of the figure was too bright for the contra jour (against the light) situation. Adding washes on this surface endangers the ones beneath so they have to be eased on gently and they tend to pool, but if left to find their level they usually settle reasonably well. I added two more levels on the shadow areas of the figure and one more on the wall giving, I consider, a stronger overall pattern of light and shade.

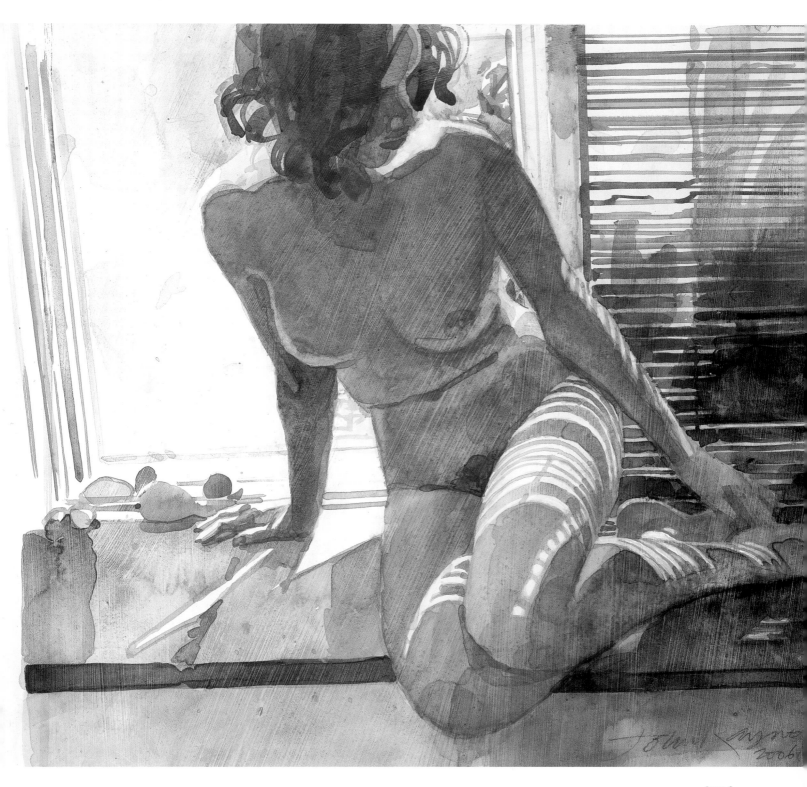

Stage 6

Figure Drawing

Clothing 1

Just as some knowledge of what lies under the skin assists in the understanding of surface form, so knowledge of the body inside the looser skin of clothing is useful when drawing the clothed figure.

Everyday western clothes consist basically of tubes joined together in various ways to enclose the torso and limbs. These tubes must permit movement of the body and limbs, and they do this by being stretched over places of tension and folding upon themselves where there is none. Not all fabrics behave in exactly the same way under these stresses but patterns appear consistently enough to be recognized and, to some extent, predicted.

Sleeve

These drawings of sleeves demonstrate the principle: despite a slightly different appearance every time an arm is flexed, sleeves always have a similar dynamic, the pulled-out folds radiating from the point of the elbow and the excess in bunched folds on the inside of the angle.

Skin tight

Tighter clothing behaves more like a second skin; the more elastic the clothing the closer is the resemblance.

I made this wash drawing as a demonstration at the Mall Galleries in London. The paper was pre-prepared with a coating of acrylic 'gesso' so as to permit a certain amount of easy correction. The model was seated on a circular dais around which gallery visitors were freely moving, she and the chair being the only static elements.

Very little creasing is present in her vest top or her trousers but although her boots are also very tight the inelastic nature of the fabric (leather) means that there must be more room for folding to accommodate movement at the ankle.

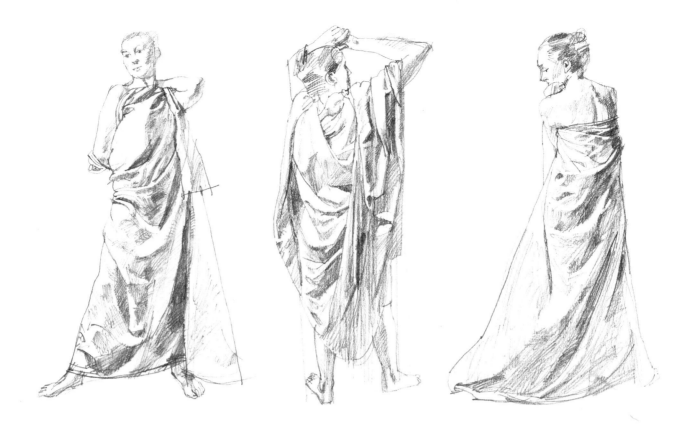

Loose drapery

In contrast to tight clothing, very loosely draped clothing is perpetually being pulled towards the floor by gravity, only being suspended or deflected by the body beneath. For these drawings the model was asked to wrap herself in a sheet in a variety of simulations of real dress to give a mixture of free falling cloth and tight folds.

Loose gown

When clothing is cut in such a way as to enclose the body but not with a particularly tight fit, there may be a mixture of gravitational pull and tubular folding. The gown worn by the model here is only loosely fastened but it has an extra folding component given by the straight folds made by ironing and storage, which would normally allow some parts of the main garment to fall freely with little or no folding. Some fabrics hold such folds more consistently than others.

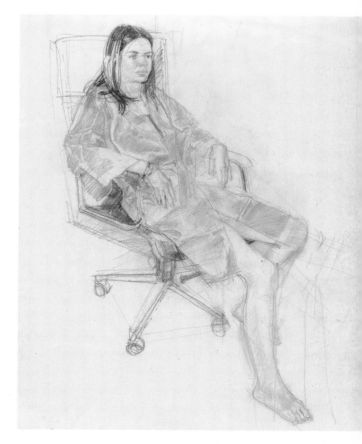

Figure Drawing

Clothing 2
Tubes

We have already seen how much of modern daily-use clothing consists of fabric tubes. They may be tightly fitting or even elasticated to perform as a second skin as mentioned above: socks and stockings are typical of this. More commonly they are relatively loosely fitting to permit movement and air circulation. A shirt or coat (or blouse or jacket) consists of two tubes attached to a larger one that can be opened or closed: pullovers and other tops are tubes that cannot be opened and must be pulled on over the head: trousers are two tubes branching from a single larger one. Once this concept is absorbed the complete logic of folds and pulls in clothing as it responds to the positioning of the body that it encloses becomes apparent and easy to deal with.

Stage 1

Using Conté pastel pencils the first marks can be quite bold since they are easily modified as the drawing becomes more precise. Drawing around the tubular forms prepares the ground for the form-following folds.

Stage 2

None of the first marks have been erased as the curving pulls of the fabric are added. Although the body of the shirt is also a tube, the folds tend to form *along* the length rather than around it. Gravity is involved here as it also is in the falling folds from the knees.

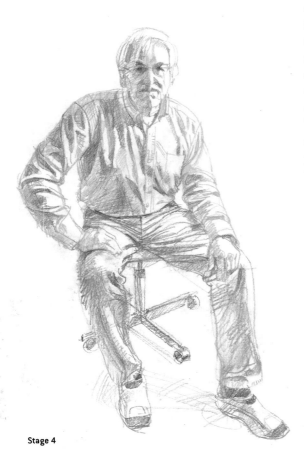

Stage 4

Stage 1

Stage 2

Stage 3

Stage 3

Some indication of the hands and face has been added at this stage, the right hand as it curves around the thigh emphasizing the form of the fabric stretched over it.

Stage 4

Analysis of the stresses is continued by gradual refinement and clarification of the forms. All the folds are described with their function in mind: from whence they begin and why they form. To complete the study, shadow tones of the pink shirt are deepened by a mixture of mid blue and a stronger pink/red.

Stripes

For this drawing (above right) I made no indication of light and shade on the striped top, the shapes of the brown stripes alone giving a clear impression of the form underneath and also of the folds that were produced by the raised arms. There was some shadow on the garment of course, as there is on the head, but I have omitted it here to demonstrate the principle of pattern revealing form.

Patterns

More complex patterns like these (right) both disguise the form and reveal it, depending on the regularity and/or detail of the patterns and the contrasts of light and shade. In this instance probably form concealment wins and the patterns dominate.

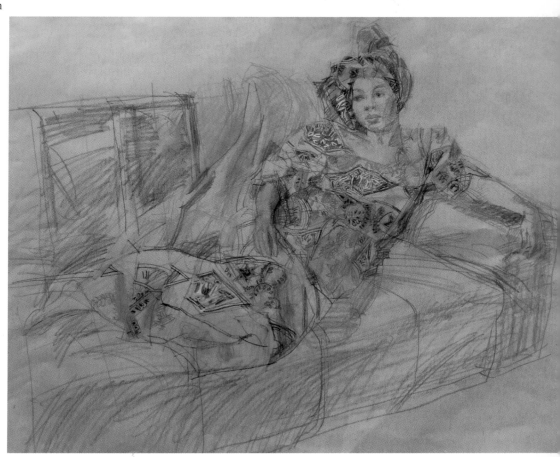

Figure Drawing

Character 1

Up to this point I have been stressing the need to concentrate on one or other of the abstract qualities of shape, light and shade, structure, balance and weight. Now I want to introduce the idea of drawing for character. By character I mean the visible signs of the particular qualities that make an individual person different from any other. Much of what we recognize as individuality resides in the face but not all: typical posture in sitting or standing, local coloration, texture of skin and muscular tension all contribute to a recognizable individual.

A drawing made with character uppermost in the artist's mind should also be sound in all the other areas but will be primarily searching for the idiosyncratic qualities that bring the personality of the model to life. Obviously most people look to the face for individual character but in the slightly different sense of 'character of shape', which can also be discovered in the unique qualities of each particular body. Whether my drawings here do that is for others to judge but that was certainly my intention and although they were mostly drawn some time ago, I do recognize and remember the individual models.

Claire in white shift

This artist's model, the daughter of an artist herself, always seemed to be able to slip into poses that were in some curious way very much her own. Even a relatively unforgiving office chair has afforded her the necessary support for a completely relaxed pose with what I consider to be a delightful and typical juxtaposition of her feet.

The sleepy expression on her propped face and head is also important to the overall feel of the drawing.

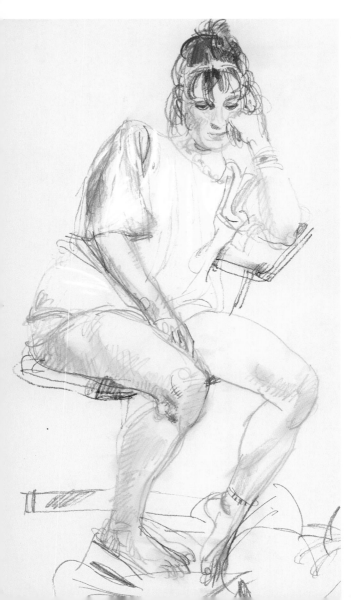

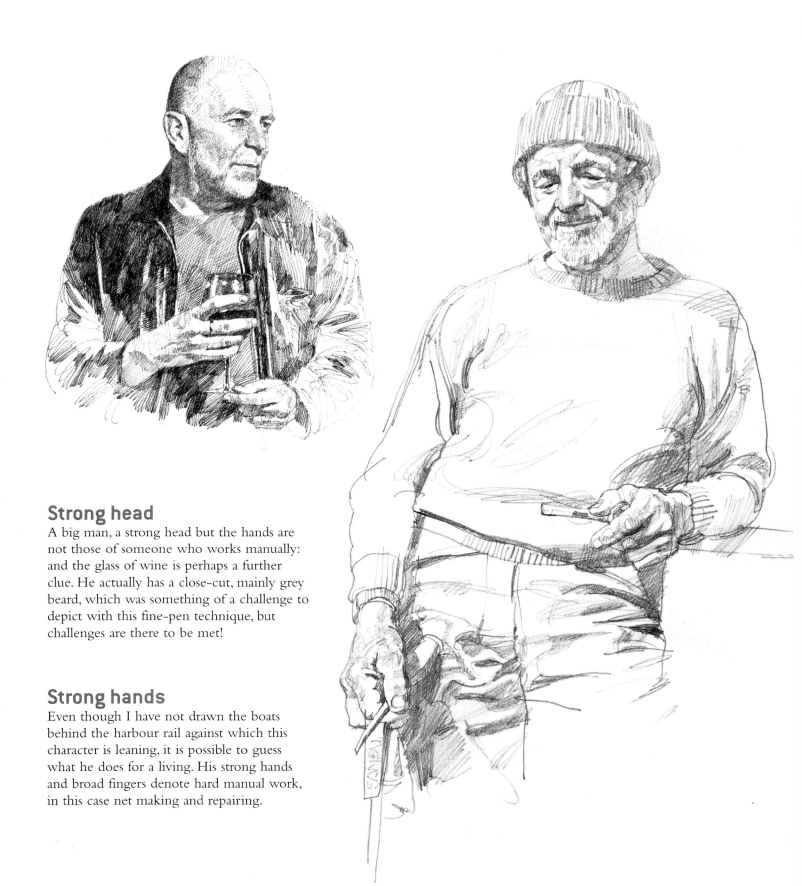

Strong head

A big man, a strong head but the hands are not those of someone who works manually: and the glass of wine is perhaps a further clue. He actually has a close-cut, mainly grey beard, which was something of a challenge to depict with this fine-pen technique, but challenges are there to be met!

Strong hands

Even though I have not drawn the boats behind the harbour rail against which this character is leaning, it is possible to guess what he does for a living. His strong hands and broad fingers denote hard manual work, in this case net making and repairing.

Character 2

Time tends to fix habitual expressions on the human face, so the creases that are increasingly present give a visible summary of the person residing therein. The sitter for this drawing was a lady of mature years with a lively expression and the naturally occurring lines that accompany it.

Time tends to fix habitual expressions on the human face, so the creases that are increasingly present give a visible summary of the person residing therein. The sitter for this drawing was a lady of mature years with a lively expression and the naturally occurring lines that accompany it.

I have departed to some degree from my usually advocated order of procedure here by starting the drawing of the head without any overall planning or measuring to ensure that all will fit comfortably on the page. A judgment was made by eye but it remained somewhat risky to be positive about the position and size of the head in a drawing that was intended to encompass most of the seated figure. With practice these judgements become more accurate and less risky and a slightly different, more spontaneous drawing may be the result.

Stage 1

Here I have made some fairly conclusive statements about the head and shoulders in the top right of a sheet of paper, judging that there will be room for the extended right arm at the left and for enough of the sitter's skirt at the base.

Reflections in the glass of the spectacles that obscure some details of the eye need to be drawn around and left as gaps in the shadow areas under the brows.

Stage 2

The head is further developed, the local background helping to define the edges of face and hair. At the same time the rest of the figure is gradually added. Now you can see more of the complete picture area and that the sitter's left arm fits neatly inside the right margin.

Stage 1

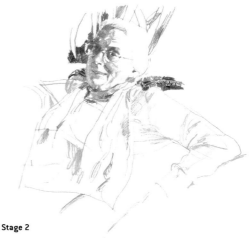

Stage 2

Stage 3

Now more colour is added to the clothing with more emphasis on the way the fabric folds and encloses the figure than on actual overall coloration. It was important to capture the alertness of the character of this sitter as exemplified by the vigour of the cross-legged pose.

Stage 4

Remember, this is a drawing not a painting – there is no compulsion to cover every inch of the paper. Although the fabric of her skirt was a strong green I felt that it was sufficient to suggest this by green in the shadow areas, and for the strong linear folds, while leaving the light areas uncoloured. The cushion propped under the sitter's right arm seemed to need the extra solidity imparted by an indication of overall colour, although it is much lighter than the reality as you can see from the photograph (opposite).

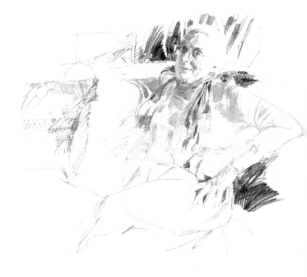

Stage 3

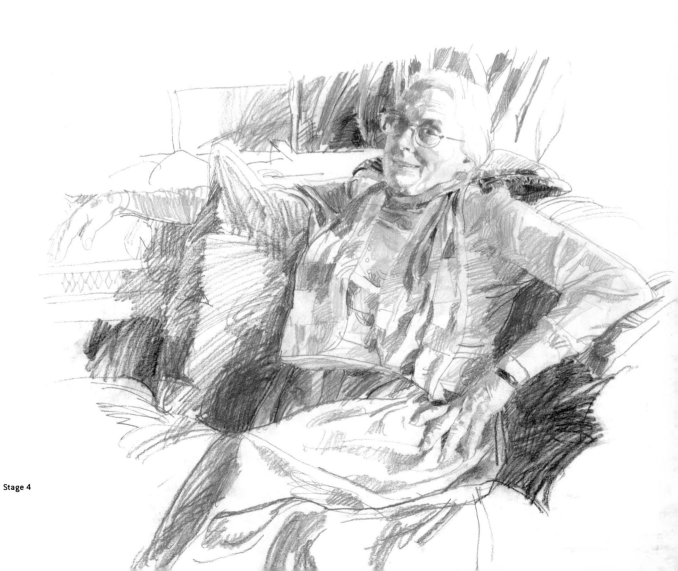

Stage 4

Pregnancy and serendipity

There is little need for explanation of the drawings on this page. Pregnancy is the one way that weight is gained specifically and entirely naturally with an eventual return to normal. Although it is not apparent from these seated poses, any change in spinal curvature, mostly in the lumbar region, is needed to balance the greatly increased frontal weight.

The picture below embodies the reason for the heading 'Serendipity': while my model was posing for this drawing, our cat clambered onto her hip and went to sleep. So I drew her in, the cat I mean (she is called Mabel) giving the drawing a unique extra element. Be prepared always to take advantage of happy accidents. Drawing can be as a sort of visual diary; making a drawing from observation of virtually any subject fixes the process in your subconscious for ever, in a way that a photograph rarely does.

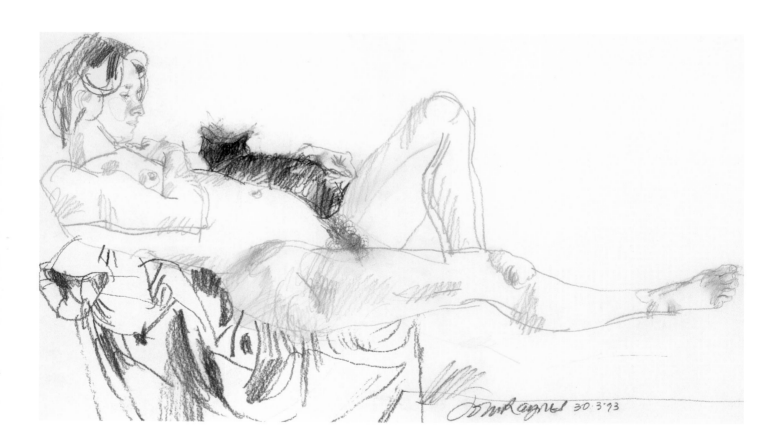

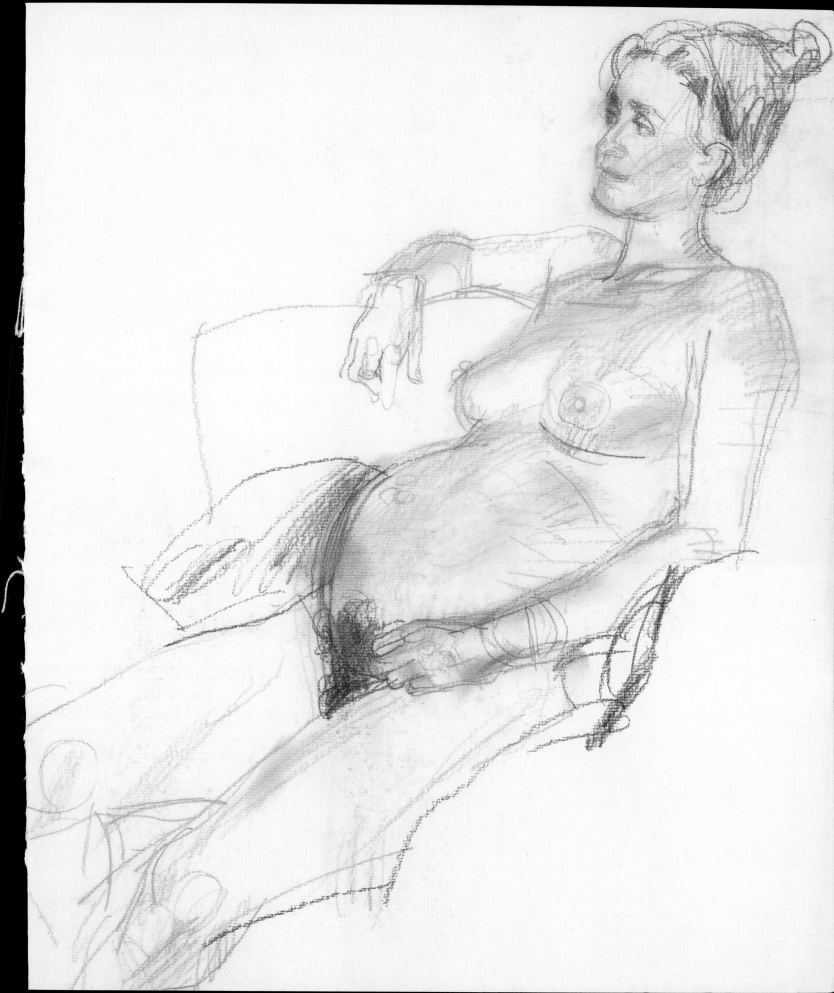

Creativity

There are many ways that artists may choose to express their reaction to the human figure – these are just a few of my own. They are principally based on the effect of an unusual fall of light on the figure, which is an extension of the lighting in Light and Shade 3 (see page 127, stage 6). Instead of waiting for light to be filtered through the slats of Venetian blinds I made slides of a variety of stripes and projected them onto the figure.

I should perhaps say some words about photography here. As I have said earlier, it is always better to draw from life wherever possible because you are then reacting directly to the three-dimensional world rather than a two-dimensional version of it, but of course there will be times when this is difficult or impossible to arrange. On these occasions a photograph must supply the source. For some reason, perhaps in a bid to perpetuate a sort of mystique, many professional artists pretend that they never have recourse to photographs, whereas in reality almost all do to a greater or lesser extent.

For those readers who are not particularly *au fait* with photography but would like to avail themselves of its assistance, what follows is a simplified set of principles.

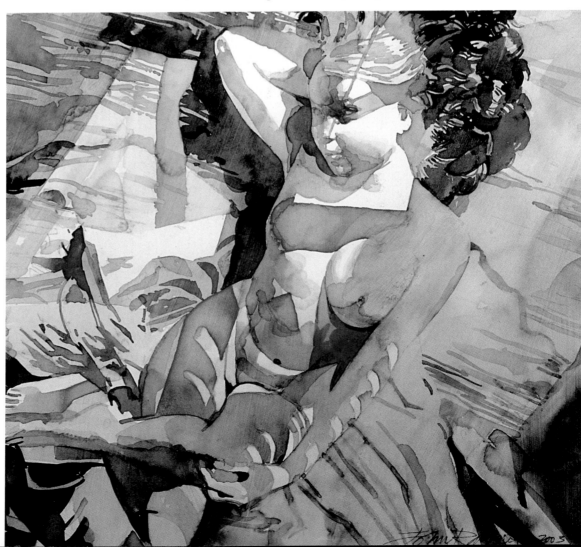

Nearly all amateur cameras, and many professional ones too, provide flash illumination on the camera body itself, often placed just above the lens. When this comes into play, usually indoors or in poor light, because the lighting appears to emanate from a position close to the eye of the taker of the photograph, the resulting image has very unnatural modelling with virtually no shadows except a thin one around the edge of the subject. While being useful as a subjective record, as a source for drawing or painting it is very limiting.

Natural light is nearly always much more interesting and out of doors there is usually enough light without flash assistance. The problem indoors is that, while there may be sufficient light for the adaptable human eye, it may not be enough for a camera to record the subject without extra light or the use of longer exposures. The necessary long exposures run the risk of blurred photographs as a result of camera or subject movement during the time that the shutter is open. Camera movement can be solved by the use of a tripod or other rigid support but subject movement cannot be solved without a head clamp! (This is a device that was actually used in early photographic experiments.)

Nevertheless, despite these problems I would always risk having slightly soft images recording the observed light and shade rather than resorting to the hard-edged and flat flash image.

Of course natural light can be simulated by the use of off-the-camera photographic lights but for those without such expertise and equipment I suggest the following guidelines for photography in most low-light situations.

1. Use a tripod or prop your camera against any convenient rigid form.
2. Use fast film, or for digital cameras that permit it, change the sensitivity to light (measured in ASA numbers) up as far as permitted, sometimes as fast as 800 or 1600 ASA. Images at high ASA numbers are less sharp and more grainy than those at the lower end of the scale but are often quite usable.
3. If your camera permits adjustment of speed and aperture, open the aperture as far as it will allow, usually to about f2 or f2.8, sometimes only to f3.5 or f4. The smaller the f number the larger the aperture (the hole that permits light to enter the camera). It may also be necessary to lengthen the exposure time to perhaps one-eighth or one-quarter of a second. Any longer exposure than this risks too much blurring from subject movement. Some amateur cameras are totally automatic and do not allow any manual adjustments; in this case, for film exposures, nothing can be done except by processing adjustments that are difficult to control. Digital photographs can often be adjusted after the event by downloading to a computer and using appropriate software to effect necessary changes.

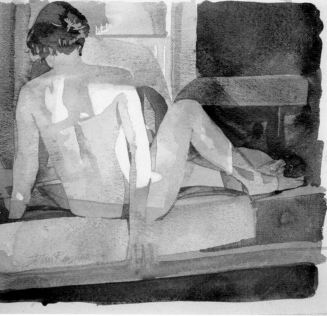

Having made and projected my slides of stripes and patterns, I took more photographs, which were then manipulated by various methods, changing colours and forms until something emerged that interested me. Then the paintings were made using the manipulated images as the primary reference but freely extrapolating along the way and using watercolour happy accidents wherever they occurred. For the later pictures the repertoire of stripes and patterns was extended to include projected light through coloured acetate film. If red and green seem to dominate in the recent pictures it is just something that I happen to be experimenting with at the present time and I am sure that other colours will re-emerge later.

These pictures represent just one way to be a little creative with figures. There is an infinite number of other approaches: by its nature creativity is personal and you will find your own way to work towards a uniquely personal vision.

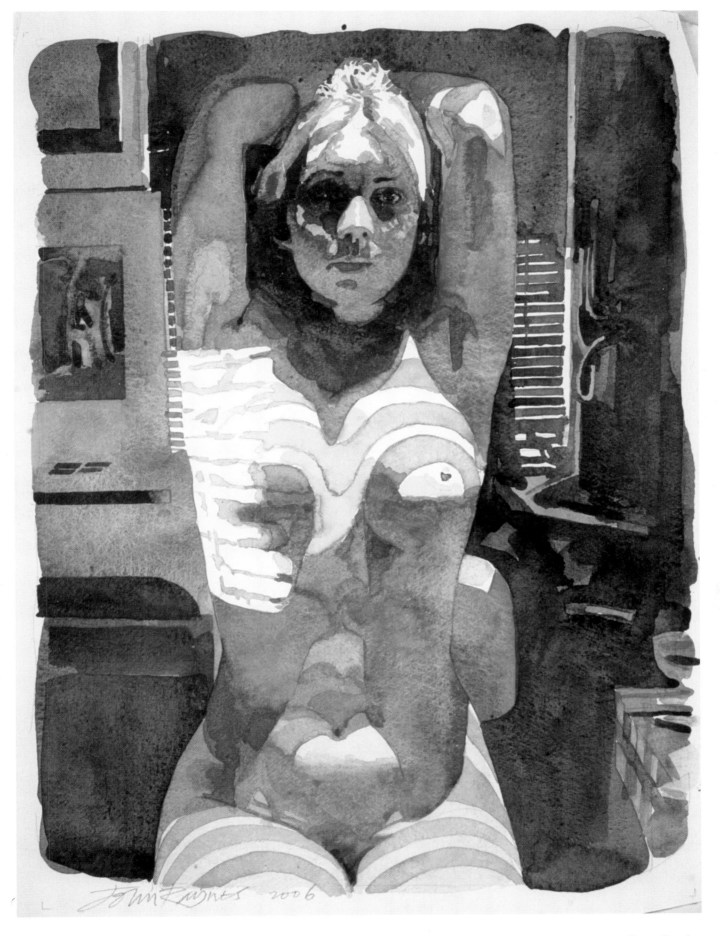

John Rignes 2006

Index